Art Students League of New York on Painting

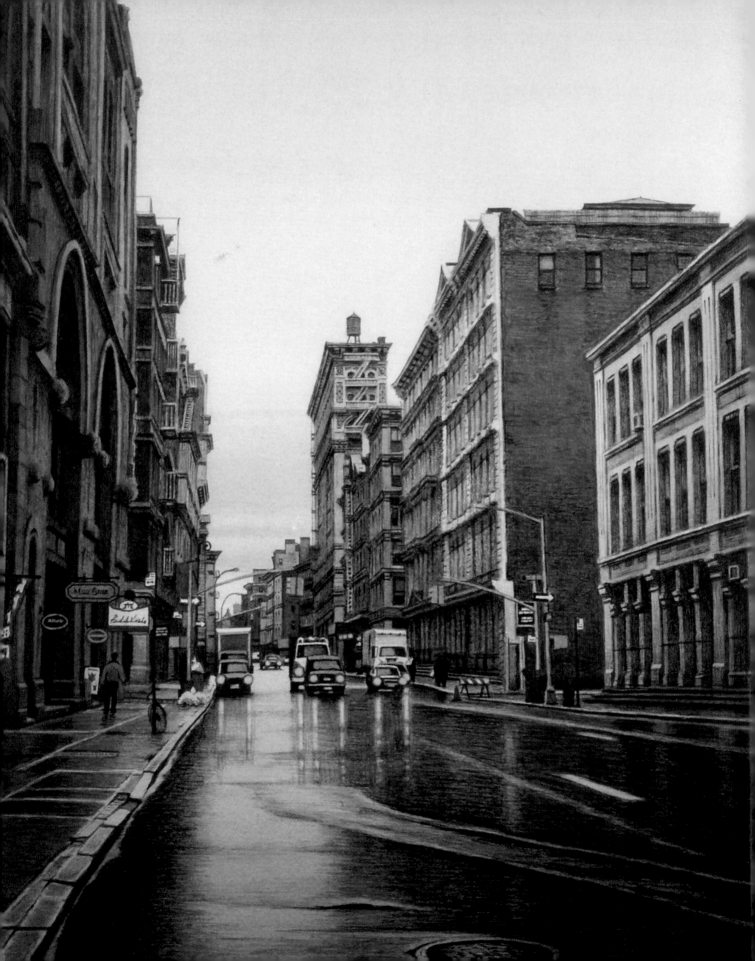

ART STUDENTS LEAGUE OF NEW YORK ON PAINTING

Lessons and
Meditations
on Mediums,
Styles, and
Methods

JAMES L. McELHINNEY
and the Instructors of the Art Students League of New York

WATSON-GUPTILL
PUBLICATIONS
Berkeley

Library of Congress Cataloging-in-Publication Data
Art Students League of New York on painting : lessons and meditations on mediums, styles,
and methods / James L. McElhinney and the Instructors of
the Art Students League of New York. — First Edition.
 pages cm
 Summary: "This book is a collection of lessons and philosophical discussions about painting
from illustrious instructors at the Art Students League of
New York"— Provided by publisher.
 Includes bibliographical references and index.
 1. Painting. I. McElhinney, James Lancel, 1952- II. Art Students League
(New York, N.Y.)
 ND1150.A78 2015
 751—dc23
 2015012084

Hardcover ISBN: 978-0385345439
eBook ISBN: 978-0385345316

Printed in China

Cover art, *Woman with Wonderbread Breasts*, by Knox Martin.
Back cover art details (clockwise from upper left), *Sagittarius* by Charles Hinman, *Andrew* by
Mary Beth McKenzie, *Rite of Spring* by Ronnie Landfield, *Rainbow XXXVI* by Costa Vavagiakis,
The Scratched and Unfixed Air by William Scharf, *Larré, Yellow and Blue* by Henry Finkelstein,
Windowpane by Sharon Sprung, *Apotheosis 1* by Dan Thompson, *The Weapons Become the Altar*
by William Scharf, and *Woodstock Torline* by Peter Homitzky.

Design by Tatiana Pavlova

10 9 8 7 6 5 4 3 2 1

First Edition

Page ii
Frederick Brosen
Houston Street
2009, watercolor over graphite on paper, 18 x 12 in.

CONTENTS

Foreword by James Rosenquist vii

Preface by Ira Goldberg viii

Acknowledgments x

Introduction: Miracle on 57th Street 1

Part 1: Lessons and Demos 15

Henry Finkelstein: On Painting, with a Critique 17

Mary Beth McKenzie: Painting from Life 27

Ephraim Rubenstein: Painting from Observation 39

Thomas Torak: A Contemporary Approach to Classical Painting 59

Dan Thompson: Learning to Paint the Human Figure from Life 75

Sharon Sprung: Figure Painting from Life in Oils 91

Frederick Brosen: Classic Watercolor Realism 107

Naomi Campbell: Working Large in Watercolor 123

Ellen Eagle: Poetic Realism in Pastel 135

Costa Vavagiakis: The Evolution of a Concept 148

Part 2: Advice and Philosophies 165

William Scharf: Knowing that Miracles Happen 167

Peter Homitzky: Inventing from Observation 181

Charles Hinman: Painting in Three Dimensions 193

Deborah Winiarski: Painting and Encaustic 203

James L. McElhinney: Journal Painting and Composition 213

Part 3: Interviews 229

Frank O'Cain: Abstraction from Nature 231

Ronnie Landfield: On Learning and Teaching 251

Knox Martin: Learning from Old and Modern Masters 269

Concours: Painting and the Public at the Art Students League by Dr. Jillian Russo 282

Index 286

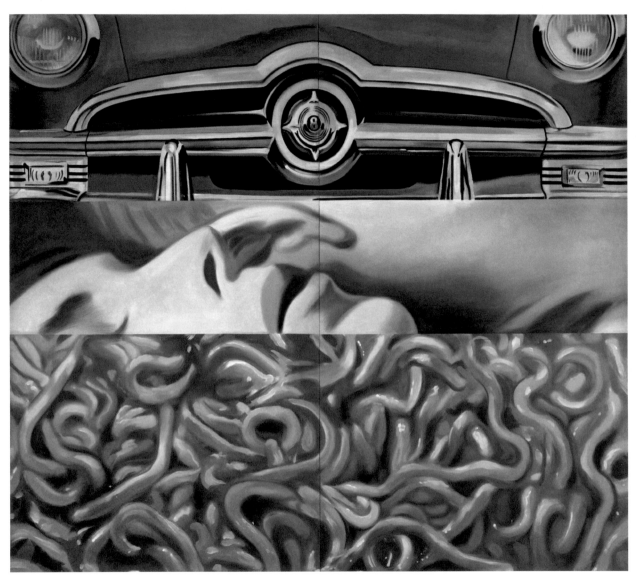

James Rosenquist
I Love You With My Ford
1961, Oil on canvas, 82.75 x 93.5 in.

Foreword

I won an out-of-town scholarship to the Art Students League in 1955 and stayed at the YMCA for 79 cents a night if I made my own bed. Stewart Klonis was the president of the Art Students League at the time, and Rosina Florio was the registrar. She said when I arrived I jumped up on her desk and said, "Hurray!"

I studied with Robert Beverly Hale, George Grosz, Vaclav Vytlacil, Edwin Dickinson, Sidney Dickinson, Morris Kantor, Will Barnet, and all the old-timers. The school was all about drawing and composition. My previous teacher, Cameron Booth, who had taught at the Art Students League and taught me at the University of Minnesota, excelled in both and gave me a good grounding before I arrived in New York City.

New York was intimidating. I walked everywhere and never took the subway. The museums were free, empty, and like sanitariums; today they are packed. I would see Marlon Brando and Wally Cox having coffee at the MoMA coffee shop. Life was free and casual. I applied myself and attended night classes at the Art Students League until I caught pneumonia and went to the Roosevelt Hospital Welfare Ward. I had a close artist friend, Ray Donarski, who lent me his last 5 dollars after he borrowed 10 dollars from painter Henry Pearson. Life was precarious but interesting.

My fellow students were Ray Donarski, Takeshi Asada, Chuck Hinman, and Lee Bontecou. The art world was small—57th Street, 10th Street, 23rd Street—with few galleries and few museum shows. Besides making art, my energies were directed to finding new lofts or apartments and getting enough to eat. My friends and I would do eating combines; we would chip in 50 cents and make huge meals. All you could eat. Also we would keep cheap apartments and pass them along as much as possible—the rents were 23 dollars a month. It was our underground. I would continue to go to free art classes at the Art Students League and continue to draw. A friend told me about a great job with the Stearns family in Irvington, New York. I went to see them, and Joyce Stearns jumped out the front door and said, "Hop in my Wildcat and I'll show you the castle." We were fixed a lunch, and Joyce said, "What do you think?" The job was to watch the children and chauffeur the family. I said, "I'll take it." Tending bar for the Stearns in 1956 I met Romare Bearden and John Chamberlain. And I later became friends with both of them.

The Art Students League showed me that methods are simple but the results can be incredible. All the paintings in museums around the world are merely minerals mixed mostly in oil, smeared on cloth by the hairs from the back of a pig's ear (a Chinese bristle brush). And all the famous drawings in most museums are done merely with burnt wood (charcoal) drawn on parchment. With these basic materials you can do most anything. The seriousness of the teaching at the Art Students League had an impact and helped me use my materials to explore the fantastic.

—JAMES ROSENQUIST, artist and former Art Students League student

Preface

Whether civilization gave birth to art or art to civilization, the two are inseparable. From the first time images were made on the walls of caves going back forty millennia, there has been an enduring enchantment with the art of painting and our ability to interpret what we see—which in turn deepens our understanding of nature and the nature of being human. Along with survival, communication is our strongest imperative, and that ongoing drive has given birth to the creation of different forms of language to bring clarity to what we perceive. Painting conveys perceptions that words cannot. We continue to be inspired by the likes of Rembrandt, Poussin, Titian, Velázquez, Rubens, Vermeer, Ingres, Corot, Cézanne, Picasso, Matisse, O'Keeffe, de Kooning, and so many more whose art endures today and will speak to generations to come. As one creates a picture from observation there is an awareness and a palpable sensation of being connected to the world we are observing. At first, we're fascinated that through the application of viscous colored material to a blank surface, we can make a picture appear like what we're seeing. That's when the journey begins. As when we learned to speak or even to walk, the beginnings are clumsy. The idea of "painting what we see" steers our thinking well before we learn to understand how to see. The language of visual art is as complex as any other, with intrinsic grammar and vocabulary that take many years of commitment, discipline, and guidance to master.

After time, the brush becomes an extension of one's hand. Intuition relieves the brain of overthinking and overanalysis. Seeing becomes perceiving. Subject matter is form, color, and space animated by a face, figure, landscape, or still life, or it can be without any literal reference. There is artistry in each paint stroke as the brush makes its way across the surface, like a signature with no name, just indications of cognizance spoken with color.

At the Art Students League of New York, more classes are devoted to painting than to any other discipline. As the League has grown with the times, so has the number of approaches to the medium. The language of art has many dialects, and we initially choose what suits our temperament. Whether academic realism, chiaroscuro, expressionism, or abstraction, the means of communicating with paint are endless, and the creation of art— to both painter and viewer—remains as significant today as it has been since before the dawn of recorded history.

—IRA GOLDBERG, executive director, Art Students League of New York

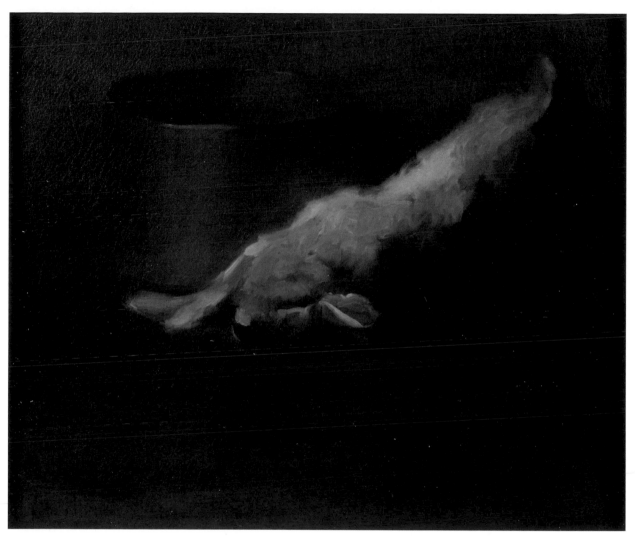

Georgia O'Keeffe
Dead Rabbit and Copper Pot
1908, oil on canvas, 19 x 23.5 in.
The Art Students League of New York, NY.

Acknowledgments

This is the third book I have assembled with help from the instructors, students, models, and office staff of the Art Students League of New York. None of these projects would have been possible without the support, friendship, and indefatigable enthusiasm of League executive director Ira Goldberg. Nor would this book and the ones that preceded it have been possible without the love, patience, and encouragement of my brilliant wife, Dr. Kathie Manthorne, who generously shared her scholarly insight via a daily tsunami of ideas and razor-sharp critical feedback. Her patience and forbearance are key reasons why this project was able to cling to life throughout its many challenges.

I must also acknowledge others who contributed to this project: Thanks to Ira Goldberg and Jim Rosenquist for their opening remarks; to Jillian Russo for her chapter on the Concours exhibitions, and for making available works from the League's permanent collections; to Ken Park, Lilian Engel, Julia Montepagani, and Meredith Ward for supplying images and captions for the book; and to Astrid Rodriguez and Rudy Bravo for their help in gathering and coordinating content from League instructors. I am also deeply grateful to my very capable former assistant Chelsea Cooksey for playing My Woman Friday in a myriad of tasks, including stage-managing the photo shoot of instructor demos by Rose Callahan, whose artistry throughout the process was greatly appreciated. Thanks also go to Ruth Anne Philips for her assistance in editing much of the manuscript and to Candace Raney for bringing the project to Watson-Guptill, where Leila Porteous and Victoria Craven provided guidance and momentum, and to Lisa Westmoreland at Ten Speed Press for her support in finally shepherding this book to completion. This book salutes the students, instructors, staff, and models of the Art Students League of New York, without whom none of the following would have been possible.

Introduction: Miracle on 57th Street

This book is about how painting is taught today at the Art Students League of New York. When I joined the faculty ten years ago, it was to teach drawing and painting. Recovering from a serious pulmonary illness, I acquired an intolerance of oil paint, solvents, and painting mediums. I was forced to reinvent my studio practice in favor of water-based mediums. At first, I was stunned. It was almost like losing the use of one's dominant hand and having to learn to do everything with the opposite one. Painting today, I can't recall oil being any different. It just feels like painting.

The book is divided into three parts, the first of which is a series of lessons in print. Ten League instructors describe in their own words their artistic practice, teaching philosophy, and instructional methods with step-by-step demonstrations of specific concepts and processes, which are illustrated in sequence.

The second part features contributions from five instructors who employ more discursive, critical-of-tutorial approaches to teaching describing how they inform, motivate, and empower students. Each of the chapters is illustrated with artworks by not only the instructors but also their students, in the form of student galleries at the end of each chapter. Showcasing student work is an important part of the League (see Concours, page 282).

The final part features interviews that reveal the nature of artistic discussion at the League.

The League promotes no specific style or aesthetic, but its teaching artists share a respect for the physical object and the craft processes used to create them. Subjects taught at any mainstream design school—such as graphic design, photography, performance, and video—are not offered at the League, which at the same time does on occasion run classes in drawing for animation, illustration, and conceptual practices. In effect, the League is an incubator for dozens of one-room studio schools.

This book delivers the reader into eighteen of these learning environments.

What Painting Is

Knowing how painting is taught requires knowing what painting is. Since the Renaissance, the art of painting has been the loftiest realm of pictorial design, the domain of genius. Giotto rediscovered spatial depth and volume, which revolutionized pictorial composition. Leonardo da Vinci married painting to empirical science and engineering. Michelangelo went a step further and did everything. Titian released color from the restrictions of line, and Rubens elevated the rank of painter to a kind of nobility. The popular notion that painting evolves from style to style, movement to movement, from one breakthrough to the next was articulated after Darwin published *The Origin of Species*. The proliferation of aesthetic manifestos and modern art movements during the twentieth century mimicked and often identified with political revolution and reform. The official version of the story of modern art was concocted for political reasons.

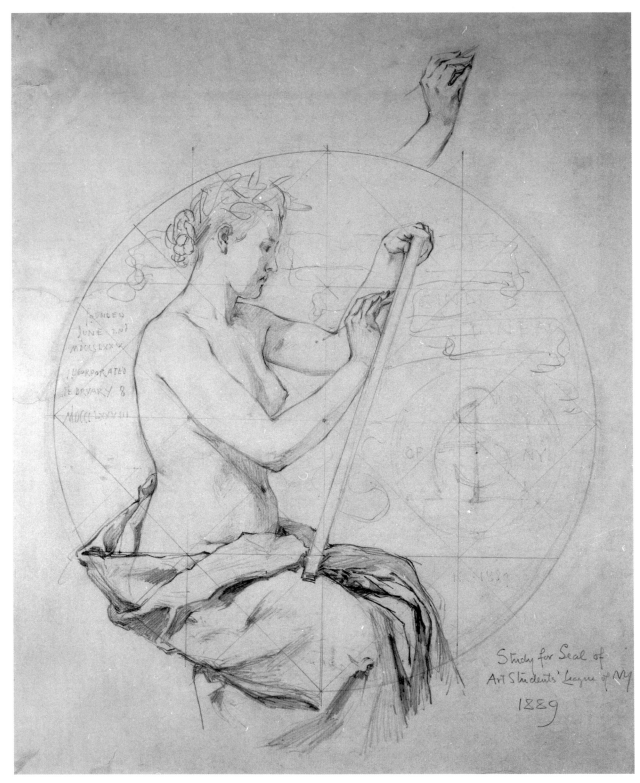

Kenyon Cox
Study for the Seal of the Art Students League of New York
1889, pencil on paper, 18.5 x 15 in. The Art Students League of New York, NY.

Critics and theorists seldom make paintings. Painters make paintings. The urge to spend hours, days, and even weeks in front of an easel, trying to reveal an imagined form that has yet to appear, is no different today than it was tens of thousands of years ago.

Painting is a formation of ideas, materials, and sensations that abides within a physical work of art we call a "painting"—not just the object itself. The superficial attributes of ordinary paintings can be determined at a glance, but great works demand study, inspire meditation, and reward reflection.

Teaching painting goes far beyond merely teaching a student how to produce images by manipulating colored materials on dedicated surfaces. Once upon a time there may have been debates about whether or not pastel is a painting medium, or if monochromatic images are paintings. None of these distinctions are particularly useful today, when artists work within expanding histories of art that encompass sand paintings by Tibetan monks, ink paintings on silk by medieval Chinese philosophers, and works by untrained outsiders.

Painting today is also being shaped by new technical parameters of visual art that are refined and updated on an almost daily basis. Those who define painting as technique see this as the death of painting, which is informed by material culture but not defined by it. New media simply challenge old habits—and force us to devise fresh, personal ways to find and shape meaning in the visible world.

As a formation of visual ideas, painting cannot be confined to a definition based on materials and processes, any more than Shakespeare can be defined by the use of quill pens or Hemingway by typewriters, even if mastery of such devices was necessary.

Sound pedagogy and student practice must balance attention paid to materials and techniques with composition and theory. While the goal is to learn how to form coherent visual ideas into paintings, students are often required to possess a basic knowledge of drawing as a prerequisite. Most teaching artists will aver that the study of drawing is a useful and necessary prologue to the study of painting. It is the bridge between theory and practice.

In serious painting, materials and techniques are subordinate to expression, regarded by some as a necessary inconvenience and by others as sensuality. Knowing how materials behave is essential to the craft of painting. While technique may be but a means to an end, the process that makes a painting is integral to its formation. The three pillars of painting are theory, practice, and expression. What is painting? How is a painting made? What does it convey?

Origins

In a Greek myth, painting was born when the maiden Dibutades, the daughter of a Corinthian potter, traced the shadow of her sleeping lover's profile, cast by the lamplight onto the wall.

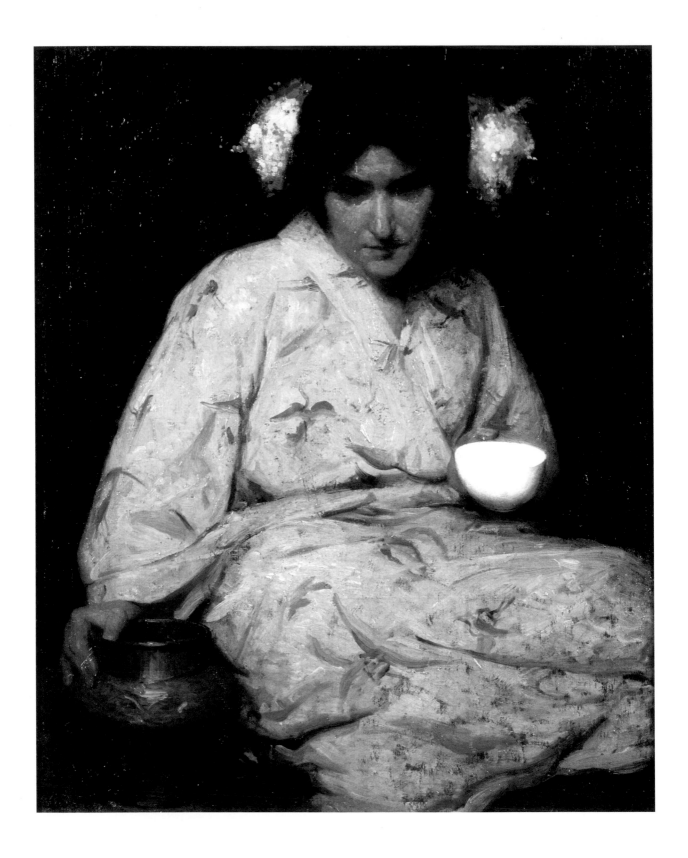

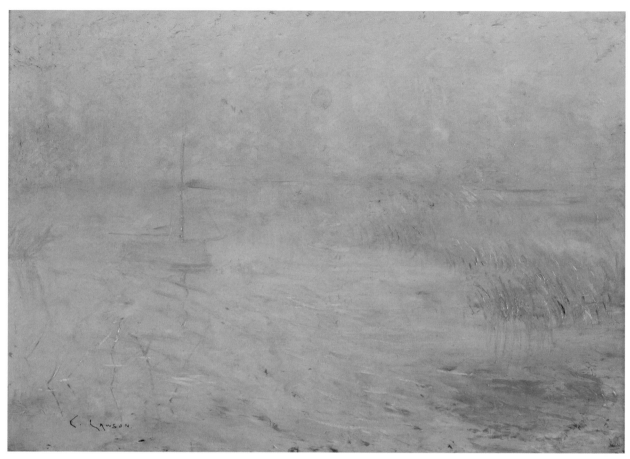

Ernest Lawson
Sunrise
c. 1891–92, oil on canvas, 20 x 28 in. The Art Students League of New York, NY.

Opposite
John Fabian Carlson
The Pink Kimono
1906–7, oil on canvas, 31.25 x 24 in. The Art Students League of New York, NY.

Painting is known to have been practiced in a far more distant time as a ritual dimension of Paleolithic nature-worship by shamanic hunter-societies whose language and mythology is unknown to us—people with whom we are connected by an ancient genome.

Visual manifestations of language began as pictures that later evolved into characters, letters, and writing systems. The role of painting in society shifted, changed, and evolved, and like any durable organism, the form survived the rise and fall of technologies, from subterranean walls to floor mosaics, stained glass, and illuminated manuscripts, from tapestries and frescoes to billboards.

Marks on the Wall

Animistic pre-literate societies created votive, ritual, and fetish images as spiritual vessels, objects of worship, and talismans against ill fortune. Cave paintings in Lascaux in the Dordogne and Altamira in Spain are the earliest known examples of a long tradition of ritual stone-art that is still practiced today by traditionalists among Native American, Australian Aboriginal, Asian, and African societies. Because these were, and remain, societies that embrace animistic religious beliefs, or preserve traditional arts today as secular assertions of cultural identity, we can infer that rock walls covered with petroglyphs, or those upon which cave painters worked, were not indifferent, mute, or passive. They were alive. Stone was their flesh. Those who adorned it also decorated their own skin with paint and with tattoos—an ancient practice today enjoying a renaissance. Neolithic artists used pigments harvested from earth and mixed them with milk, fat, blood, and water. Protein-based paint has the greatest longevity and durability. Perishable goods like animal skin clothing and shelters, and wooden tools and weapons would also have been decorated. The domestication of livestock and poultry created a ready supply of milk and eggs, which in turn led to the invention of casein and egg-tempera painting. The development of masonry and carpentry provided painters with both interior and exterior surfaces to be decorated. Wood and plaster rapidly became the most prevalent surfaces to benefit from the painter's art. Painting developed into a trade practiced and learned in workshops, but in time that too evolved into an art practiced by geniuses. From milk and eggs to encaustic, fresco secco, and buon fresco, from the invention of oil painting, watercolor, pastels, acrylics, and alkyds to iPads and Wacom tablets, studio practice is always stalking new technology. Regardless of which tools we find at hand, whenever new painting begins, we are standing in a cave, scratching marks on the wall with a burnt stick.

Painters

The first historic painters to be known by name—regarded as more than tradesmen—first appear in antiquity. Zeuxis and Apelles in Greece, Gu Kaizhi in China, and Vatsyayana in India are remembered individually, while their predecessors remain anonymous. The emergence of painters with individual reputations, distinct from workshops operated under

the auspices of temples and royal courts, seems to be linked to changes in society. Poets won laurels by preserving oral tradition, while the makers of mute objects rose to fame along with their wealthy patrons who treasured artistic genius. Poets were to a community as a whole what visual artists were to powerful individuals, whose influence elevated their standing in society. The hardships that followed the fall of Rome cast painters back into the ranks of tradesmen, from which they reemerged in the thirteenth century. Shattering Byzantine archetypes by reviving the dimensional space of Greco-Roman painting brought fame to Cimabue, Duccio, and Giotto. Scholars, artists, poets, and architects were the midwives at the rebirth of ancient knowledge. The van Eyck brothers' drying oil and the invention of glazing achieved startling naturalistic effects, but Caravaggio was the first painter to work primarily from life, a process that in the hands of Rembrandt, Vermeer, and Chardin reached a kind of maturity. The Enlightenment triggered democratic revolutions celebrated in the paintings of Jacques-Louis David, John Trumbull, and Eugène Delacroix. The rise of industrialism inadvertently sparked an explosion of landscape painting. Painters like Joseph Mallord William Turner, Caspar David Friedrich, and Jean-Baptiste Camille Corot traveled to and from distant motifs via mechanized vehicles like steamboats and railroads.

A reunion of science and art inspired works by William Hodges, John James Audubon, Carl Rottmann, and Frederic Edwin Church. Nineteenth-century Bohemian aestheticism redefined painters as free agents, rebels, and pioneers. Gauguin, van Gogh, Toulouse-Lautrec, and Whistler rejected the optically mimetic confines of both impressionism and the artistes Pompiers in favor of more personal expression. Cézanne dismissed the tyranny of the eye by devising a rigorous process of observation and description that did not simply reproduce visual experience but reconfigured it in a way that was personal, rational, and accessible to younger artists like Braque and Picasso, who used it as a springboard for their own experiments and discoveries.

The subsequent phenomenon of European modernism was manifested in dozens of new styles, forms, and practices. With the rise of abstraction, painting remained the dominant form of personal artwork well past the middle of the twentieth century.

Today new genres, mediums, and audiences focused on cults of celebrity have displaced painting from a position of primacy. Art makers in many instances have been replaced by art directors, following the example of the late Andy Warhol. Someone recently remarked to me that painters have become more like poets or jazz musicians. I can think of worse fates.

Regardless of how art is exhibited, bought, and sold, people are still drawn to painting. The impulse to pick up a brush and form an idea is mysteriously hardwired into our nature. We might do it for pleasure or make a go of it as a profession. Painting promises to reward a basic desire to make visible something we imagine or to understand something we behold. Whether or not our toils produce works of art is coincidental. Painting is both the desire and the reward.

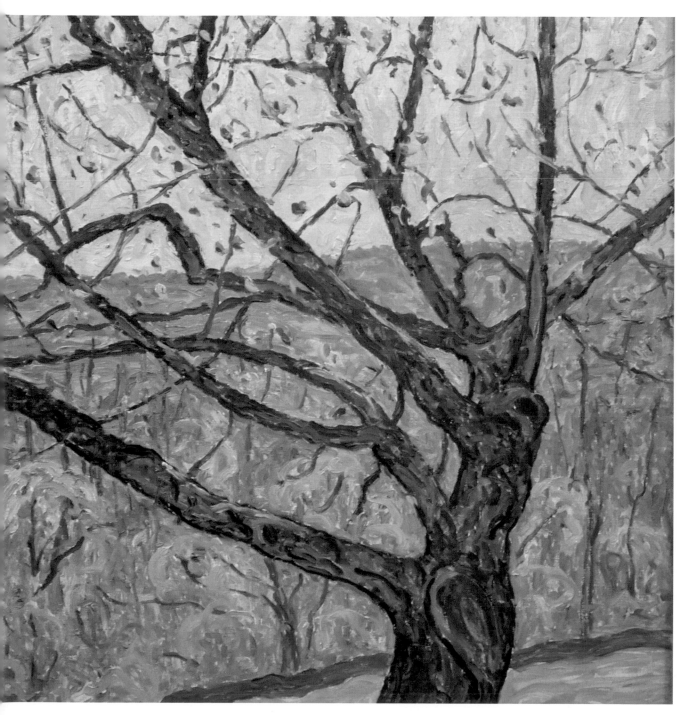

Allen Tucker
Apple Tree
1920–9, oil on canvas, 30 x 36 in.

Opposite
Will Barnet
Portrait of Djordje Milicevic
1967, oil on canvas, 37.5 x 21.5 in. The Art Students League of New York, NY.

Students and Teachers

The practice of teaching studio-art subjects to large groups of students began in the sixteenth century. The Carracci brothers are credited with devising the first atelier school: Accademia degli Incamminati in the university city of Bologna. Prior to that, artists were trained under recognized masters, working as assistants and apprentices. Entering studio workshops as preteens, students were assigned at first menial tasks and received basic instruction—perhaps copying prints. Those who demonstrated promise and dedication might be elevated to the rank of apprentice, assisting the master on commissions. In time they would submit an original work of their own—a masterpiece—that when approved, would serve as their diploma. Newly minted masters would then seek patronage to underwrite the creation of their own ateliers, where they would take in students of their own, following the same practices that shaped their training.

By the late Renaissance, apprenticeship had become obsolete. Artists no longer regarded themselves as mere craftsmen. Young people desiring to enter the profession sought to be educated in the arts more than just trained in a trade. The academy model had the advantage of letting students work under many masters instead of only one. Under the apprenticeship system, students had to win their independence by competing not only with their peers but also with their masters.

The academy system recognized the individuality of new students, if not their fitness to be recognized practitioners. Annual concours exhibitions tracked student progress. It was from these exhibitions—and later, acceptance into the official salon exhibitions—that students graduated from the classroom to professionalism.

By the end of the eighteenth century, fine arts academies were formed throughout the Western world—from Paris and London to Mexico, and from Charleston, New York, and Philadelphia to Rio de Janeiro. During the first quarter of the nineteenth century, that number almost doubled. After the Civil War, a crop of new museums scattered across the country, equipped with affiliated art schools, such as the Corcoran Institute in Washington, DC; the Art Institute of Chicago; the Boston Museum of Fine Arts; the Layton School of Art in Milwaukee; and the Philadelphia Art Museum. These were the precursors to today's leading design schools—a second wave that represented an evolution from the existing system of art instruction represented by the Pennsylvania Academy of the Fine Arts, the Art Academy of Cincinnati, and the school of the National Academy of Design.

A Community of Learning

The Art Students League of New York was formed in 1875 by a disgruntled band of students from the National Academy Museum and School who defected to a rented cockloft a few blocks away and began running classes on their own. Life drawing classes

began meeting at once, but soon afterward, painting, printmaking, and sculpture were added to the League's course offerings. Instructors met their students each week at an appointed time in studio classrooms controlled by the League. Students enrolled month by month. No degrees were offered in an environment where students learned at their own pace. The League still operates in this manner. It has always harbored divergent points of view on the theory and practice of painting. In its early years, battles raged between instructors like William Merritt Chase, trained in Munich, or Kenyon Cox, trained in Paris. A century later, instructors and students quarreled over the validity of abstraction versus figuration. In the wake of the 1913 Armory Show, exponents of the new art clashed with the guardians of tradition. Modern art took root in the United States. Many League instructors were homegrown talent like John French Sloan, Stuart Davis, Reginald Marsh, Thomas Hart Benton, and Will Barnet, while artist-instructors like Jean Charlot, Yasuo Kuniyoshi, and George Grosz hailed from Latin America, Asia, and Europe. From the late nineteenth century through the nineteen-sixties the League trained generations of outstanding young artists such as Georgia O'Keeffe, Lee Krasner, Jackson Pollock, James Rosenquist, Audrey Flack, and Ai Weiwei.

When the Art Students League of New York relocated from 15th Street to its present location at 215 West 57th Street in Manhattan in 1894, access to artistic training had reached a historic high-water mark that would be exceeded fifty years later when the GI Bill of Rights and subsequent baby boom swelled enrollments at colleges and universities that soon clamored to establish new professional programs in studio art, theater, dance, creative writing, and music. By the late twentieth century, these programs were flourishing. More than a decade later, many are foundering due to a miscalculation of the impact of digital media on analog skills at a time of financial hardship.

The Art Students League of New York has been unaffected by these forces mostly because it has unswervingly adhered to its original mission and model. It chose not to reconfigure itself as an accredited art college, which led to a decline in the number of professional students and the subsequent rise in the number of students seeking personal enrichment. In recent years this trend has reversed.

The digital age took everyone by surprise when animation design sparked a renewed interest in freehand life drawing. Students who seek professional training in traditional analog arts like painting, sculpture, and printmaking are migrating back to studio schools and private ateliers located in urban centers. Anticipating this shift, the Art Students League of New York launched new outreach programs and established partnerships with accredited colleges and universities, an artist residency program, and venues for students to exhibit their work. Open studio classes run as they have for nearly 140 years on a monthly basis, each mounting an annual class concours exhibition in the galleries. The instructors who teach these classes are professional artists who collectively represent a

broad spectrum of aesthetic and instructional philosophies. This book is a visit in print that lets the reader be a fly on the wall, to witness how painting is taught at the League today. Most of its teaching studios are located in the historic 1894 American Fine Arts Society building designed by Henry Janeway Hardenbergh at 215 West 57th Street. The school is open seven days a week offering a wide array of full- and part-time classes. Lectures, special programs, and workshops supplement the regular slate of courses. Apart from the flagship facility in midtown Manhattan, the League operates an artist residency program thirty miles north in Rockland County, as well as instructor-led study-abroad programs. Today's League operates more as a community of learning for visual artists who see themselves as object makers. It is also a magnet for individuals within the community—be they permanent residents or visitors to New York who wish to improve themselves and enrich their lives through art.

—JAMES L. MCELHINNEY, New York, 2015

James Rosenquist
Headlines
1976, etching, 5.875 x 11.75 in.
The Art Students League of New York, NY.

Norman Rockwell
*But in His Duty Prompt at
Every Call... (Illustration for the
Deserted Village)*
1911, charcoal on paper, 20 x 16 in.
The Art Students League of New
York, NY.

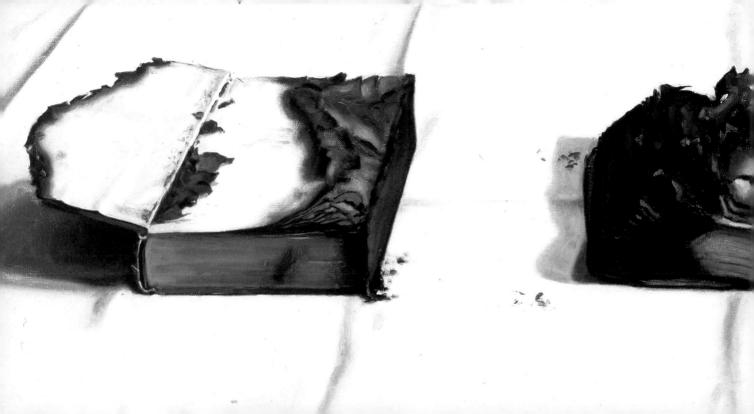

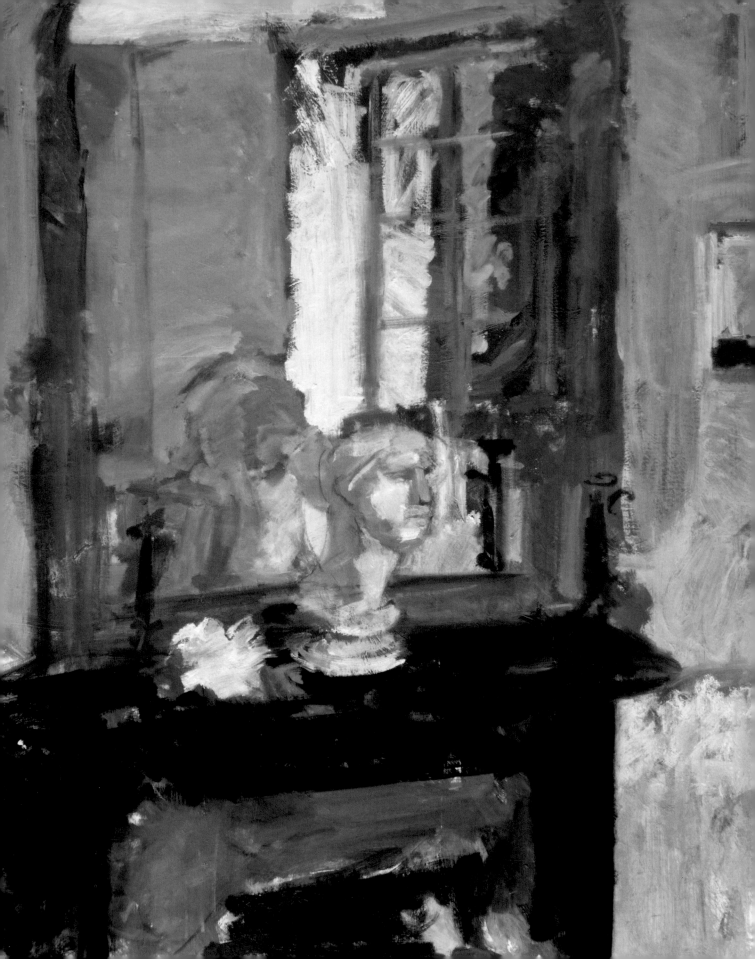

HENRY FINKELSTEIN

Henry Finkelstein is a representational painter whose priorities are process, composition, and expression. Born into an artistic family—the son of distinguished painter-educators the late Gretna Campbell and Louis Finkelstein—Henry Finkelstein earned his BFA from Cooper Union and his MFA from Yale. He is an active member of the National Academy of Design. His courses at the League focus on the reciprocal importance of drawing and painting—how the one practice necessarily informs the other.

Opposite
Henry Finkelstein
Interior with Bust of Minerva
2011, oil on canvas, 46 x 40 in.

Pages 14–15
Ephraim Rubenstein
Still Life with Burned Books
1997, oil on linen, 39 x 50 in.

HENRY FINKELSTEIN

On Painting, with a Critique

I paint from observation, mostly out of doors in the landscape. Color, light, space, and volume are central to my explorations. Rhythm also, the way one form flows into another, helps my drawing become more credible. Ultimately, I arrive at a sense of place.

As a student in the late seventies and early eighties at Cooper Union and at Yale, I also studied with artists of the abstract expressionist generation, who talked of painting as an act of discovery, of technique as a kind of performance. They drew on the history of art going back several centuries. It made me appreciate art as a tradition much larger than the particular genre in which I worked.

My Teaching

Essentially, my teaching is all about plasticity—relationships of form, color, and shape, and developing a unified visual statement with them. In my class, students mostly work from observation, but this is not required. While they work, I present many elements of the visual language. We look at drawings and paintings from history, old and new, to find visual ideas being repeated and seen anew through time.

Students are encouraged to deepen their knowledge and discover something new in each work that they produce. My approach to teaching is traditional, but not academic. That is, I engage students in the visual culture, but I avoid formulas. I encourage them to search, to discover, in an intelligent way, and not so much to create a product. This can be frustrating for some students at first, when I don't demonstrate for them how to make a picture. But they soon catch on that this is because neither of us really knows how we should paint. It is very rewarding for both of us to find out. Ultimately, their results—the fruits of their labor—become talismans of their learning.

Marquet Assignment

I might offer approaches or "assignments," and these naturally come from my own experience as a painter. But I try to stand back enough for them to discover what they can do with these ideas for themselves. And this can only happen as they work. This assignment is something that I offer both to beginning students and to ones who have already been painting for a long time. It even plays a part in my own painting process. I like the universality of it.

Based on the paintings of Albert Marquet I ask students to work from a studio "setup" using a figure, still life, or interior setting, making paintings in which no two colors are repeated on their canvas. Of course they will find different quantities of some hues over others: a lot of salmon and very little violet, for example. They just need to ask themselves, if they see a given color in one place, how it is different from a similar one somewhere else. What distinguishes three different greens from one another? Or how does one pink differ from another? These differences can be subtle changes in hue, or in value, or in intensity, or any combination thereof—just different in some way. This is the opposite approach to repeating the same color throughout a painting, but like that, it is aimed at a kind of unity or relatedness. I also ask them to try to include some amount of every color in the hue wheel—some amount, say, of orange, even if it's just a dot, in a painting that has mostly cool colors. There is no need, of course, for their work to look like a Marquet. In fact, it's better if they interpret the problem

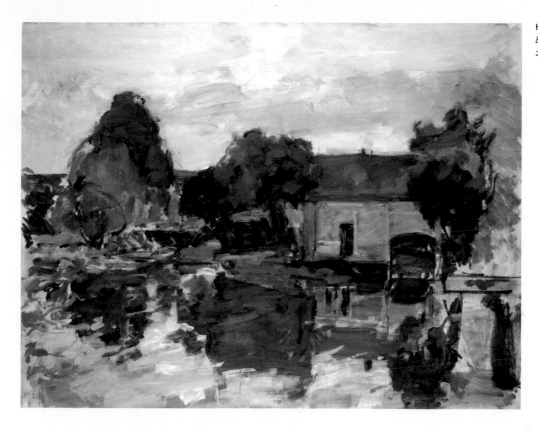

Henry Finkelstein
Boathouse at Malestroit
2010, oil on canvas, 40 x 52 in.

in their own way. Marquet is just an example of someone who almost always follows this rule.

From this, students can learn a few things:

- How to give unity to a painting through a conversation between the colors.
- How to create a sense of atmosphere through variations of color.
- How to look more specifically at each color—perhaps the most important part of the exercise.
- How to mix different versions of what could be called the same hue, not only by adding white but by using other colors.
- How to attain a deeper understanding of what can be called different hues: How some browns

are basically neutral variations of yellow, red, or violet. That grays are usually versions of blue or green; they are not "bluish"—they are blue! And when it comes to earth pigments, that raw sienna is actually yellow, raw umber is green, burnt umber is dark orange, and so on.

All of this applies to my own working methods as well. It is a provisional rule that I break when I wish to. But as an expressionist I often find myself "telling" a certain color to be green, while that same color might function as blue in another painting. But what I tell colors to be, and how they might resonate in my work, participates in this very basic craft.

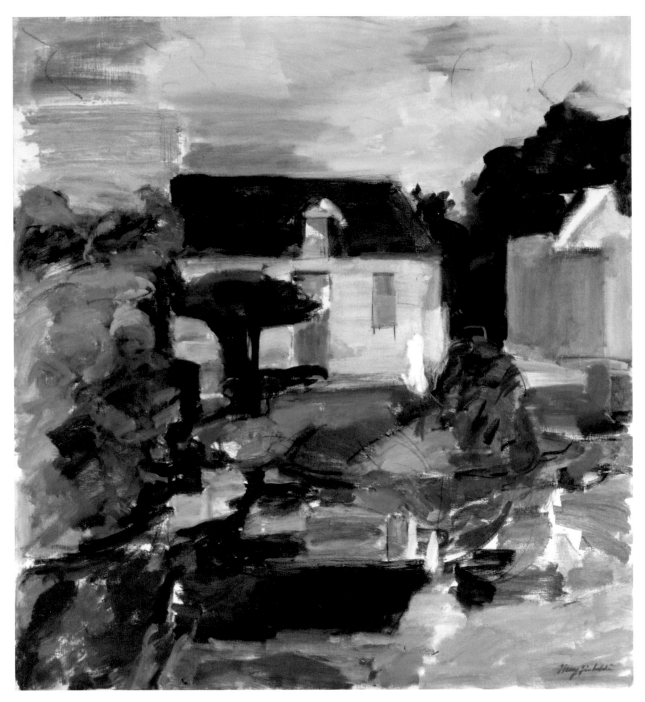

Henry Finkelstein
Larré, Yellow and Blue
2012, oil on canvas, 50 x 46 in.

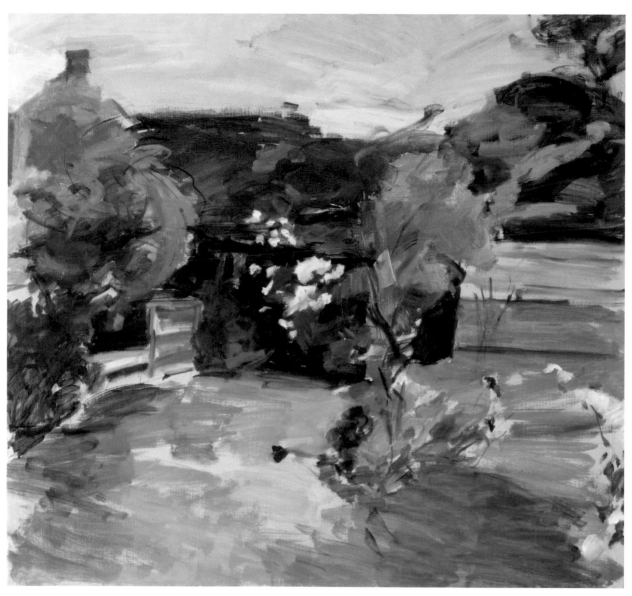

Henry Finkelstein
Garden Shed with Roses
2013, oil on canvas, 46 x 50 in.

A LESSON IN PRINT:
TWO STUDENT CRITIQUES

Figure with Window. I like the specificity of each color in Drescher's painting *Figure with Window*. That vivid red and the amount of it on the surface seem just right. It speaks nicely to the subtle orange on the floor. Notice the four blues, and then the blue-violet under the model's arm, which works as a kind of transition to the red. The similar value between the neutral green in the background on the left and the neutral, almost unnameable color on the model's right shoulder creates a beautifully soft edge, especially in how it is compared to the higher contrast between the other shoulder and the color that touches it. The green background color to the right is ever so slightly more vivid, and more blue, than the other green.

This helps to make both of them come alive in the painting. This is so important because painting is truly dead if the background doesn't play an equal role to the colors in the figure. I don't even like the word *background* because it implies that it is less important. All the colors in a painting must be equally considered, and this is what Hans Hofmann might have meant when he said that every part of a painting should be a "color," or that it should come forward (i.e., declare itself). I believe that this is happening here. The simplicity of the way the figure is rendered belies the care with which it is drawn. Look at the elegant curve to the downward-moving line of the lower leg on the left. While at first viewing the head might seem too large for the rest of the figure, I think it's just right. It makes the model seem more "real" and less idealized. This is something that the painter Philip Pearlstein has often mentioned to me.

This painting depicts a simple model in the studio, without narrative embellishment. But through its thoughtful composing it still has a soul. Several other paintings of

Diane's have been more tonal in nature, while this one is more colorist. But her clear understanding of value (light and dark) and edges is still embedded in the picture and gives it a good deal of control.

Orange Dress. I find Haksul Lee's oil pastel (on page 24) especially impressive because he had previously drawn only monochromatically, or with two colors at a time. That technique served to render the figure in a sculptural way. This work, too, shows a strong sense of anatomy in the clarity to the directions of the planes and the sense that the figure has bones. But here there is a radical departure in that color is used to depict an environment, or an envelope of space that contains the figure, as opposed to modulations on the figure alone. It is the first of many works that he has done since with this theme in mind.

One of the things about working with pastels, unlike mixing paint, is that one often feels that one never has enough colors. Experienced pastelists buy increasingly larger sets attempting to expand their choices. But they almost always still have to create new colors by weaving together, but not smudging, different combinations of the same sticks. The effect of these stripes or hatchings is called "optical mixture." By placing two or three pastels together at a time one can find a great variety of colors, beyond the set one starts with. In this case Haksul had only twelve or so sticks to use, although they were of very high quality and pigment content.

Look at the mustardy greens that are on both sides at the top of the piece, interrupted by a vivid blue drape between them. The one on the right has some ochre/orange stripes mixed in with it. These are not used at all in the green

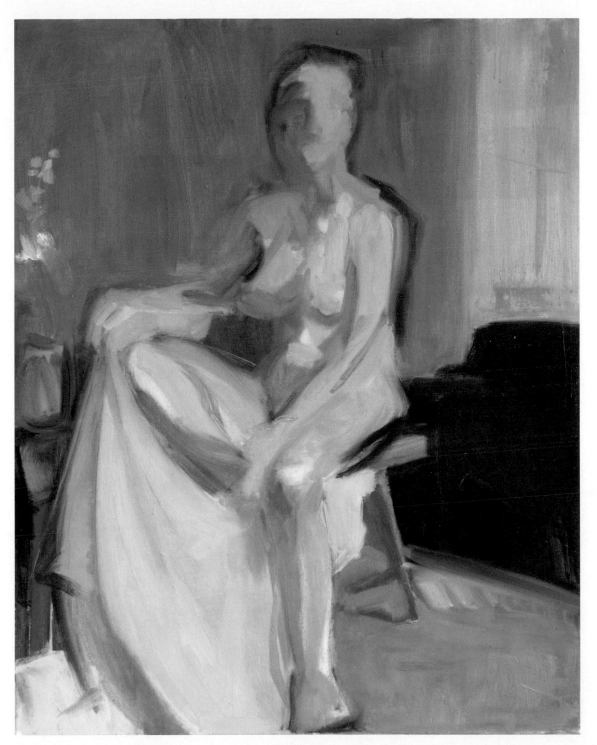

Diane Drescher
Figure with Window
n.d., oil on canvas, 30 x 24 in.

on the left. The result is that the green on the left side seems more minty/blue by comparison. The sparseness of application allows the pinkish gray color of the paper to show through more, which adds to the effect. The mintier green acts as a transition between the other green and the vivid blue drape between them. This blue, which is "right out of the tube," or not combined with anything, is a fairly green blue—especially within the context of this mostly warm painting. It makes the intense orange dress sparkle. The warmer green mixture on the right serves as a transition to these vivid oranges. In the dialogue between all of the greens we can also appreciate the limelike yellow-green on the model stand below. The character of that green, its sort of zing, is heightened by two small stripes of bright orange just above it and a dash of intense blue in between them. Some other little notes of color, such as the bright red marks on the model's forehead and the pure green that delineates the lower part of the figure, add considerably to the overall color statement. It's easy to almost miss the quiet lighter and redder blue to the right of the figure, even though it takes up a fairly large area. This, too, is important to the whole balance of warm and cool in the painting.

As he observes the situation in front of him, Haksul makes color choices that are highly selective. The painting has only about ten color mixtures in it. They are applied fairly flatly without much rendering, somewhat in the manner of an early Vuillard. The work being quite small has probably forced him to do this. To carry off a piece like this, you have to be intensely aware that painting is a language that operates on relationships. You can't slavishly copy everything that is in front of you, but rather you have to interpret it in your own way. Color is the central tool that Haksul has chosen to use. To me it has an electrified quality, a psychological effect.

The work depends upon the conviction that colors are formed by decisions; they are not givens. These choices cannot be completely conscious, however, or they wouldn't have the element of surprise and discovery. They are found intuitively, through the process of comparing them to one another as they are applied. The artist has a consistent feeling for all the colors at once, but this can only be sensed as he goes along. It cannot be calculated in advance. As an anecdote, early on while Haksul was making this piece I asked him to stop and leave it alone, as I could see that he was using color in a new way, and I feared that he might lose this and return to his previous conventions. His response was, "I refuse to do that!" I love it when students have the confidence to forge ahead on their own, without following orders. Instinctually, Haksul must have known that he was onto something, and that there was more that needed to be said.

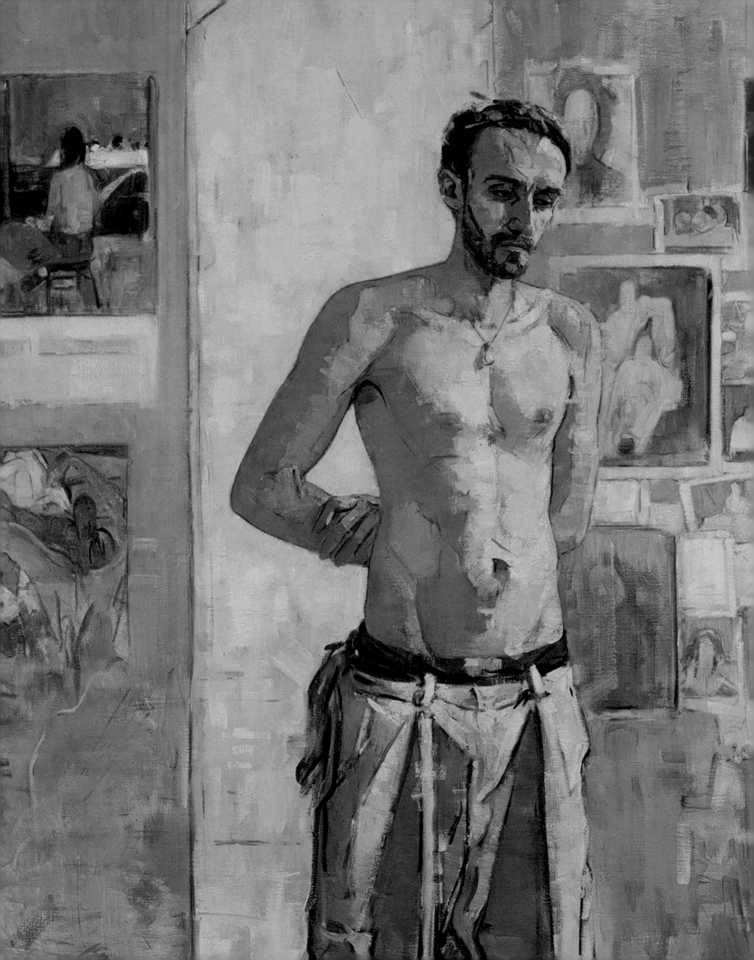

MARY BETH
MCKENZIE

Mary Beth McKenzie always works directly from life, and teaches her students how to master her methods. McKenzie's subjects are often friends and family. She is able to match her impressions with a concern for the formal aspects of pictorial construction. There is always a subtle mood to her work. She has said, "When I paint someone, I am less concerned with likeness than with the character or spirit of that person." McKenzie was born in Cleveland. She studied at the Art Students League of New York, the Boston Museum of Fine Arts, the Cooper School in Cleveland, and the National Academy. Her teachers were Robert Philipp, Robert Brackman, José Cintron, Daniel Greene, and Burton Silverman. She is represented in many public collections, including the Metropolitan Museum of Art, the National Museum of American Art, the Smithsonian Institution, the Brooklyn Museum, the New Britain Museum of American Art, the National Museum of Women in the Arts, the Butler Institute of American Art, the Museum of the City of New York, the National Academy, and the New York Historical Society. Her paintings are in numerous private collections. Watson-Guptill published McKenzie's book, *A Painterly Approach,* in 1987. Her work was on view at the Metropolitan Museum of Art as part of the *Looking at You* exhibition in 2001 and 2009. She currently teaches at the Art Students League and at the National Academy of Design. She was elected to full membership in the Academy in 1994.

Mary Beth McKenzie
Beñat
2006, oil on canvas, 64 x 48 in.

MARY BETH MCKENZIE

Painting from Life

People are far too concerned with results. Probably the hardest thing for students to accept is that they won't come away with a painting every time. Learning to paint is a slow, unconscious process. Real progress takes place over a long period. There are no shortcuts. Just as you learn to draw by drawing, you learn to paint by painting. Something valuable, something that will deepen your understanding can be learned from each attempt. Often you learn more from a painting that doesn't succeed. Most of the time you forget what you have learned and discover it all over again. If in one little section of a painting you do something you have never done before, you have been successful. Eventually you will add it all together; you will build a vocabulary.

One of my teachers, Robert Brackman, used to say, "Miles and miles and miles of canvas."

Robert Philipp, who was a huge influence in my life, often said, "The first fifty years are the hardest."

You have to put in the time. Continually challenge yourself, set up problems in order to develop your technique, and experiment with new ideas. Vary your approach. Try different mediums, different-sized canvases, unusual points of view, more ambitious compositions. Always try to extend your reach. In this way, your work will continue to change and develop naturally. Unless you approach painting with an experimental attitude and are willing to take risks, your progress will be slow. You must evolve as an artist, and this is a lifelong process.

Composition

Composition is of the utmost importance. If you don't have a good composition, no matter how well it is painted, you will never have a good painting. A little preliminary work makes such a difference. Because painting is a visual language, anything you put on paper will help you sort out what excites you. I usually do a color study to record my first impulse, my response to the large shapes, and the impact of the color. I also make thumbnail sketches from the color study to explore the design. Framing the figure with line helps you to see the positive and negative spaces. Clarity is a big part of design. When you begin painting, your goal is to abstract the big shapes. In the middle of painting, everything seems to fall apart and go in different directions. In the final stages, you bring back the big shapes. It is about simplifying and getting back to where you were in the beginning. Every good representational painting has to be a good abstract painting.

Let painting dictate. While your initial concept is important, you must allow a painting to find its own course. It grows in stages. Each stage and your reaction to it will influence the next stage. A painting has its own existence and reality. You need to make changes freely to meet the needs of the painting. This sometimes takes you in other directions, opening up new possibilities that are often more interesting than your original idea.

Drawing

Drawing plays a role in my work, but I don't believe in starting with a drawing and coloring it in. The drawing should evolve while you paint. If you approach the drawing in different ways, you are most likely to get good results. Start with line, move to volume—pushing out—then to negative space—carving in—and then back to line, volume, and negative shape, repeating this process over and over. Everything should equate, and if it doesn't, you have to figure out what is wrong. Often you'll find the problem is not where you thought but in the next area. If you check a line from the bottom up,

you will see the character of the line. What you must do is refuse to believe anything you've put down and continually challenge everything by drawing in a different way. The drawing takes place all through the painting. The real drawing takes place at the end.

Painting People

I have always been preoccupied with the human figure, people alone or in relation to other people or objects. Certain objects and places have their own character, and I want to convey a sense of that object or place. I work from life, because I like to have a direct response to color and shape and a direct interaction with the subject. I enjoy the special relationship you develop with someone you work with over a long time. What I hope to convey is the character or spirit of the person, to say something on a deeper level, maybe even about myself, but this is never a conscious aim while I paint. I don't think while you're painting you can be aware of what the painting says to someone else. Later I may see something of the psychological content or someone may point it out to me. Instead I am conscious of and consumed by the formal qualities of picture-making: composition, line, shape, form, color relationships, and, always, light. These are what express something about the model. When you paint someone, you want to abstract and see things so clearly that you make visible your excitement.

Basically, you paint your life. This is probably true for everybody, and perhaps inevitable. My paintings stem from my everyday experiences. I always carry a sketchbook, much like a writer carries a notebook. Sketches are your ideas. The things that fill your life will emerge in your work: the books you read, the plays you see, the people you surround yourself with, especially the artists you admire.

Looking at Paintings

Nothing can compare with actually seeing and experiencing a painting. No matter how good the reproduction, a photograph cannot evoke the same response or give you an idea of scale or the impact of color or a sense of the paint surface. It is important to look at what others are doing, and not necessarily your contemporaries. As you expose yourself to the work of others, your views will change. I spend hours in museums looking at what artists have done in the past. Not only is this inspiring, but when I'm having trouble with a painting, I often find solutions to problems. Sometimes I discover artists who might not have appealed to me a year earlier. This is generally because I have come to understand what they were after. I have been influenced by many artists. Some of my interests change as I do, but others remain constant. Some of my favorite artists are Rembrandt, Velázquez, Bruegel, Uccello, Piero della Francesca, Cézanne, Matisse, Degas, Käthe Kollwitz, Egon Schiele, Richard Diebenkorn, and, most recently, Lucian Freud.

To me, the best way to teach people to paint is to show them how on their canvas. Painting is visual; demonstrating how to solve a problem is more effective than describing the problem. When I first started Robert Philipp's class, he picked up a giant brush, said, "You're not seeing the light on the model," and used practically a whole tube of flake white on my painting. You can't be precious about your work if you want to learn. He introduced me to a new way of painting: the physical aspect. His remarkable enthusiasm and excitement for life as well as for painting was contagious. He really enjoyed the act of painting, and through his bold handling of paint, I became aware of the sensuous side to painting— the lushness of the paint surface and the beauty of color. I loved his loose, seemingly effortless way of working. Until he died at eighty-seven, he painted every day. Being around him made me realize that painting is a way of life.

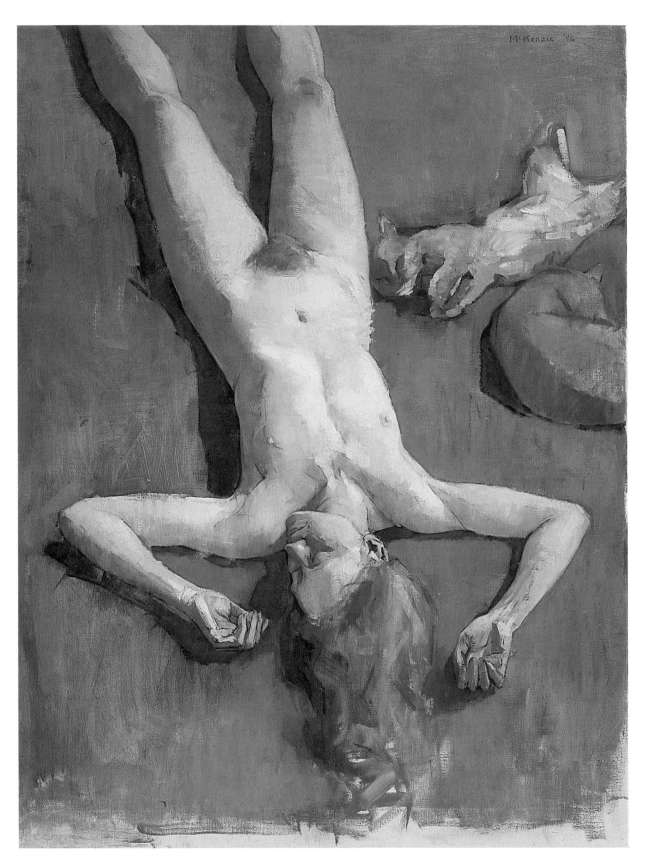

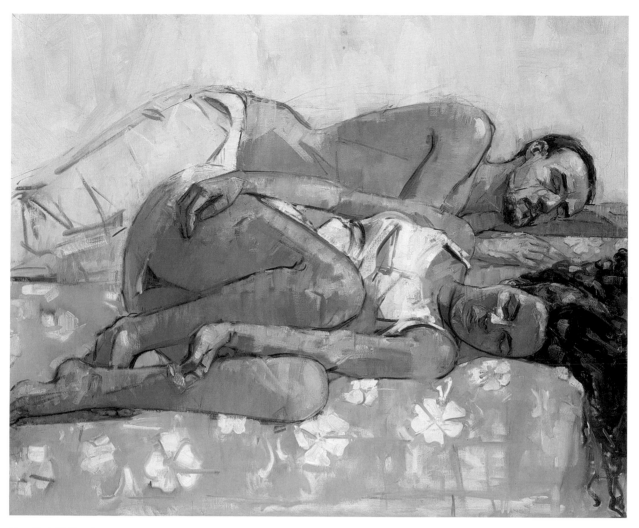

Mary Beth McKenzie
Couple Sleeping (Christina and Beñat)
2006, oil on canvas, 48 x 64 in.

Opposite
Mary Beth McKenzie
Inverted Figure
1996, oil on canvas, 50 x 36 in.

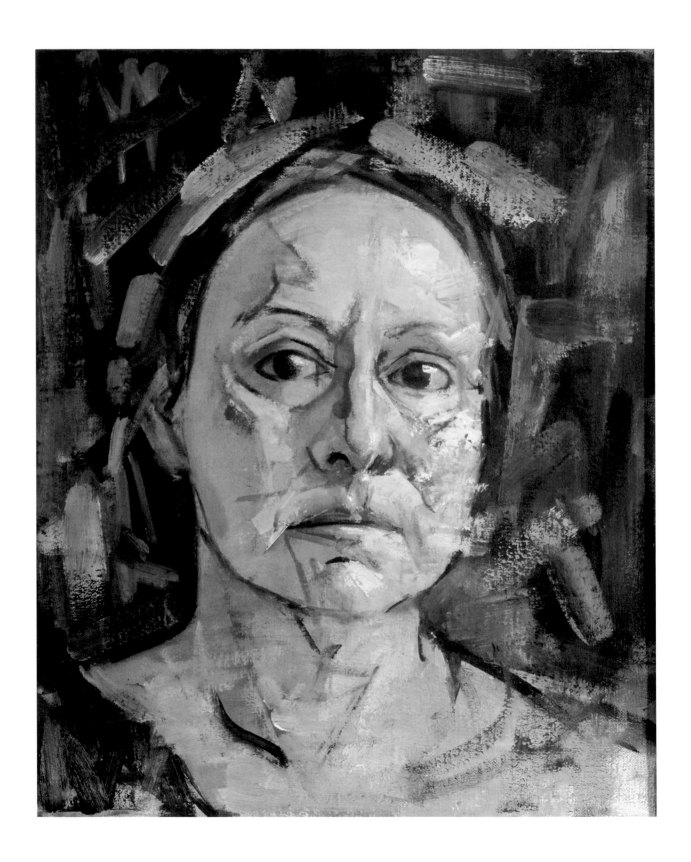

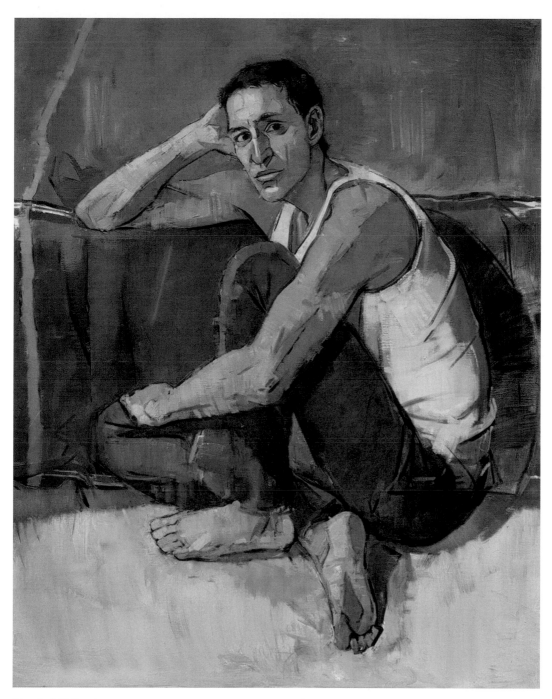

Mary Beth McKenzie
Andrew
2006, oil on canvas, 64 x 48 in.

Opposite
Mary Beth McKenzie
Self-Portrait, Green Background
2009, oil on canvas, 18 x 14 in.

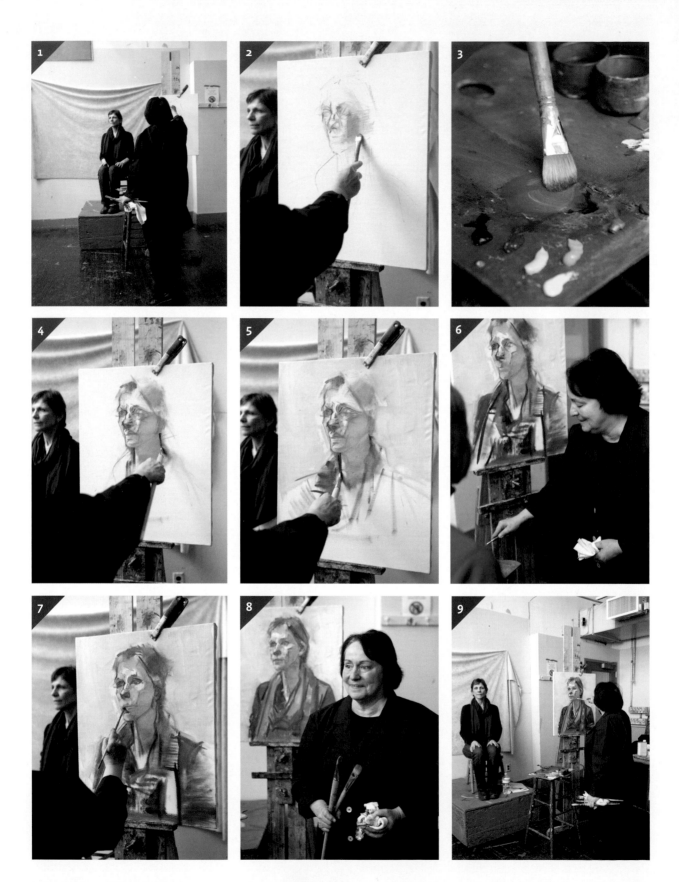

A LESSON IN PRINT:
WORKING FROM THE MODEL

1. I begin with a very rough sketch made with charcoal just for placement.

2. I always work on a white canvas. I begin with the darks and mass in the shadow areas, trying to see these areas as simple abstract shapes, and allow the white canvas to work as the light pattern.

3. I use a large brush and work in a dry-brush manner, using very little turpenoid, scrubbing paint into the canvas rather than building up any paint on the surface. I use a neutral tone so that it won't interfere with the overall color of the painting and work rather tentatively so that I can easily make changes.

4. I was very aware of the triangle of the nose, making sure the head size was established—from the eyebrow to the bottom of the nose is one-third of the head.

5. I try to shape the figure by carving in with the background color. Once the background is established, I can see immediately that the shadow pattern has to be stronger.

6. I further develop the shadow areas as they relate to the background. At this stage I start to pay more attention to the exact shape and color of the shadows as well as the warm and cool variations within them.

7. I make the shadow shapes more specific and continue to work all over the canvas, pushing out from the middle of each shape to make sure each shape is full enough. At this stage, I start to refine the drawing and pay more attention to detail. At the same time, I am very aware of the overall image, and very careful not to paint anything by itself, going from one shoulder to the other shoulder, from the bottom of one eye to the bottom of the other eye, from the top of one eye to the top of the other eye. I use a mirror to determine how the head reads from a distance, checking that the eyes are on the same level.

8. I use different brushes for different colors, which always leaves me with a handful of brushes.

9. I redraw and strengthen the darks and begin to paint more directly, freely placing colors where I see them. I also start to initiate rich color. At this stage, I leave the lights alone. I want to keep the contrast of the white canvas as long as possible while I set up the darks and middle tones, trying to keep everything in the same stage of development. I continue to work in an abstract way. Trying to develop the large relationships of color, I continue to work all over the canvas.

I constantly step back and compare these relationships from a distance. By this stage, the darks and middle tones are developed, so I am better able to judge the lights. To bring back some of the light areas I had lost in the face and throughout the painting, I use a rag wet with turpenoid to wipe away and get back to the white canvas in the lightest areas. I want to maintain the light and dark contrast as long as possible—the impact of the painting.

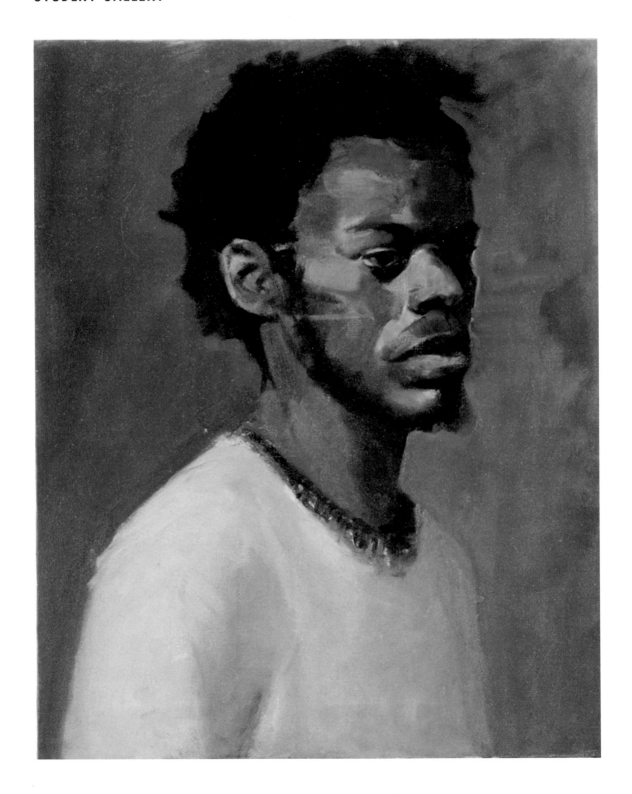

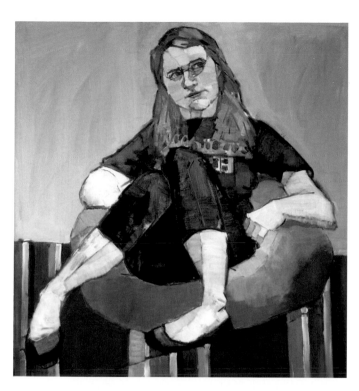

Top
Patricia Delahanty
Marissa
2010, oil on canvas, 40 x 40 in.

Bottom
Antonia Walker
Young Man in Red Shirt
2009, oil on canvas, 20 x 20 in.

Opposite
Renée Larson
Tribal Necklace
2011, oil on canvas, 16 x 20 in.

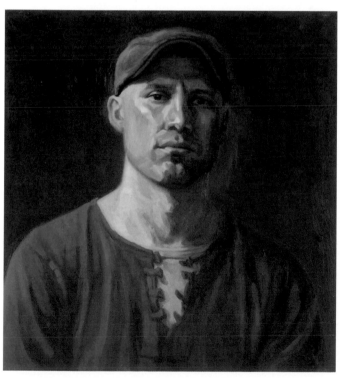

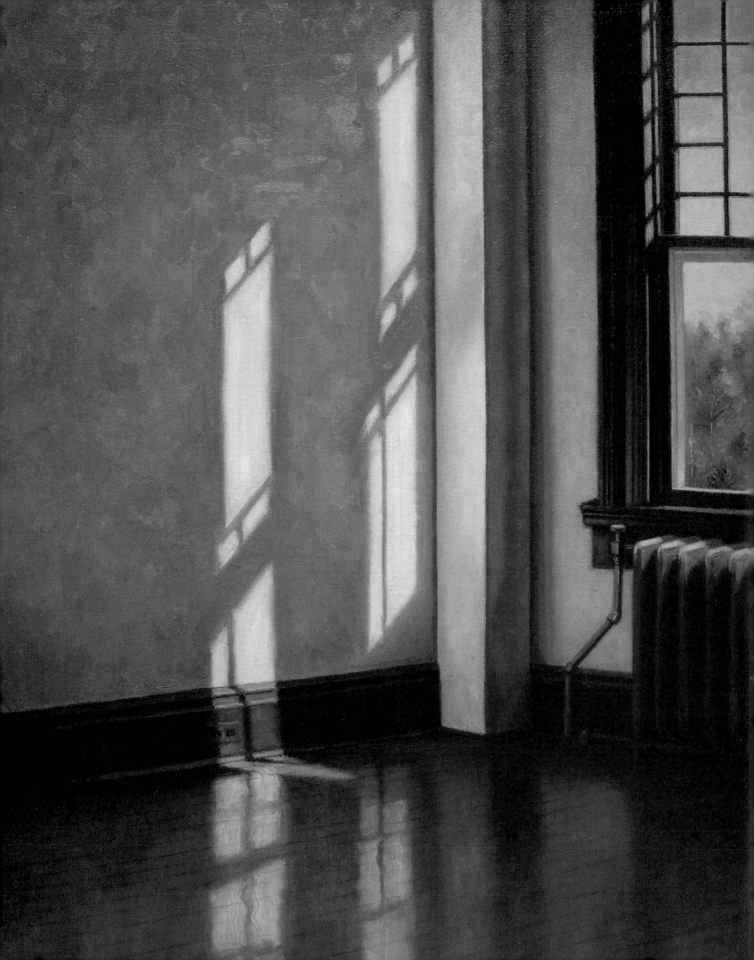

EPHRAIM
RUBENSTEIN

Ephraim Rubenstein was born in Brooklyn, New York, in 1956. He received his BA in art history from Columbia University and his MFA in painting from Columbia University's School of the Arts. In addition, he attended classes at the Brooklyn Museum Art School, the National Academy of Design, and the Art Students League. Rubenstein just had his eleventh one-person exhibition in New York: seven at the Tibor de Nagy Gallery, one at the Tatistcheff Gallery, and three at the George Billis Gallery. He has exhibited, as well, at the National Academy of Design museum, the Butler Institute of American Art, the Virginia Museum of Fine Arts, and the Maier Museum of Art. His work is represented in numerous public and private collections, including the Metropolitan Museum of Art, Exxon Mobil Corporation, and Deloitte & Touche. Rubenstein was associate professor of art at the University of Richmond from 1987 to 1998, where he received the Distinguished Educator Award and the Outstanding Faculty Award from the Commonwealth of Virginia. He has taught at the Rhode Island School of Design (RISD), the Maryland Institute College of Art (MICA), and the National Academy of Design. He is currently on the faculty of both the Art Students League of New York and Columbia University, where he teaches the Literature of Art seminar and life drawing in the department of narrative medicine. For more information, visit www.ephraimrubenstein.com.

Ephraim Rubenstein
Woodley Interior, Sunlight 3
2014, oil on linen, 28 x 20 in.

EPHRAIM RUBENSTEIN

Painting from Observation

I have wanted to be an artist for as long as I can remember. My grandfather, Edward H. Freedman, was a commercial artist and illustrator, and he taught me to paint and draw at a very early age. I can still smell the turpentine in his studio, and remember the exhilarating feeling of looking at all of those *colors* waiting for me in their trays and boxes. The excitement of the materials themselves, and of all that *potential*, has stayed with me my whole life. For a while, I also dreamed of being a professional tennis player, but I learned the hard way that I wasn't good enough. However, the focus, concentration, and discipline of having been an athlete proved very important to me as an artist.

I grew up on Eastern Parkway, across the street from the Brooklyn Museum. It had a first-rate art school at the time that was based on the *atelier system* like the League and that taught students of all ages and backgrounds. It was there that I took my first professional art classes. The school occupied a full wing of the museum, and the students were encouraged to go back and forth and study the works in the collection. One summer when I was in college, I copied Eakins's portrait *Letitia Wilson Jordan*, a great learning experience for me.

The first painting I remember falling in love with was a George Inness landscape in the museum's collection. As a young boy, I used to wander into the galleries after school, and since I came from a noisy, urban environment, this Inness painting seemed to me to be the most peaceful, lovely place imaginable: green meadows, a running brook, field after field unfolding into the distance, delicate clouds scudding away. . . . The thing that captured my imagination the most was that it didn't matter if it was twenty degrees and snowing in Brooklyn; it was always this lovely spring day in the painting. The power of painting to transcend time and place really

got to me, and the fact that a painting could create an alternative reality that spoke to me as much or more than my actual one.

Through a tennis connection, I met David Levine, who invited me to join a weekly painting group that was held on the Upper West Side of Manhattan, in a huge loft over Fairway supermarket. The group was made up of a cadre of some of the best realist painters working in New York at the time: Dave, Aaron Shikler, and Burton Silverman, among others. You can imagine how thrilling it was for me, a young teenager, to be able to work with these guys, watching them block in their paintings, beautiful models walking around, the air heady with cigar smoke and the sounds of Puccini soaring from the stereo system. For the couple of years that I went to that group, I spent as much time just looking and asking questions as I did working myself.

When I was a junior in high school, I was awarded a BACA scholarship to a Sunday Honors Painting Class taught by Francis Cunningham at the Brooklyn Museum Art School, which was made up of some of the best high school art students from all over the city. This class turned my world upside down and represented the first serious challenge to the way that I had been previously taught to paint. Cunningham had been a student of Edwin Dickinson's at the League for several years, and he taught us "color-spot" painting and "tonal drawing," which were practiced by a handful of Dickinson students around the country. In color-spot painting, we worked on the white of the canvas, established the key of the painting through a comparison of adjacent color values, and had the painting develop by expanding out, largely finished, from this initial set of observations. This way of painting was in complete opposition to the "allover, all at once" philosophy I had been taught by Dave, Aaron, and

my grandfather. It took me a while to catch on, but its virtues became completely apparent to me. I practice it to this day, and it taught me that there are many ways to paint, all of them with advantages and disadvantages.

I work in all sorts of mediums: oil, pastel, gouache, and all sorts of drawing materials. In addition, I spent about a decade making prints—mostly etchings and drypoint intaglio prints, but also some lithographs. All of these processes have taught me something and have added some dimension to my work. I find that going back and forth among mediums is essential to my work rhythm. Sometimes in the middle of a large, complicated oil painting on which I have been laboring for months and months, I will stop and do some small gouache paintings. That fresh, matte, high-key tonality comes as such a relief from the thick, heavy shininess of oil paint. Maybe because I teach so much drawing, I spend a lot of time drawing myself. Many artists I know stopped drawing once they got out of art school. They get preoccupied with painting projects, and drawings don't sell. But I think that is unfortunate. Besides the obvious pleasures of graphite, charcoal, chalk, or silverpoint, drawing keeps you honest and keeps your hand-eye coordination sharp.

I work in almost all genres—figure, landscape, still life, interiors—the whole range of representation. When asked about subject matter, Edwin Dickinson said that he was a *general painter*, and I would classify myself that way. On some level, painting all subjects is the same; we don't paint with cloth or flesh or trees or stone. We paint with shapes of colored paint on a flat surface, and if we get it right, it will *look like* a piece of drapery or a figure or a landscape or a building. I can recognize a Degas immediately, regardless of the subject, because he always reveals his sensibility through his color harmonies and his exquisite drawing.

Growing up in New York City, I started out as a figure painter and thought that would be my primary subject. But early on in my career, I moved down to Virginia to teach at the University of Richmond and found it was much harder to find models. New York has a real *model culture*—it is an accepted part of artistic practice, and there are great models all over the place. It proves much harder in other places. Van Gogh's letters are filled with laments about how hard (and expensive) it was for him to find models. So when I moved down to Richmond, I started looking around me, and I discovered that I loved landscape, and interiors and still life as well.

I am mostly interested in the expression of my innermost feelings. In this regard, almost all of my work can be said to be autobiographical. If it takes a figure to say it, or a foggy riverbank, or a ruined Doric temple, so be it. We sense our deepest feelings present in nature and strive to find the objects or locations that can express them. These are what the poet Rainer Maria Rilke called "sensuous equivalents": objects or places in nature that express our most ineffable feelings. We are constantly on the lookout for these. Jamie Wyeth said that even a bale of hay could be a self-portrait if it is painted with feeling.

My friend David Dodge Lewis taught me (among many things) the value of working in series. The concept of *series* acknowledges the fact that it may not be possible to say everything you want to say about a given subject in one piece. Every artist knows the feeling of getting to a crossroads on a painting or drawing and realizing that you could develop it one way or in a very different way instead. Working in series allows you to have your cake and eat it, too, to continue down both paths, maybe even three or four paths, without the sadness and resignation caused by "the road not taken." The same motif, explored with several different outcomes, becomes like the idea of theme and variation in music. The concept of series became crucial to me, and has become a standard part of my conceptual equipment.

I have two studios in my house: one that has good windows that I use for daylight projects and an attic space that I use with artificial lighting. There are almost no north-facing windows in my house, so I have learned to work with east light, which is hot in the morning but

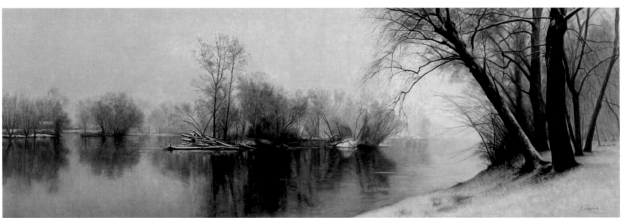

Top
Ephraim Rubenstein
Woodley Summer Dawn
2011, oil on linen, 30 x 50 in.

Bottom
Ephraim Rubenstein
James River, Winter 2
1999–2000, oil on linen, 25 x 72 in.

which cools down as soon as the sun moves around the corner of the house. I made some screens that I stretched with Mylar, a film that lets the light through while diffusing the direct, raking light. I have spent a lot of time thinking about, and setting up, the lighting in my upstairs studio, and I try to have all different sorts of lights, lamps, and fixtures on hand in case I want a different effect. For an observational painter, nothing is more important than light.

My studio is a very private place, and something like the ancient *caves*—images on the walls, rites involving mysterious objects, and so on. As I get older, more and more of my space is devoted to storage; but I still have room for reproductions of work that interests me, favorite objects, the work of some friends, and, of course, drawings and studies for projects on which I am currently working. My studio is reasonably well organized; I try to be efficient in that department so that when I need a particular type of brush, I can find it quickly. I get a real kick out of looking at paintings of nineteenth-century studios: huge spaces with skylights, bearskin rugs, ancient statues, potbellied stoves, naked models—nice work, if you can get it.

My teaching has evolved over the years to try to include the best aspects of all the approaches that I was taught myself. However, I always try to emphasize that there are many, many ways of constructing a painting or drawing, all of them with virtues and limitations. I emphasize the fact that no matter what one's strategy for approaching a painting, one's technique should always be in service of a vision. I teach a large number of beginning students, and I teach them about the importance of basic skills and a thorough knowledge of their materials. Just as a music teacher teaches "ear training," I teach "eye training"; the ability to measure and to control scale and proportion, mastery over the color/value range, sensitivity to shapes within the initial rectangle, and so forth.

I try to make my classes a place filled with what Robert Henri called "the art spirit"—a place of energy, excitement, and mutual cooperation. I try to impart the importance of having colleagues and friends with whom one can work and to whom one can go for criticism and the exchange of ideas. Perhaps the hardest part of being an artist is the ability to work alone for long periods of time, and connecting to some sort of larger community is crucial.

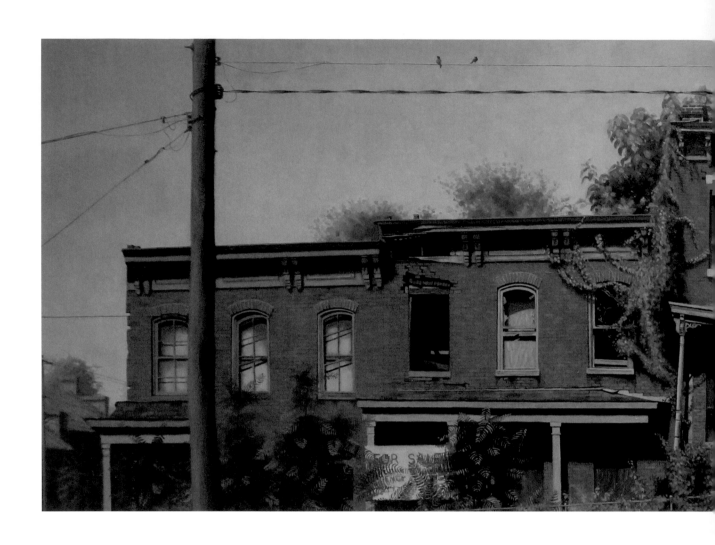

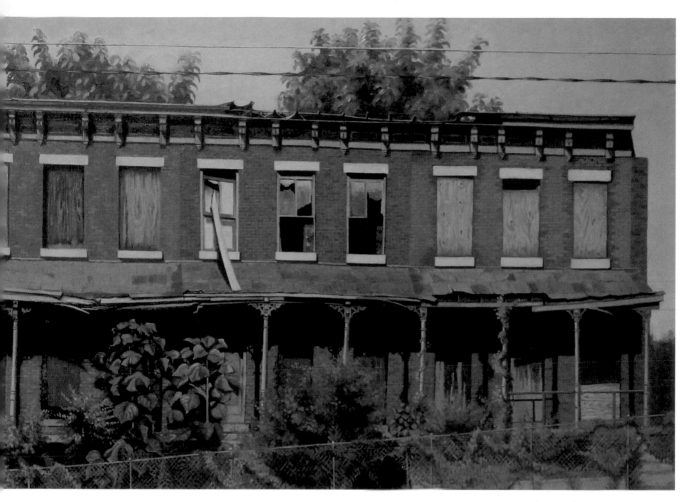

Ephraim Rubenstein
Abandoned Houses, Richmond, Virginia
2012–14, oil on linen, 34 x 68 in.

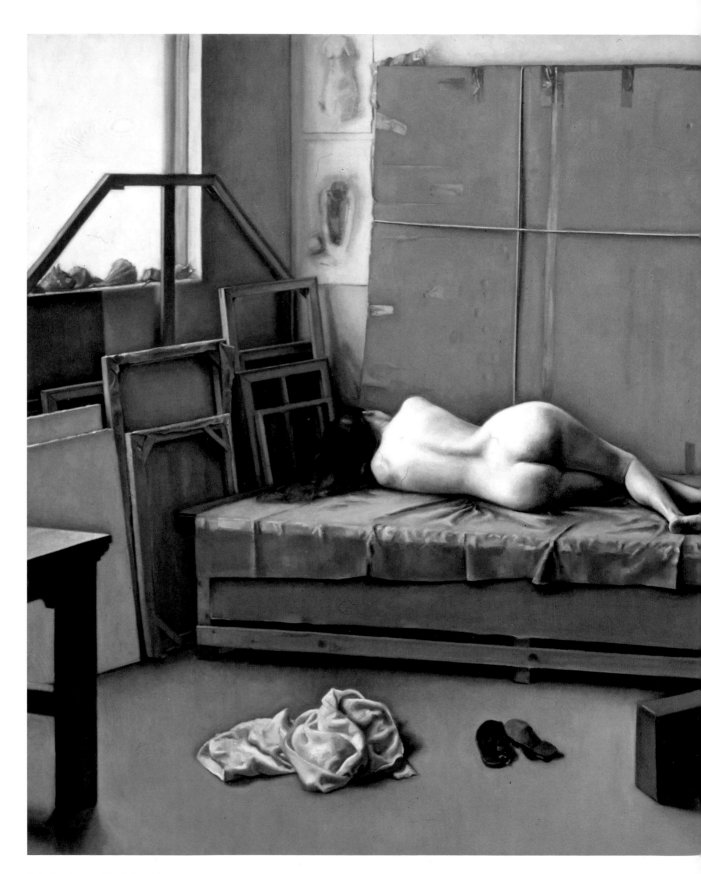

Ephraim Rubenstein
Studio Interior with Model
1995, oil on linen, 42 x 50 in.

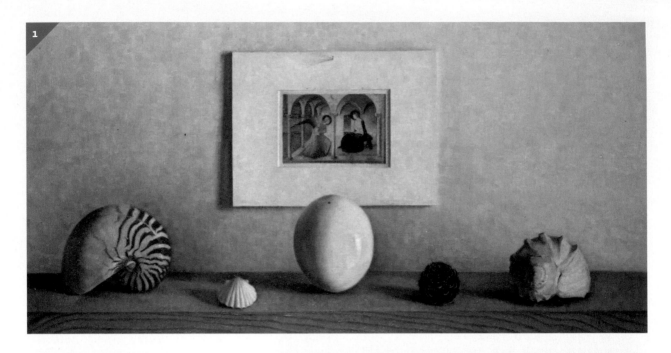

1. **Ephraim Rubenstein**
Annunciation
1985, oil on linen, 19x 36 in.

2. **Ephraim Rubenstein**
Les Roses 1
1993, oil on linen, 60 x 30 in.

3. **Ephraim Rubenstein**
Still Life With Empty Nests
1992, oil on linen, 30 x 48 in.

A LESSON IN PRINT:
THE SENTIENT OBJECT

Still life painting has traditionally been thought of as the most abstract of genres. Emotionally neutral, it allows painters to pick out forms, colors, and patterns for their visual effects alone. At best, it encourages artists to play with compositions and color harmonies in the abstract; at worst, it is a genre best suited for studies and exercises. Because of this, many viewers have decided that still life painting is emotionally vacant or even boring. But I have always found it to be deeply moving, and the difference lies not so much in the treatment of the subject but in the attitude toward it. The world is absolutely *filled* with natural objects and objects of material culture. Everywhere we turn there is evidence of nature's bounty and man's ingenuity, as well as objects of deep personal significance for us.

1. For instance, when my wife became pregnant with our first daughter, Amelia, I painted an "Annunciation" still life for her that included a large ostrich egg, a pinecone, and a seashell (which, because they illustrate the Fibonacci sequence in nature, have always been symbolic of birth and growth), and a postcard reproduction of Fra Angelico's San Marco Annunciation fresco, which we had recently seen in Florence. The painting hung over our mantle and seemed to protect the whole endeavor.

Rilke developed a concept that he called "sensuous equivalents," or objects in the real world that were suffused, or could be suffused, with deep personal meaning for the artist. The word *sensuous* is used to connote an actual thing existing in the world, and not just an internal feeling, although the one becomes a stand-in for the other.

2. Rilke loved flowers, and he wrote a poem about pink hydrangeas, one of my absolute favorites.

> Who thought such pink could be? Who knew it there
> Accumulating in each blushing cluster?
> Like gilded things which by and by unluster
> They gently grow unred as if from wear.

—Rainer Maria Rilke (Walter Arndt, translation)

In *Les Roses I*, it is amazing how a single flower can electrify the simple corner of a room and make all the surrounding color notes come alive. The blue/gray wall looks completely different in the presence of that tiny note of brilliant yellow.

3. The opposite pole from the abundance of flowers is the still life of loss, as embodied by *Still Life with Empty Nests*, a collection of old nests, hives, and cells that have outgrown their use and have been abandoned. Here, everything has been reduced to the grays, blacks, and browns of the colors of the earth.

4. Books have always been extremely important to me. My library is one of my "places of peace," another one being in front of my easel. In *Library I* (page 51), the photograph on the desk is of Charles Dickens, one of my favorite writers.

5. *Still Life with Books, Mirrors, and Lenses I* (page 51) is a meditation on how we know what we know. In it, my books are seen among all sorts of optical devices: magnifying glasses, diminishing lenses, prisms, convex mirrors, even a Victorian "gazing ball." If everything can be distorted by how one is looking at it, how can we be sure of what we know?

6. Violence against books is violence against the beliefs encoded within them. A society that bans books may end up burning books; and burning books has tragically been a prelude to burning people. I laid out the charred remains of three books that I burned sacramentally on an altarlike surface so that they could be mourned in *Still Life with Burned Books*.

7. Still life objects assembled together can create a compelling portrait of a person, a sort of still life of attributes. The objects speak to the interests and pursuits of the person, and become an eloquent stand-in for the person themselves. I have done two such *still life portraits*.

I began *In Memory of Primo Levi 1919–1987* (page 52) upon hearing of the death of Primo Levi, another of my favorite writers. Levi was a chemist by training but became a writer after surviving the Nazi death camp at Auschwitz-Birkenau. His experiences there became a central theme of his writings, and he often interwove them with his insights as a research scientist. I took a large, old university-type desk and filled it with objects from a chemistry lab as well as with books and writing instruments. I wanted it to seem as if Levi had been sitting in the chair thinking and writing, took off his glasses, got up, and has not returned.

8. Continuing the concept of still life as portrait, I explored my grandfather's participation fighting in the First World War. I had no idea, however, what the reality of his experiences were until I happened to find a tiny journal that he kept from 1917 to 1918, when he went to France with Pershing's Expeditionary Forces. The journal is at the very center of a still life painting I made entitled *The Great War and Me* (page 53). His written account was a blow-by-blow description of the Meuse-Argonne Offensive, all seen from his point of view. The objects all refer to parts of his body and constitute a symbolic portrait: the helmet

is his head; the uniform, his chest; the medal, his heart; the canteen, his stomach; the gas mask, his lungs. The shovel is his strong arms, which he used to repair roads and bury the thousands of horses and mules that were killed in bombings. It was absolutely thrilling for me, as I worked on the painting and read about the war, to experience the intersection of one of the defining moments of the twentieth century and my family's history. My grandfather was especially important to me, because it was he who first taught me how to paint.

9. The World War I gas mask in *Gasmask II* (page 54) is a difficult object to contemplate. I laid it out, without specific comment, just so that it could be examined. On the one hand, it is horrific to view—it looks like some kind of wizened, reptilian fossil. On the other hand, it is strangely human: the mask is the face; the tubing, the throat; and the canister, the lungs. It all folded up and got put in the sack. Masks such as these kept millions of men alive, as we began to introduce chemical warfare to the history of the world.

Paintings like these show, I hope, the emotional range that still life painting can have. If you think that still life as a genre is emotionally vacant or even boring, it is because you have failed to exercise your imagination. Each day, you encounter hundreds of objects in the world. Which of them are compelling enough to paint, and how would you present them to the world?

4. Ephraim Rubenstein
Library 1
1998, oil on linen, 30 x 18 in.

5. Ephraim Rubenstein
Still Life with Books, Mirrors and Lenses 1
2002, oil on linen, 36 x 60 in.

6. Ephraim Rubenstein
Still Life with Burned Books
1997, oil on linen, 39 x 50 in.

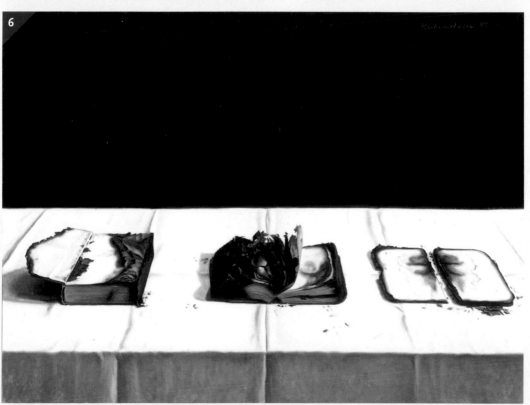

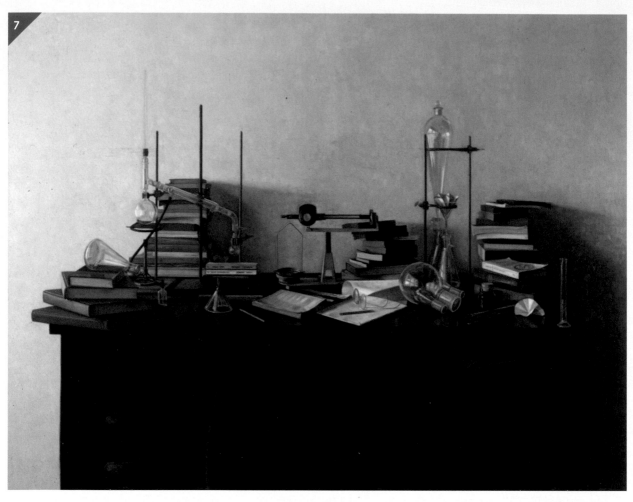

7. Ephraim Rubenstein
In Memory of Primo Levi
1988–90, oil on linen, 60 x 70 in.

8. Ephraim Rubenstein
The Great War and Me
1998–99, oil on linen, 72 x 60 in.

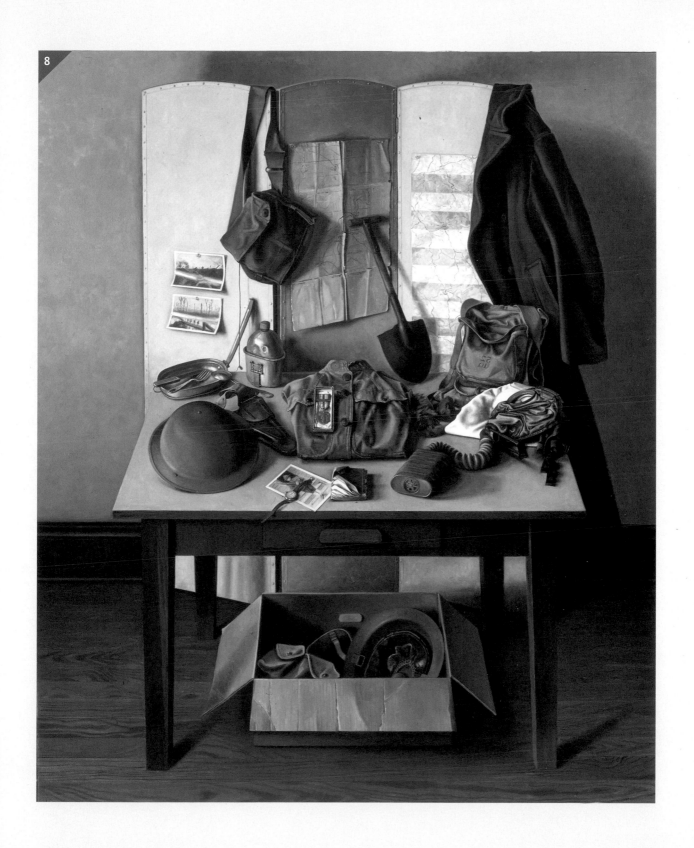

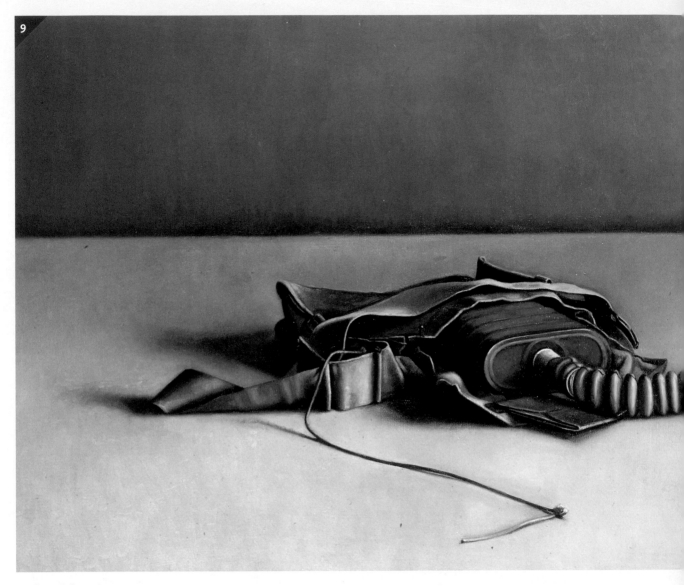

9. Ephraim Rubenstein
Gasmask 2
1999, oil on linen, 22 x 54 in.

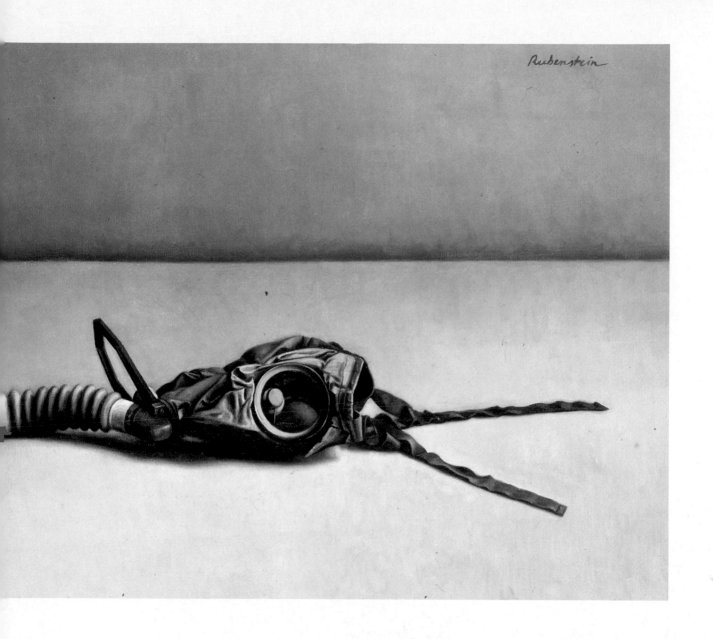

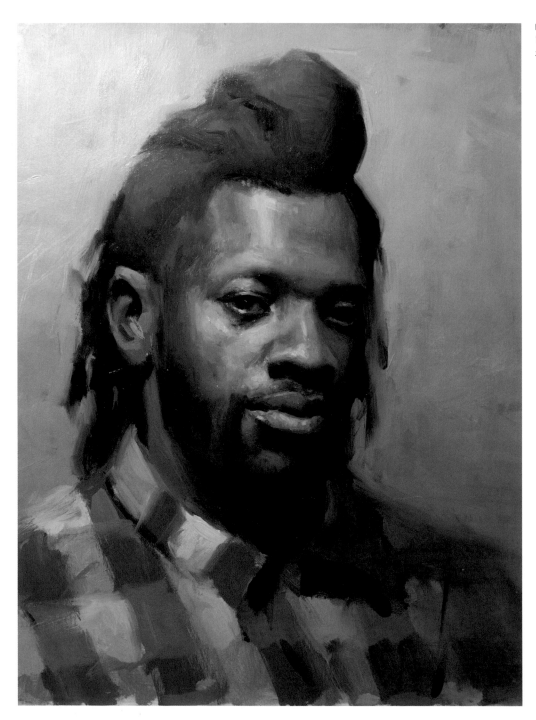

Diego Catalán Amilivia
Tyrone
2008, oil on canvas, 15 x 11 in.

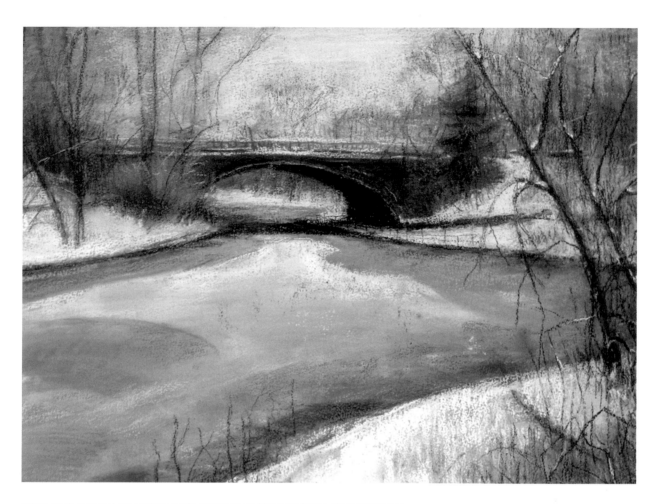

Top
Hipólito Torres López
Between Woods and Frozen Lake
2005, pastel on sabertooth paper, 22 x 30 in.

Bottom
Eric March
Hymn for the General Slocum
2005, oil on canvas, 16 x 60 in.

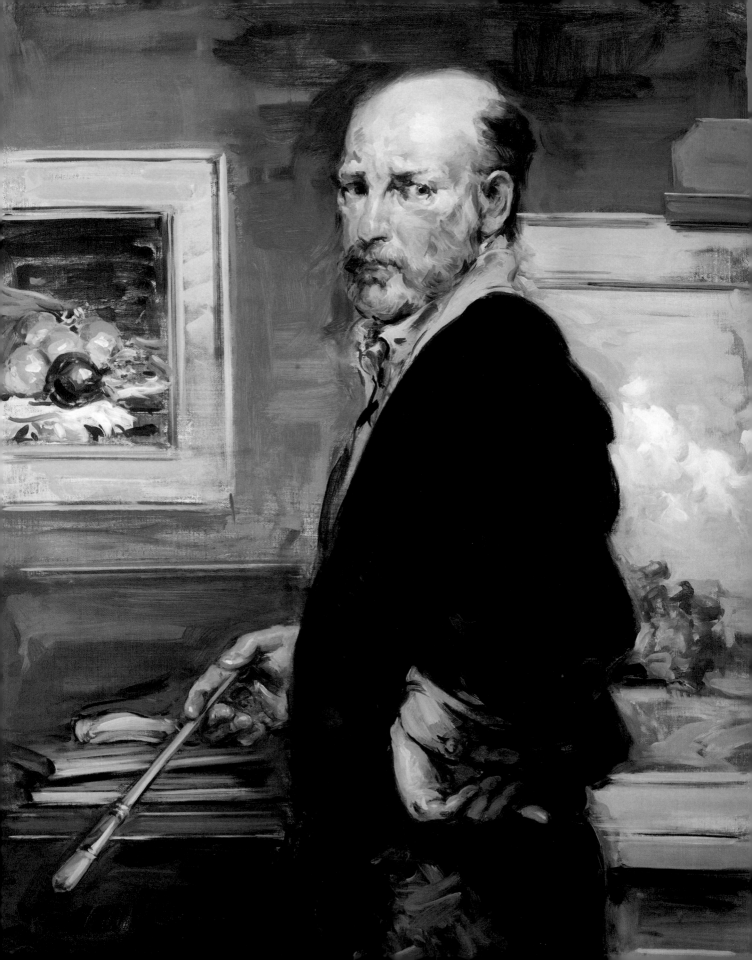

THOMAS
TORAK

Thomas Torak teaches the core principles of traditional painting technique, with stress on the importance of a logical and organized approach. Students learn to use light to create the illusion of form in an atmospheric space on a two-dimensional surface.

Torak studied at the Art Students League from 1974 to 1983 with Robert Beverly Hale and Frank Mason. His paintings have been recognized with the Audubon Artists Gold Medal of Honor, the Allied Artists of America Silver Medal of Honor, the Academic Artists Association Gold Medal, and the American Artists Professional League Frank C. Wright Medal of Honor. He has received the top awards at the Salmagundi Club (New York City) at their Thumb-Box Exhibition and Annual Floral Exhibition. His painting *The Artist* was purchased by the Masur Museum of Art (Monroe, Louisiana) for their permanent collection. His paintings have been seen at the Butler Institute of American Art, the Springfield Museum of Fine Art, the Huntsville Museum of Art, the Bergstrom-Mahler Museum of Glass, the San Diego Art Institute, the National Academy Museum, the Krasl Art Center, the Danville Museum of Fine Arts & History, the Wiregrass Museum of Art, and the Chautauqua Institution galleries.

Thomas Torak
In the Studio
2013, oil on linen, 40 x 30 in.

THOMAS TORAK

A Contemporary Approach to Classical Painting

There are some artists who think all art from the past should be discarded so that new works can be created without their influence. Others think we should reject all modern art and return to the academic tradition of the nineteenth century. Some suggest we need to rediscover the secrets of the Renaissance, while others advocate adopting a pre-Raphaelite philosophy. I suspect there are some who want to reestablish illuminated manuscripts or cave painting as the art of the day. But we can't undo what was done in the past, or what is being done in the present, and it is unimaginative to re-create work that has been done before. I think the artists of the Renaissance had a healthy approach to their creative endeavors. They admired the work of the ancient Greeks and, rather than trying to re-create Greek art, studied the principles and techniques that made those works great, then added their considerable talents, intelligence, and philosophy to those principles to create brilliant, unique new works. For me, the Renaissance and Baroque periods represent the height of the art of painting, and my work is influenced by their principles and techniques; however, there have been many changes in materials (especially pigments), technique, and theory since then, and when these new materials or concepts are useful, I am delighted to bring them to my work. Every artist should study the work of the great geniuses that came before them and then create exciting new paintings that express their own philosophy and personality.

Although I have always liked to draw, and was never discouraged from doing so, I come from a culturally challenged background. I never heard the music of Chopin or Brahms until I left home and never knew anyone who had ever been to a museum. When I was eighteen I took myself to the Philadelphia Museum where I saw, and was profoundly moved by, Rubens's *Prometheus*. I stood spellbound. I had no idea a painting could be so powerful, expressive, and glorious yet be so subtle and beautiful. It was more alive than the people walking through the museum. Yes, the story the painting told was incredible, but this was not an illustration of a story; the event seemed to be taking place before my eyes. The tormented figure of Prometheus and the eagle pecking at his liver were amazing; I could have sworn I saw them breathing. The paint itself, nearly four hundred years after the work was created, was rich and vibrant. I vowed on the spot to spend the rest of my life drawing and painting. I wanted to paint like Rubens—not to produce works that looked like his but to create paintings that were alive and made the hearts of those who saw them beat a little faster. The next year I moved to New York to attend the Art Students League, where I had the privilege and pleasure of studying with Robert Beverly Hale and Frank Mason.

How I prepare to paint is vitally important to the outcome of the work of art I intend to create. When a violinist has a recital at Carnegie Hall, he does not run down to the music store and quickly grab an instrument to play on. He uses the finest instrument available to express his music. If artists intend to paint masterpieces, they should not just grab a canvas from an art store but should use the best materials possible.

People often remark on the beautiful quality of my work. This is usually followed by a query about which varnish I use. A rich, lively surface, however, is not the result of the final layer; it begins with the ground. I stretch the finest linen I can find, size it with rabbit skin glue, and then apply a white lead oil ground. Lastly I sprinkle a little dry color on the canvas and spread

it over the surface with a final coat of glue to give the surface a middle tone. I also want to use the finest colors, so I often grind my own paint. This allows me to determine the amount of pigment and both the quantity and quality of the oil in my paint. It is not difficult to do, although it can take some time. I also prepare my own painting mediums. The basic formula for medium is equal parts linseed oil, turpentine, and dammar varnish. This can be varied to suit my purpose as I paint. It can be made thicker or thinner. I can add driers or cook it to make a gel. There are infinite variations, and artists can determine which formula or formulas will work best to express what they have to say. The more artists know about their materials, the better they will be able to control and manipulate them.

In addition to using the best materials, it is important to use the finest light. A high north-facing window gives me the best light for mixing my colors and lets the most beautiful light fall on my model. Natural light contains the full spectrum of colors; artificial light is less subtle. Artists can create good paintings using artificial light and tube paint on commercial canvases, but with a little more attention to their materials, they can create masterpieces that express their ideas with more subtlety and eloquence, and will retain their beauty for centuries.

Laying out my palette is key to the success of my work. I often refer to my palette as my piano. I set it up like a keyboard, with colors arranged from light to dark. Below the pure colors I lay out a series of grays, also light to dark. The grays remind me to control the value of the colors I am mixing—to stay on pitch, so to speak—and can also be used to moderate chromatic intensity. As I paint, I mix my colors as if I am playing on my keyboard. The lightest tones, or highest values, are mixed at the light end of the palette, the middle tones in the middle, and the lowest tones at the dark end. This organizes my thinking and allows me to mix colors as easily as a musician plays scales.

Once my materials are ready I need to consider what I am about to paint. All subject matter for representational painting, be it figurative, landscape, or still life, is essentially the same: light on form in space. As I prepare for each painting I imagine my canvas is an empty space. I see light fall into that space and the subject of the painting enter the space. Each of these three elements is equally important to the success of my work. The subject matter, the form, is the easiest to see and copy from nature. It takes a bit more effort to be aware of the light, but if I observe it carefully I can use it to create luminosity in my work. Space is the most difficult, because it cannot be seen or touched. The existence of space around and between the objects I am painting is undeniable, but how can I paint something I can't see? Artists paint things they cannot see all the time. Portrait painters can't see or touch the personality or character of their sitter but wouldn't consider their painting complete without them. Still life painters cannot see the weight of the objects in their paintings but endeavor to express the difference between the lightness of a flower and the heaviness of a book. Landscape painters cannot see cold, but it is a vital aspect of a winter landscape. Now that I have a full understanding of what I am about to paint I am ready to begin.

If I intend to create a painting that is alive when it is finished, it must be alive from the beginning. I have already started that process by preparing my canvas with a rich oil ground and giving it a neutral middle tone to set off my beautiful colors. Many artists begin their painting by blocking in the subject, and then plod along and build their painting until completion. But a structure, no matter how well constructed, is not alive. I prefer to begin by going after the rhythm, the life force, of what I am painting. This need not take a long time. I let my brush move freely as I suggest the action of the form in space, set the parameters for my design, and begin painting. Because I have established a middle

tone on the canvas, it is easy to jump in and begin expressing the light and forms.

I am most excited when I am beginning my painting. I use that excitement to make the painting live and breathe from the first strokes. The light, form, and space are all painted together, the same way they exist in nature. I let the form emerge in the space within the canvas, and then develop that form by allowing my brush to caress and sculpt it. Keeping the brush on the surface of the canvas and moving the paint over the form is more effective than adding repeated brushstrokes. Starting in the center of the form, I move over and around the form using light and shade to give it volume and weight, remembering to paint the illusion of space between that form and others in the painting. My brush is always in motion; I've been told I look more like the conductor of an orchestra than a painter. The brush also moves on the palette, gliding from light to dark, exploring the tonal relationships. Well-modulated tones are essential to set off purer colors. These more vibrant pure colors are used to create excitement and express vitality; used judiciously they can make the painting sing. Whether the brush is on the canvas or the palette, it should be doing something amazing and delightful. Many artists finish their painting by adding highlights and details. In my paintings highlights and details can appear at any time, however, and are often subdued in the final passages as I reestablish the unity and harmony of the whole. A painting can take forty-five minutes or forty-five days to complete; it is done when I have expressed everything I want to say.

I don't have a step-by-step approach to get from the beginning to the end of a painting; my method is more organic, but the ideas presented here are more important to creating a masterpiece than any nuts-and-bolts tips I might offer. We all want to get to the mountaintop, but there are many different ways to get there. All artists must find their own way, using their own style and their own voice. If Rembrandt is right, that doesn't mean van Gogh is wrong. If Whistler is right, it doesn't mean

Titian is wrong. If I am right, it doesn't mean you are wrong. If ten artists paint the same person's portrait, there should be ten valid, unique interpretations of that sitter.

The canvas is a void. It is the job of the artist to fill that void with light and form and atmosphere, with wisdom and challenge, with thunderous noise and breathtaking silence, with the glory of heaven and the horrors of hell, and with all the infinite variety and nuance of the human condition. The goal is to create works of art that are able to reach out of the canvas and touch the viewer, to move them in a profound way. Rubens painted his *Prometheus* in 1612; I first saw it in 1973. A great work of art is something that can change someone's life 361 years after it was created.

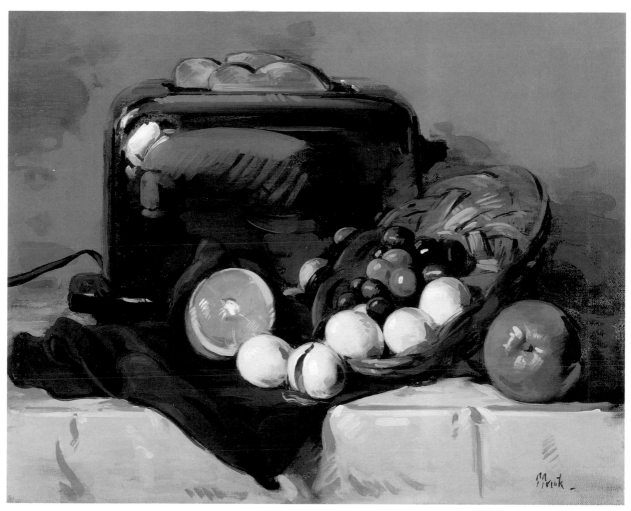

Thomas Torak
Breakfast
2004, oil on linen, 16 x 20 in.

Thomas Torak
New Onions
2007, oil on linen, 15 x 26 in.

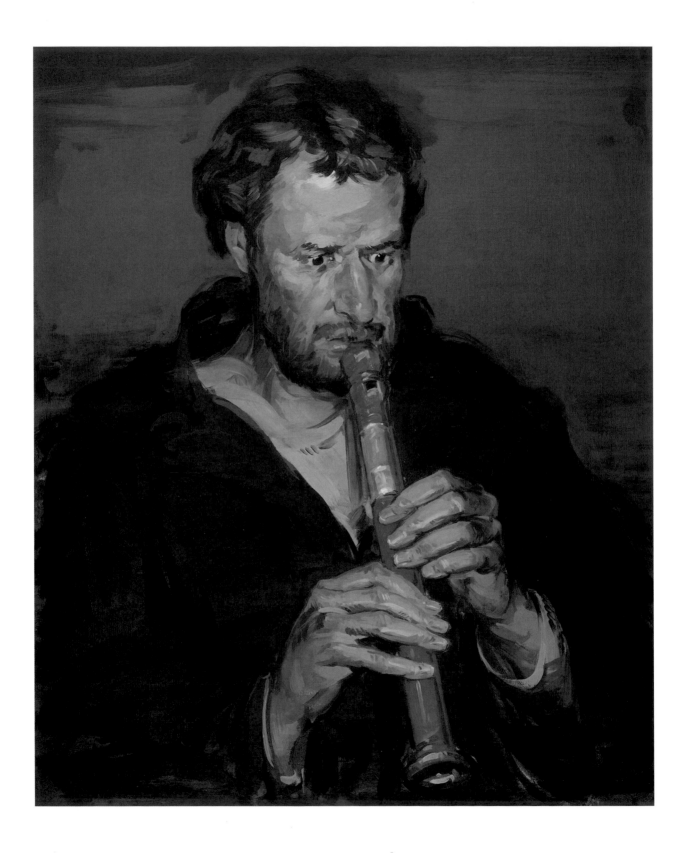

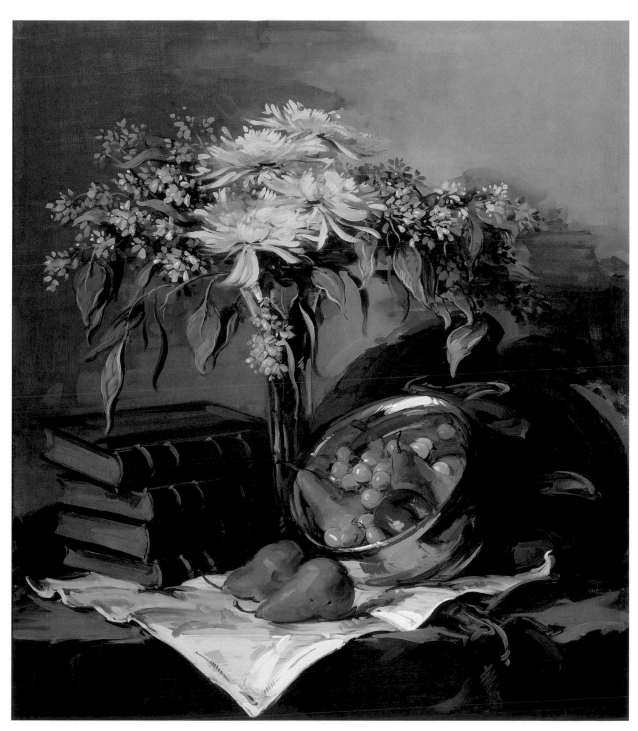

Thomas Torak
The Silver Bowl
2008, oil on linen, 34 x 30 in.

Opposite
Thomas Torak
The Recorder Player
2008, oil on linen, 24 x 20 in.

Thomas Torak
Women in Art II: Preparing to Paint
2010, oil on linen, 30 x 40 in.

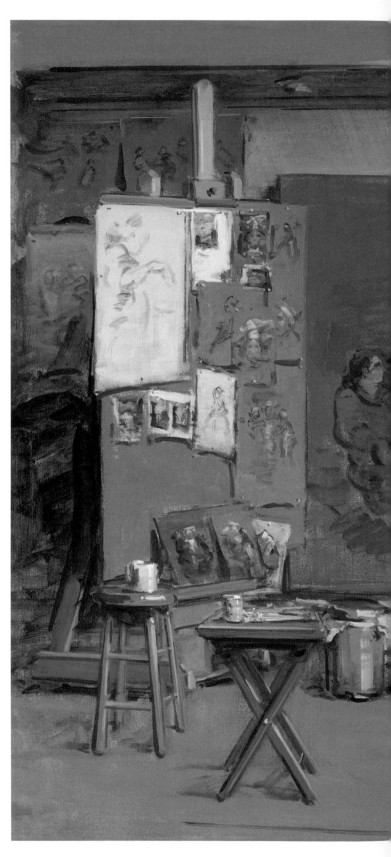

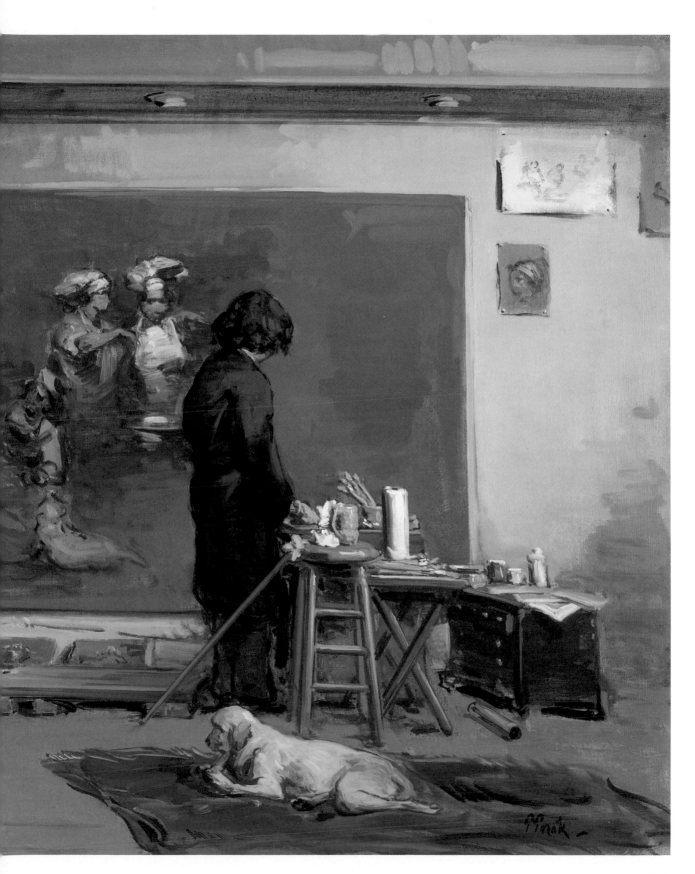

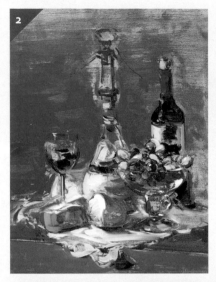

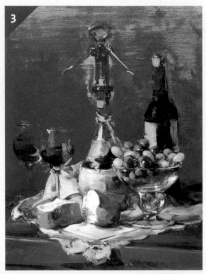

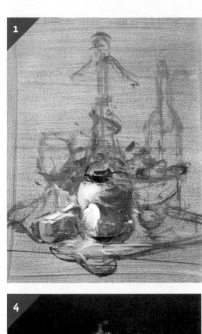

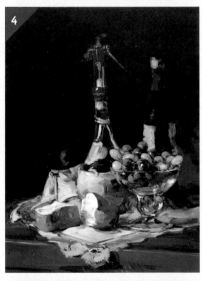

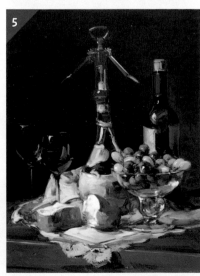

A LESSON IN PRINT:
KEEPING THE PAINTING ALIVE

I like to think of my still life paintings as group portraits. All of the individual personalities must be fully expressed, yet each one must take its place within the whole. Each grape is a unique character, yet no one grape is more important than the bunch of grapes, and the bunch must be in harmony with the rest of the painting.

Every part of the painting is in play until the work is complete. At the final sitting, I do whatever is necessary to create unity and project a single sense of purpose: a wash here, a glaze there, reinforcing an opacity here, or creating more atmosphere there. At every stage of the painting I endeavor to keep the painting alive. In the end, the work must be harmonious, with light and space that live and breathe, and forms that have character and express vitality.

1. Preparing the canvas with a middle tone before I begin allows me to quickly enter into the excitement of the painting. Using a shadow value tone, I explore the rhythms within the group of objects and design the composition. With a middle and dark tone established, I can easily jump in with higher, lighter values to begin creating form and luminosity.

2. Each of the objects in the painting is established before finishing any one object. This allows the entire still life to develop as a single unit. My brush moves freely through the painting, exploring tonal and spatial relationships. I generally paint the light on the forms with opacity and allow the shadows to be more transparent than the lights.

3. This still life was set up using an intensely dark shadow box. If I copied the tones from nature, the deepest part of the shadow would be painted a dead flat black. In order to give that part of the painting more resonance, I began with a chromatically intense cadmium red underpainting.

4. Once the underpainting is dry, I can develop the blacks in the background. The darkest, richest area is painted thinly to allow the red to show through. This keeps the deepest shadows alive and creates a dynamic contrast with the brilliantly lit objects in the foreground. Where darks in the background are less intense, the tones are modulated, their opacity increases, and the effect of the red underpainting lessens.

5. Each object is painted from the center of the form to where it disappears from the eye. I prefer to call this a turning plane rather than an edge, because I want my thinking to continue around the form. If I paint a hard edge, my object will be more like a mask than a form in the round, and I will lose my sense of space.

6. The finished work.

Thomas Torak
Bread and Wine
2013, oil on linen, 24 x 20 in.

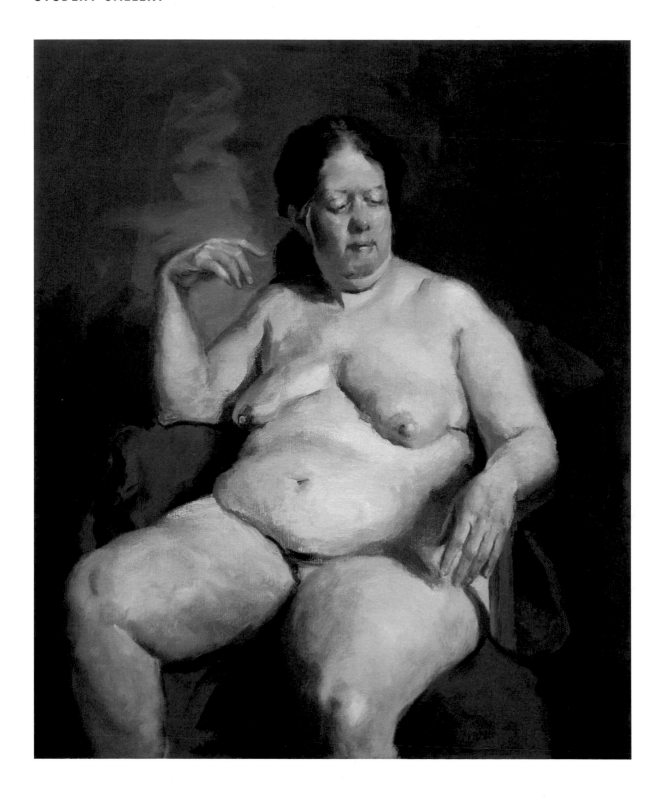

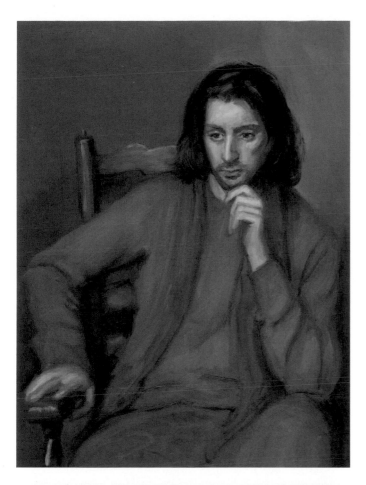

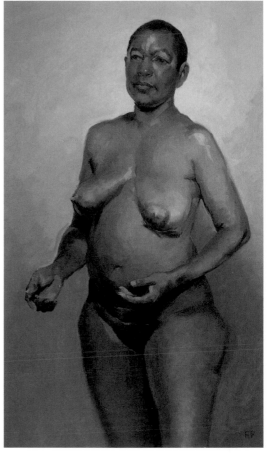

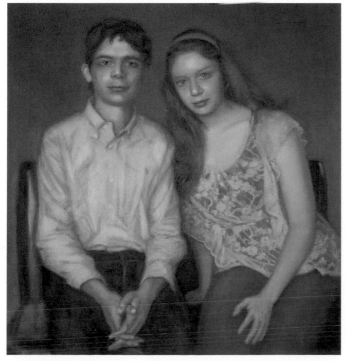

Top left
Walter Lynn Mosley
Evan
2013, oil on linen, 28 x 22 in.

Top right
Rick Perez
Roshmi
2013, oil on linen, 36 x 24 in.

Bottom
Walter Lynn Mosley
Ben and Maeli
2013, oil on linen, 34 x 30 in.

Opposite
Rick Perez
Betty
2013, oil on linen, 24 x 20 in.

DAN
THOMPSON

Dan Thompson has received numerous awards, including Grand Prize for Best of Show in the American Society of Portrait Artists International Portrait Competition at the Metropolitan Museum of Art in New York, the Erlebacher Award from the New York Academy of Art, the Ethel Lorraine Bernstein Memorial Award for Excellence in Painting from the Corcoran College of Art and Design, and the Elizabeth Greenshields Foundation Grant. He has been designated a Living Master by the Art Renewal Center.

In 2006, Thompson cofounded the Grand Central Academy of Art in New York. In 2008, he cofounded the Janus Collaborative School of Art, also in New York. Thompson also teaches regularly in the MFA program of the New York Academy of Art and at Studio Incamminati in Philadelphia, and conducts workshops throughout the United States and Canada. In 2011, he created two instructional DVDs for *American Artist* magazine entitled *Figure Drawing I: Anatomy of the Head* and *Figure Drawing II: The Gesture*. His artwork has been included in recent books from Abrams, Sterling, and Watson-Guptill Publications.

Thompson's work has been exhibited in public and private collections throughout the world, including the Eleanor Ettinger Gallery, John Pence Gallery, Arcadia Gallery, the Art Gallery of Ontario, the Corcoran Gallery of Art, the Noble Maritime Collection, Sotheby's, the Pasadena Museum of California Art, the National Arts Club, the United States Capitol in Washington, DC, and the Beijing World Art Museum. For more information, please visit www.danthompsonart.com.

Dan Thompson
Irina
2014, graphite pencil, 24 x 18 in.

DAN THOMPSON

Learning to Paint the Human Figure from Life

Like many of my students, my own experience in studying painting in an art school was not what I had hoped for or expected. From the moment that I entered the foundation program, I was told that I was already an artist. The key to my education, evidently, would be to discover a profound personal expression hidden within me. This expression would come into being through experimentation and would exist beyond the rules of craftsmanship, rudimentary drawing, or painting skill. They called it abstract expressionism.

I began in earnest, keeping an open mind and striving to find academic success as the atmosphere of self-expression gathered momentum. At the very beginning, as an applicant, I had been informed by the admissions officer of the school (an institution that has, as of the date of this reminiscence, collapsed after more than a century of existence) that "we teach our students how to draw everything during the first year." But when I matriculated, the instructors said that I never really understood drawing, much less painting. I needed to be convinced that drawing was about expressing and not learning to draw, and painting was to focus its merits on free-flowing, impulsive, pure visual ideas, resources, and mediums. I was asked to suspend what my gut was telling me I needed to study.

Eventually I saw some light in the darkness. I studied with a minority of instructors—one in particular—who promoted the importance of learning the tradition of painting technique, but no one who thought this way could influence the school's curriculum, so their input only stoked disaffection in me. The limited time that I was provided with a live model, which was, for me, a window into tradition, was treated by the core faculty as a remnant of the dead past. Drawing ability was shortsightedly labeled "a gift." Students who clamored for more structure were dismissed and told to paint from photographs. As a neophyte, I assumed that all of my core teachers could draw beautifully, but later it became known among the student body that photography was replacing hand-eye coordination and authentic academic training. Regardless of the circumstances, I didn't have the confidence to ask why everything in art school was valid *except* realism.

I was about to emerge from art school ignorant, directionless, and despondent when I found myself in the archives of this once venerable institution. I was there doing research on a painter—the deceased father of an artist about whom I had heard wonderful things. I found him in several very old prospectus magazines that were created in order to attract students. They dated from 1918 to 1930. I was blindsided by the imagery—figure paintings and drawings that showed complete proficiency adorned page after page. Composition classes, tonal studies from the antique, portraits of great character, anatomical lectures, aesthetics . . . this was the program of the 1920s. What a school I had gone to—seventy years too late. Nevertheless, my doubts were behind me.

Resolute, I studied drawing and painting from life for seven more intensive years in various other schools and with a number of private teachers. I learned to respect the past. I learned that my instincts for what had been missing in an art school were not unique to me. The language of drawing and painting became a fascinating neglected subject that the more it crystallized, the more its total comprehension became my mission. Toward the end of this period, I started teaching drawing and painting, which further clarified things for me.

My efforts eventually brought me the supreme honor of teaching at the Art Students League of New York.

The painting room that I teach in, Studio 15, is the same one that was once graced by Robert Henri, John White Alexander, Emil Carlsen, Frederick Judd Waugh, and others in their iconic 1907 instructors' photograph. My class keeps the photo nearby: those notables represented such excellence on so many levels that their mere presence continues to drive us to higher standards. With the generosity of the Art Students League archivist, my students and I have borrowed *academie* drawings from H. Siddons Mowbray's pupils from the 1890s and George Bridgman's 1920s demonstrations, as well as other Art Students League instructors, giants of America's artistic heritage.

As an instructor for this generation, my concerns involve isolating aspects of the painting language into core lessons and exercises. A new idea is brought forth as an additional layer in my dialogue with a student. I try to articulate a progressive, adaptable strategy in painting from life as a path to learning and, finally, expertise. I try to craft imaginative lessons and orchestrate studies that give students the opportunity to absorb fundamentals. In my critiques, my aim is to delve more deeply than, say, using correction-based feedback, such as "move the mouth up." I care about teaching my students how to see, because real seeing involves real thinking, processing, interpreting, and self-revelation. This type of learning, which is based upon principles and not methods, should ultimately allow a student to demonstrate *artistic* ability. One of the surprising things I've learned as a teacher of drawing and painting is that the team of teachers from my very first art school was right about believing in content and expressiveness above all things—I just think they had the order wrong. The visual narrative should transcend technique and exist beyond the student mode—once a muscular, nuanced facility from direct observation can be demonstrated.

For teaching others the process of learning how to paint, I first ask students to respond to the impulse of gesture: that frozen figurative essence, arresting and glorious, on the model stand. With all manner of drapery dangling beyond, and a feeling of weight throughout, students begin to emotionally respond. All elements in a composition possess action and character—and character is, on a responsive level, feeling. I demonstrate how to channel the living energy of their subject and show students how to let it reverberate through instinctive mark-making. We talk about paint handling, of making instruments of oil paint "invisible." We focus on disciplined exercises that demand fundamental marks in order to articulate an armature of the figure, representing the captivating abstraction of a given pose. We work quickly and make many attempts at gestural vitality, from a variety of poses.

From the inspiration of gesture and the context for design, we shift to the perception of shape. When a subject is viewed as an arrangement of abstract dark and light patterns, every piece of the visual puzzle seems easier for beginning students to see. For this exercise there are no human figures, no complex geometric forms, no landscapes or cityscapes. For the moment, the students see only shapes in front of them on a single plane, as if they were staring at a broken window. Together we process a massive world of visual phenomena into simple, perceptual painting. We map mighty continents of dark and light by omitting the trivial, painting furiously, and squinting. Tones break and then re-converge. All the while, we talk about proportion, the first read of the image, using plumb lines, angles, and axes. Our compositions materialize. This period of exploration and discovery in the world of abstraction increases our level of visual engagement, informing our representational work in aesthetic ways. When we allow ourselves to return to the world of recognizable symbols and patterns, we see differently. We see more.

Later, we make our move to the three-dimensional world. I address structural drawing so that students can expand their understanding of volume and gain insight into intrinsic form with a kind of "X-ray vision."

Students learn about notional space and how thinking like a sculptor can become a catalyst to better painting. Students also learn what three-dimensional spaces involve as a visualization exercise: how to imagine and reinterpret forms as well as how to navigate through them. We paint with insight and expectation, and conjure our own visual metaphors. From orientating the human figure's main masses of pelvis, rib cage, and head, we shift our energies to planar archetypes and study the organic geometry of the body in pose. In long pose—always an engineering miracle—weight thrusts spirals into musical rhythms, which percolate up from within the figure to the subject's surface. Students learn how the exterior contours of any subject mirror the behavior of an internal dynamism: that great frozen contraction of long pose. Armed with theories that save them from copying the model, I help students strive for an interpretive vision.

My students paint with natural filbert bristle brushes and palette knives on toned canvases. We also explore painting on hand-toned boards with a controlled palette, where they learn about chromatic impact. I introduce ideas of transparency and opacity, where we begin to texture light passages for emphasis as well as for structure. Once students have become comfortable using brushes and paint, we expand our palette to include the strongest colors available. These include cadmium, quinacridone, perylene, anthraquinone, and phthalo, as well as several earth colors. I arrange these majestic pigments in the arc of a color wheel on my wooden palette, and I encourage the class to do the same.

When our concentration shifts to figure painting with a full color palette, the term *light key* becomes commonplace. Opposing a value arrangement, we strive to paint the "colored masses" as components in a visual harmony of illumination before us. Each colored mass is considered a color note in a chord that, when "sounded," should synchronize with the

other masses to create a light effect, or likeness. If it doesn't, there is disharmony. All masses must be restated. Sometimes, I demonstrate the light-key phenomenon for my students by using a theater boom light and colored gels to illuminate a subject on the model stand. Immediately students recognize that they are seeing something atypical, even if they don't yet understand how to paint it. I guide them through the exercise by changing the normal tools to palette knife and strong tube colors. With these tools, light can be examined more freely, since drawing finesse is not particularly important; massing color notes can be accomplished quickly and with clarity. Over time, the exercises take us from the use of intense gel light filters to more subtle ones until we arrive at a state of mind where all light is perceived as effect.

In the closing strategies of a pose, refinement in life painting becomes a matter of emphasis. Color and tonal variations are organized as aspects of form painting, as students search for more insightful ways of deciphering the human figure from life. Through theory and practice, they unveil personal paths to learning. Those willing to invest the time and energy will find that consummate technique can enable students to become artists. Those hours in the life room are irreplaceable. The great laboratory of the long pose allows one to know oneself: how you dissect the painting language, reassemble it, and calibrate it to your own temperament. These issues must all lead to a kind of ever-present thrill in the act of painting the human organism—without enjoyment, the fire behind the willingness to see may dim to an ember.

Fine performance in the life room is the result of absorption, demonstration, and transcendence of the visual technical language. Without considering much of this teachable, a painter's work may be ridden with ignorance and unintentional awkwardness. A painter's work should be a form of elevated artistic expression, a confluence of feeling and the ability to turn this feeling into a treasured visual artifact. As a subject, I see the human figure as the source: the origin of inexhaustible design principles, science, and aesthetics. Painters search the sublime body with a technical refinement that is based upon training, on exercises in the life room. By challenging their technical aptitude, painters are adding to the capacity of their artistry. Using a brush and colors to interpret the living—which we call painting from life—painters work from direct observation. All the glory that one could ever seek is bound up in the act of painting, as a trance-like engagement compels the painter to channel his or her response to a canvas. The human figure, as the total embodiment of grace, is the greatest form in art.

The human figure in its purest state, the nude, has always been a marvel. The enigma of an artist re-creating the living essence of the figure within a drawing, a painting, or a representation in sculpture goes deeper than mere appearance. Artists venerate the nude as a form born of the same mythic forces that shaped this world. The mysterious beauty of the figure predates art. By closely observing the nude on the model stand, in endlessly flowing emotions, there is a feeling, a rapture, that overwhelms the artist at work. The expression of the figure, so based on mental feeling, echoes through the body in rhythmic currents of weight, suspended in a pose. The attitude of the figure becomes the likeness and mirror of that person, as in body language. We know this because we are the human figure. Figure painting is therefore an attempt to come to terms with what makes us beautiful, by discovering a more profound beauty in the human being before us.

Opposite
Dan Thompson
Kitakiya
2014, red chalk, 15 x 22 in.

Dan Thompson
Untitled
2008, graphite pencil, 23 x 17 in.

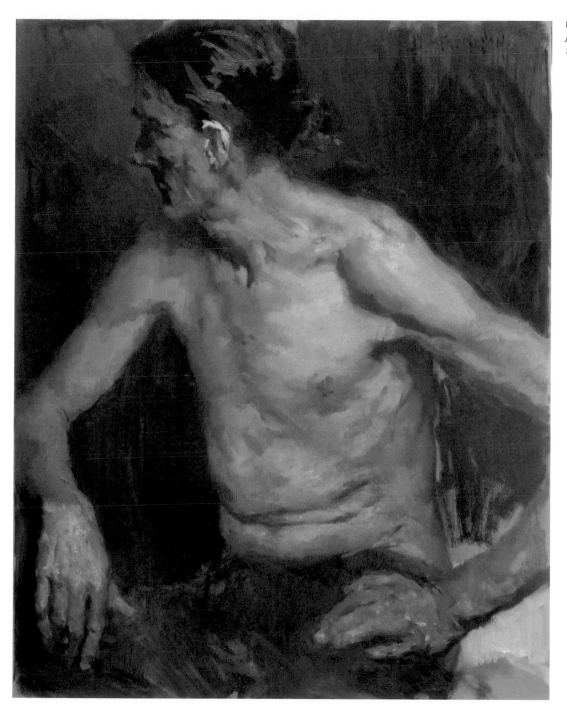

Dan Thompson
Dream of Yusef
2009, oil on linen, 40 × 30 in.

Opposite
Dan Thompson
I against I
2003, oil on linen, 32 × 28 in.

Dan Thompson
Apotheosis 1
2013, pen & ink, 17 x 12 in.

Opposite
Dan Thompson
Persian Archer
2004, oil on linen, 28 × 18 in.

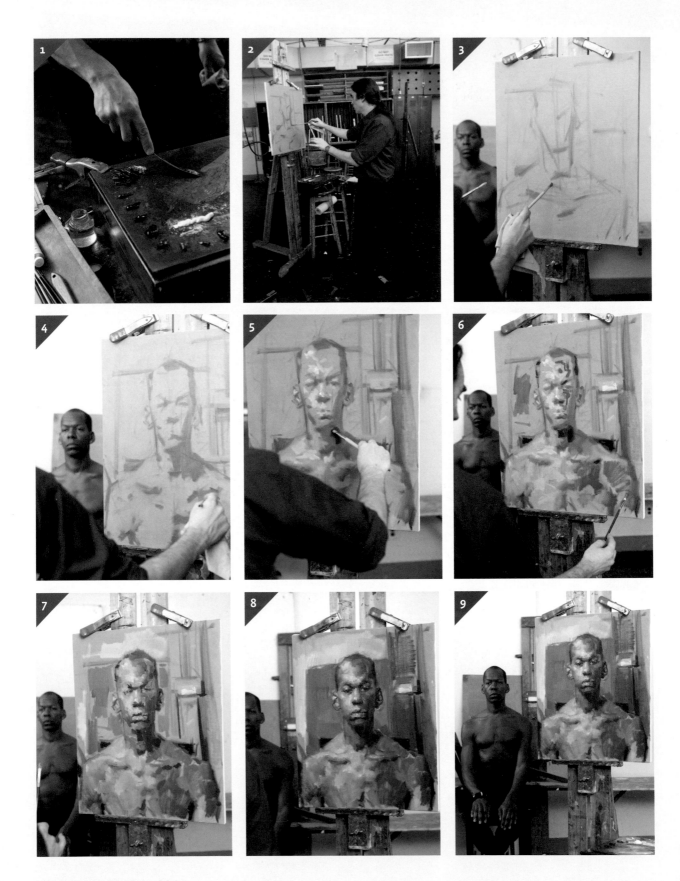

A LESSON IN PRINT:
DIRECT PAINTING A PORTRAIT BUST

1. Begin the painting process by making your materials versatile. Do this by preparing oil paint as a "drawing color." Try raw umber as your dark and cremnitz (lead) white or flake white as your light. A white oil color, such as real lead-based white, will possess a heaviness that is reminiscent of plasteline or clay—it is almost unworkable. Take a palette knife and spread out plenty of white and raw umber mixed together; make a tonal range from dark to light.

Then add medium mixed from 1 part stand linseed oil and 7 parts mineral spirits. As medium is added, the viscous mixture turns watery. Your job is to find the delicate balance where oil can act as line without dripping off of your canvas but can also hold its mark without seeming difficult to move. The amount of medium added will vary from canvas to canvas and from painter to painter.

2. Begin the activity of painting by considering gesture. Gesture is life: vitality, personality, and character. Above all things, search for ways of utilizing simple linear strokes to determine the action of the body. Consider building an armature or large format of the pose on your toned canvas. Your brushwork will be huge in relationship to the size of the canvas, necessitating medium- to large-sized brushes. Work with conviction; the challenge before you is worth the effort—your solution will be unique and self-revelatory. As your linear construct develops, think about the way that extremely long lines of both figure and environment interact. They do not always do just one thing, depending on what you include. The way that you place the longer lines will determine composition, which is really emphasis. Strike a compelling arrangement—observe how a variety of diagonals and different intersections of lines keep your eye moving.

3. If you reach a point of visual intrigue, expand the process by leaning into the side of your brush a bit and articulating shapes. In the formative stage, one tone for all dark shapes will do.

4. The lights may all be determined by contrast with your gray-toned canvas. Squint constantly as you work. Compare all shapes for proportional refinement, and try not to repeat their sizes. Do not vary edges yet—clarify the edges as sharper, precise statements in paint.

5. As the piece develops, focus on the body as a structural form in space by expanding your range of oil tones into a full grisaille. The corners of blocklike human form can be accented with lighter strokes to define structural alignments. Do this where you see highlights on the bony landmarks of the body that can crystallize the locations of mass for you. It will be upon these important decisions that any planar study can be based.

6. After scrutinizing the tapering planes of the human figure, set a wooden palette on your taboret with all the oil colors that you need. Back away before mixing a single color, and mentally organize a few massive colored areas. These areas will comprise the effect of light on your model. You may use either a brush or a palette knife, but scan your subject as you initiate the colored areas on your painting to harness the visual impression. React to the colors in a bold, unapologetic set of statements.

7. Tune the colors as a musician would his or her instrument. Do this by keeping things simple and repainting the areas until you have an effective arrangement that seems characteristic of the figure before you in that light. Next, begin issuing color changes within each larger area that seem substantial. These will bridge the massive statements and the details that follow.

8. While painting colored variations, pay attention to your brushstroke. Try to flesh out the surfaces of the body by reviving your planar study in an interdisciplinary analysis of color and plane. Later, search for rhythm as a way of eroding the planes and uncovering a morphological basis for details.

9. The finished work.

STUDENT GALLERY

Alisyn Blake
Dancing on the Fringe
2013, oil on linen, 16 x 16 in.

Bottom
Sergio Verdeza
Figure Study
2014, oil on wood panel, 9 x 12 in.

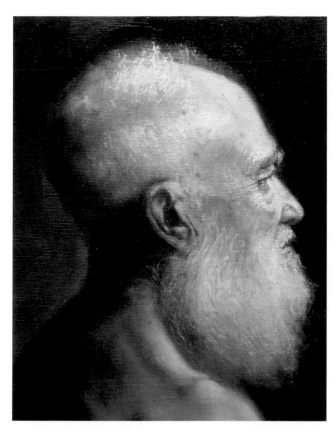

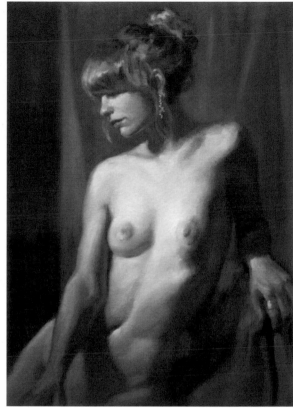

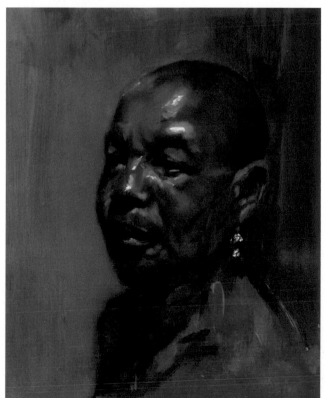

Top left
Jason Fondren
Tram
2013, oil on canvas, 16 x 12 in.

Top right
Roy Mendl
Marissa
2011, oil on linen, mounted on board, 20 x 16 in.

Bottom
Daniel Da Silva
Female Portrait
2014, oil on panel, 10 x 8 in.

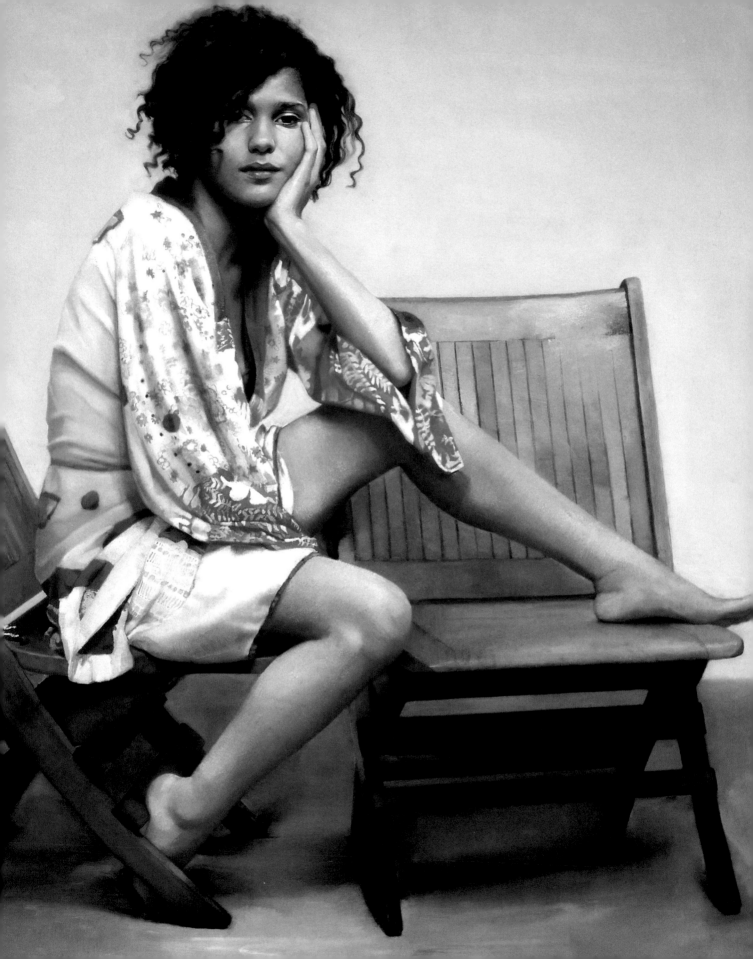

SHARON SPRUNG

Sharon Sprung attended Cornell University before training at the Art Students League and the National Academy of Design. She has had numerous solo exhibitions at venues that include Gallery Henoch in New York City and the O'Kane Gallery of the University of Houston, Texas. Her work was featured in the exhibition *Self-Portrait and Portrait of an Artist from the 18th to the 21st Century* at the Museum of the Russian Academy of Arts in St. Petersburg. Her work was selected for the Smithsonian's Outwin Boochever Portrait Competition. She is represented by Gallery Henoch and Portraits, Inc., in New York City.

Sharon Sprung
Zeli
n.d., oil on panel, 36 x 36 in.

SHARON SPRUNG

Figure Painting from Life in Oils

I first attended Cornell University in the Art and Architecture Department and soon became unhappy and disappointed with the scope and level of art instruction. After a year I left to study full-time at the Art Students League and the National Academy Museum and School of Fine Arts. They appeared to me to be the only places where I could get instruction at the depth and sophistication I wanted. I was not disappointed. It worked for me. Today I work in a large studio that shares the upper floor of my home in Brooklyn with my bedroom. There are two sturdy easels, a wheeled sculpture stand for my palette, a big old lithographer's table, and half a dozen large bookcases where I keep all my art books. It is very spare—I like the emptiness and quiet—with white walls and no other distractions except for the painting on the easel. I have a large, north-facing skylight that brings in a beautiful, diffused light. The one exception to the quiet is a corner of the room where an antique wooden folding screen is festooned with fabrics—colors and patterns from all over the world. I have a very large palette with plenty of room to mix paints, but I use a very limited range of colors.

My palette—my color system—is simple and limited. I use flake white, yellow ochre, raw sienna, permanent bright red, ruby red, scarlet sienna, alizarin crimson, raw umber, burnt umber, red umber, Payne's gray, and cobalt blue. That's it. I paint in oils, predominantly. They are so rich and complex, and I often feel that I will never be able to tame them. The surface I work on is a wooden panel with an oil ground. I work a lot with a palette knife, and I like the hard, strong surface.

I prefer to work from life, but sometimes use photographs and drawings as visual aids and color studies. Working on a few different paintings at the same time prevents me from becoming obsessive—too focused on any one piece. At the same time, it gives me a useful emotional distance from each work. I work from a posed model for as long as possible, and then I like to be alone to sort out the painting's completion. Following the time-honored practice of "fat over lean"—increasing the quotient of oil in the painting medium with each layer—my approach is basically the same, except that because of the strength and solidity of the panel, I can use more powerful strokes and wield the palette knife freely.

When I was given an opportunity to teach, I realized how much I enjoyed it and how much *I* could learn from the experience. Even now—almost forty years later—I find teaching painting almost as rewarding as painting itself. Teaching keeps me fresh and maintains my integrity as an artist. I had two very different formative teachers: one who taught technique and the other who found a way to convey what being an artist means. Daniel Greene and Harvey Dinnerstein were my mentors. Their example continues to inspire me to this day.

We all develop our own styles of teaching. My class works from a live model over an extended period of time. I deliver lectures when appropriate, about subjects like anatomy, to inform specific areas of interest related to the current sitter. I might also demonstrate color mixtures or how to approach the painting of drapery. I give talks and lectures on many diverse subjects: particular artists, the history and chemistry of paint, and different working methods. Some lectures are prepared beforehand, designed to elevate the class to the next level, and many are impromptu and extemporaneous,

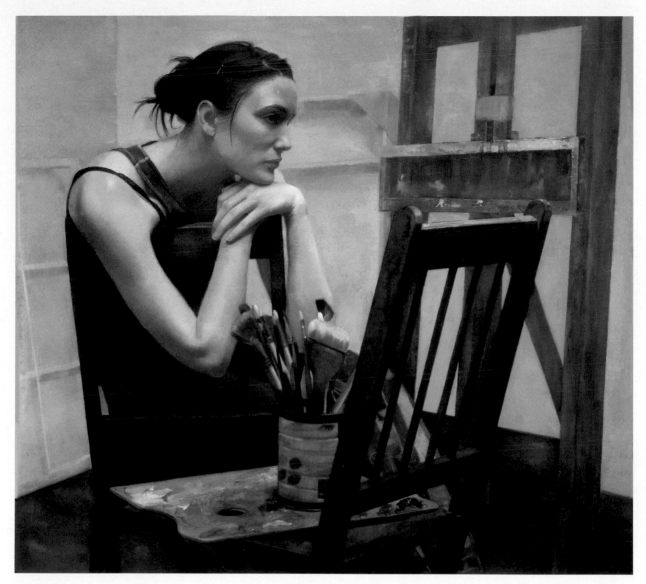

Sharon Sprung
Art Student
n.d., oil on panel, 40 x 42 in.

growing out of the moment. I strongly believe in the value of frequent demonstrations to show the students the way.

The best advice I can give them is *work hard and long from life*! In teaching I like to address my comments to the individual, to help them envision a place where they would like to go with their work. It is about getting further—teaching people how to see, how to interpret what they see—and finding a place of depth and sensitivity from which to work.

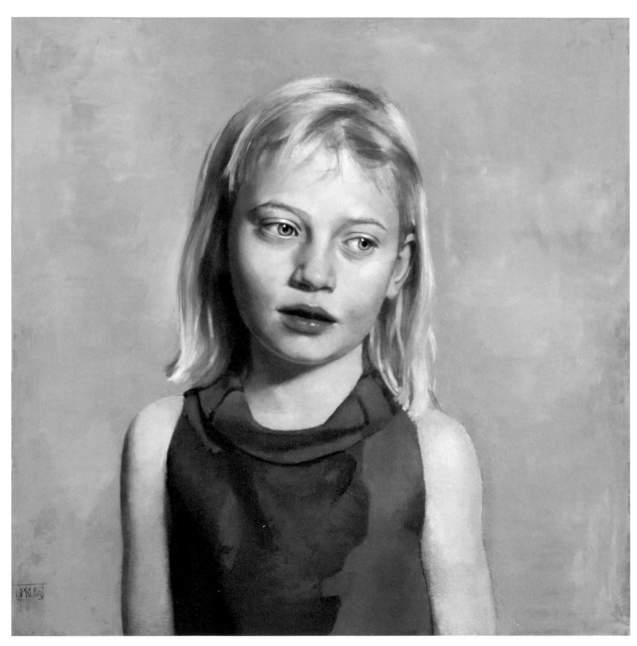

Sharon Sprung
Portrait of L
n.d., oil on panel, 22 x 22 in.

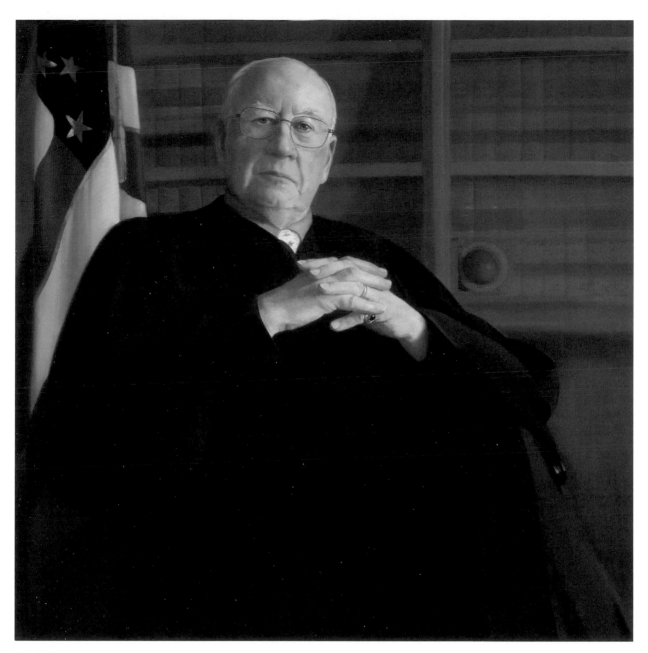

Sharon Sprung
Portrait of the Honorable John Keenan
n.d., oil on panel, 40 x 40 in.

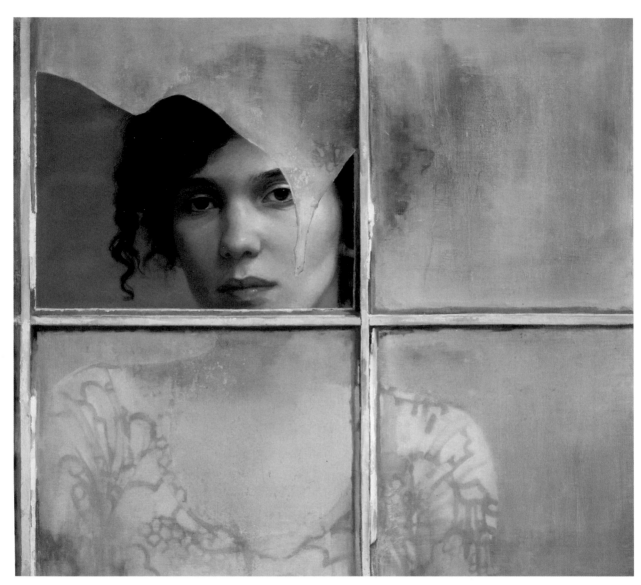

Sharon Sprung
Windowpane
n.d., oil on panel, 22 x 22 in.

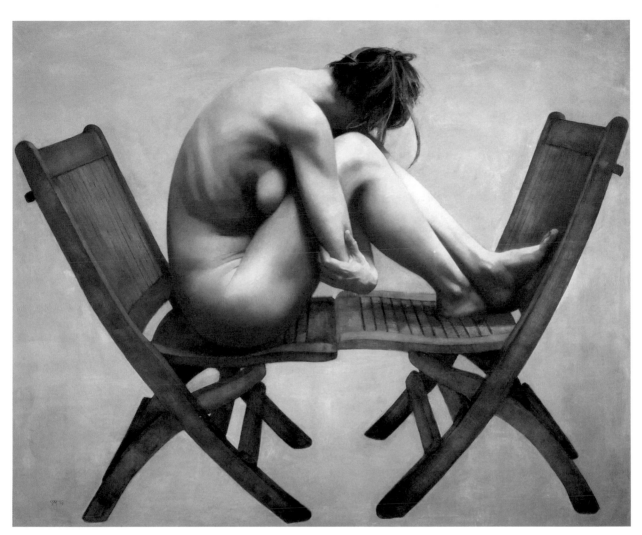

Sharon Sprung
Folding Chairs
n.d., oil on panel, 36 x 47 in.

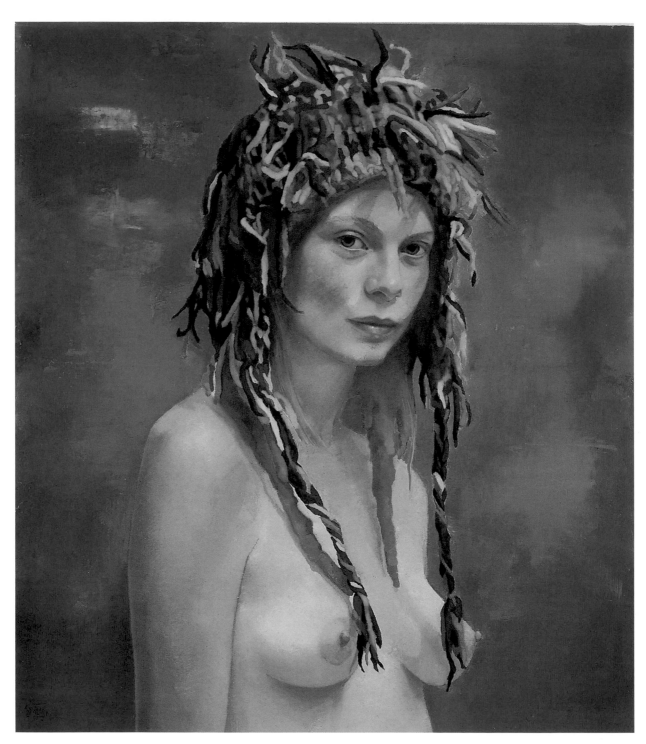

Sharon Sprung
P
n.d., oil on panel, 32 x 28 in.

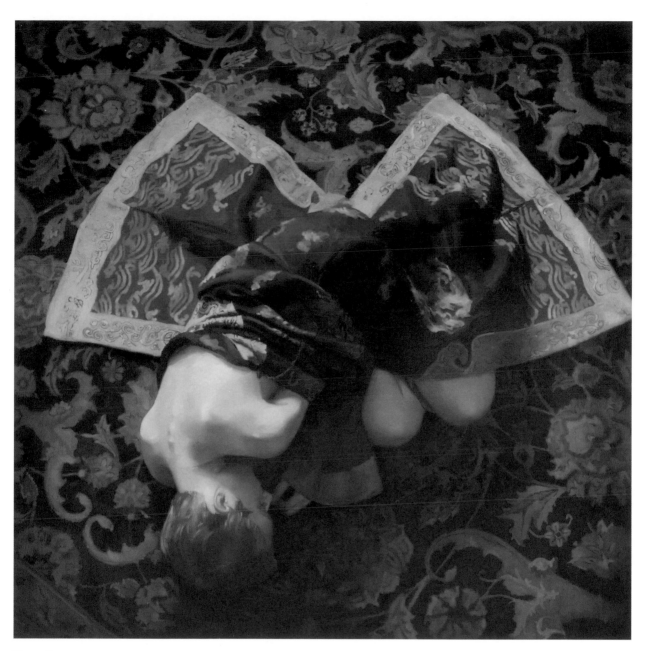

Sharon Sprung
Callas
n.d., oil on panel, 40 x 40 in.

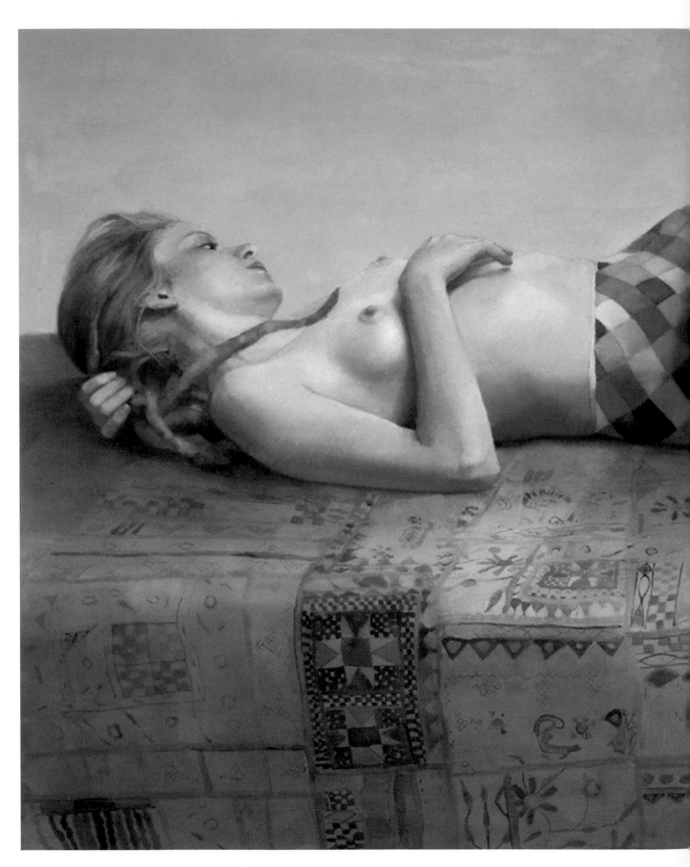

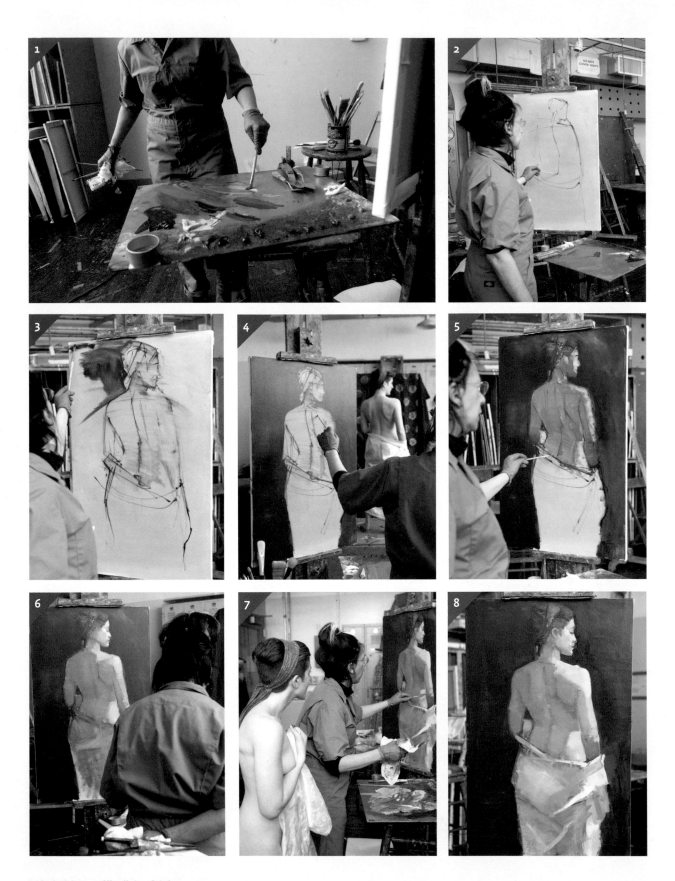

A LESSON IN PRINT:
OPENING MOVES—PAINTING FROM A NUDE MODEL

A demonstration I might do in front of my class would be a three-hour study, starting with movement and openness in the pose. I like to start my own paintings with physicality and energy. If the initial notes ring true, each subsequent layer that develops into a finished picture just adds truth and resonance to the opening moves. My advice to everyone is to look harder, look more than you paint. Immerse yourself in the visual world. Ask a lot of yourself, but without negativity and self-doubt. You need to risk being wrong if you ever want to be right

1. The palette and setup are very important. I use a limited palette for the flesh tones: flake white, yellow ochre, Mars yellow, raw sienna, permanent bright red, ruby red, scarlet sienna, alizarin crimson, raw umber, burnt umber, red umber, Payne's gray, and cobalt blue. My paints are handmade by Vasari Classic Artists' Oil Colors, and have beautiful saturation and texture. Notice how the paints line the external edge of the palette to allow me maximum space for mixing large quantities of paint with a palette knife, then brush mixing to form smaller puddles of related colors. I place the palette between where I am standing and the canvas. This prevents me from working too close to the surface of the painting. Standing up to work is best. Remain at a good distance from the work and keep moving.

2. After posing the model, I position myself parallel to the picture plane. Starting with a gesture drawing using only rough lines, I make a sketch using Payne's gray mixed with turpentine. Movement and composition are the most important considerations at this point. I strive for fluidity, working *all over* the canvas, trying to get the life and the essence of the pose. Gesture is emotion in movement. I begin by making a very loose drawing of the figure. Next I start laying in the background. Drawing the model and the space around her at the same time is essential to balance the dynamic exchange between the *positive* and *negative* spaces.

4. Having used line to redraw and solidify the figure as well as the negative space, I begin to construct the figure from the inside out starting with the four curves of the spinal column: the cervical, thoracic, lumbar, and sacral regions. I then add notes in line about the anatomy of the figure to add weight and authority to the pose.

5. I then analyze the tonal values and colors that make up the figure, focusing on how the relationships between specific shapes reveal the anatomy. Finding the darkest value in her hair, I set up a relationship between it and the value of the flesh in the shadow next to it. I mix puddles of paint, which can be manipulated to make colors that are darker, lighter, cooler, warmer, more chromatic, or less chromatic. I consider the masses of color in terms of shadow, half tone, and light. It is initially important to work quickly to cover the canvas, block in the colors, and balance the tonalities. Beginning to really understand my subject, I continue to make the boldest statements possible. Being in constant motion is crucial. I work fluidly, imagining that I am dancing on the surface of the canvas.

6. Then I concentrate on refining the patterns of shadow, half tone, and light to give the figure a sense of volume, a three-dimensional form. At this stage one must pay close attention to specific value relationships—patterns of light and dark—to impart greater truth to the image.

7. I like to use a palette knife to cover a larger area more quickly than with a brush. I find this helps me rapidly establish patterns of movement in light and dark. The palette knife also helps me to apply the paint with thickness, richness, and opacity.

8. This is a good start for a three-hour session. If I were at home in my own studio, I might continue to refine and develop the drawing, correcting the shapes, values, and colors of the shadows. This is a beginning, a loose, emotional start.

Robin Smith
Peter
n.d., oil on canvas, 20 x 20 in.

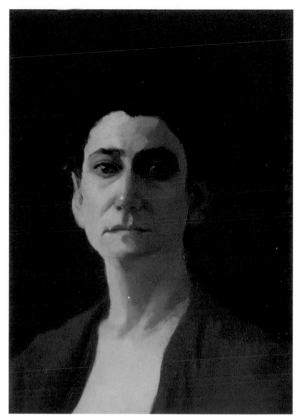

Sun Shim
Liz
n.d., oil on canvas, 20 x 16 in.

Eleanor Adam
Erin
n.d., oil on canvas, 20 x 16 in.

FREDERICK BROSEN

Frederick Brosen's watercolors have been the subject of over thirty solo exhibitions in galleries and museums across the country, most recently at Hirschl & Adler Modern and the South Street Seaport Museum, both in New York City, in 2012. His work is in the permanent collections of over a dozen major museums, including the Metropolitan Museum of Art and the Museum of the City of New York. From 2005 through 2006 the Museum of the City of New York held an exhibition of his work in conjunction with the publication of a monograph of his New York City watercolors, *Still New York* (Vendome Press, 2005). Currently two of his paintings are featured in *Coney Island: Visions of an American Dreamland, 1880–2008*, premiering at the Wadsworth Atheneum and traveling to several museums, including the Brooklyn Museum in November 2015. A show of his recent works of Rome, Italy, is scheduled to open at Hirschl & Adler Modern in March 2016. Brosen has taught at several major art schools, including the National Academy of Design, Lehman College, and Pratt Institute, where he earned his MFA in 1979. He has been teaching watercolor painting at the Art Students League since 2008.

Frederick Brosen
East Sixth Street Synagogue
2010, watercolor over graphite on paper, 36 x 24 in.

FREDERICK BROSEN

Classic Watercolor Realism

Since I was a small boy, drawing has provided both a nurturing private escape and a positive sense of identity for me. But until I went to Europe for the first time, on my own at eighteen, that activity largely comprised cartooning, with Thor and Spider-Man as my models. My first time in Amsterdam, at the Rijksmuseum, however, quickly changed that. The Dutch seventeenth-century rooms thrilled, moved, and inspired me. Coming from a Manhattan neighborhood of brownstones, the cityscapes had a wonderful familiarity for me. But it was the combination of great technique and open accessibility in the paintings that I deeply responded to; unlike so much contemporary art of that time, the seventies, you didn't need a PhD or the latest issue of *Artforum* magazine to understand them. They invited you in, let you move around, yet were profound in their understanding of light, color, and form. That combination, beautiful craft and depth of feeling, became the ultimate goal in my desire to become a professional artist.

That desire, that romantic approach, has become the basis of my philosophy of painting; an artist's technique is a fusion of subject and feeling: the subject, technique, and interpretation are indivisible. The artists I fell in love with, like Vermeer, Chardin, and Ingres perfected this way of seeing within their own work; in watercolor, J. M. W. Turner, John Sell Cotman, and John Singer Sargent; there are many others, both well and lesser known.

I also believe that landscape painting is primarily about the creation of space, that people instinctively respond to moving around within a painting, with being pulled into deep space.

In these ways, I am, I suppose, an anti-modernist in that for me the subject and the artist's connection to it are as important as the style. And although a painting should work as a flat design of color and shape on an abstract level, I want my landscapes to pull one into deep space, to puncture the picture plane and create a forceful illusion of depth. I admire authenticity and genuine feeling; I do not respond to the ironic detachment of the current pop culture, and its foundation of insincerity. I want to be moved, transported by great art. I want art that enhances how I look at the world, not a celebration of celebrity culture.

I had formal art training in high school at the High School of Music & Art, then City College of New York for a BFA, and lastly Pratt Institute for my MFA. At that time, 1968–1979, traditional skills were not emphasized, particularly at the graduate level. I did seek out the few professors who were empathetic to my interests, but once I began doing watercolor, in my second year of graduate school, I developed my technique by independently studying the great early masters of the medium. That meant seeking out the work of Richard Parkes Bonington, Cotman, Thomas Girtin, and the great early English watercolorists. I also continued to find inspiration in the cityscapes of the Dutch, and of Canaletto and his nephew Bernardo Bellotto (also sometimes called Canaletto), and in the melancholy romantic landscapes of Friedrich. By the time of my MFA thesis exhibition at Pratt in 1979, I had found my medium, watercolor, and my subject, landscape and cityscape. Over the next few decades, my work has been a continuous development and refinement of these interests.

The technique I derived from this study is based on the early English approach to watercolor. Over hard graphite drawing (4H–6H pencils) many layers of transparent washes, or glazes, are overlaid. The larger, lighter washes are laid in first, usually the sky along with an undertone of a light warm color over the architecture and landscape, which both creates a cohesive color scheme and fixes the drawing. Washes of color are

Frederick Brosen
West 76th Street
2014, watercolor over
graphite on paper, 34 x 25 in.

then built up over this in layers, allowing drying time in between so that each layer is dry enough to be glazed over. The darkest passages and finely resolved details go in last, over these earlier layers. This employs the four main watercolor applications: wet-in-wet, wet-on-dry, scumbling (or dry brush), and point-of-brush (using a fine brush almost like a pen, for final detailing). I employ a limited palette of nine colors, five warm and four cool, because a good colorist is one who can create many colors from a few. This also simplifies your material setup. It is a technique that takes time to master but that provides great subtlety and depth of color.

In my own studio work I do a range of scales, often taking a successful composition through a small study, a midsize work (around 18 x 12 inches), and a larger finished work (from 36 x 24 inches to 30 x 50 inches). I stretch my paper, Arches cold-pressed watercolor paper, by first soaking it in cold water for fifteen minutes and then affixing it to a drawing board with a combination of brown gum tape (aka postal tape) and staples, using a lightweight staple gun and 5/16" staples. This creates a taut smooth surface that will not buckle through several wettings and rewettings.

I mix my colors in separate white ceramic palettes, often premixing enough color to use throughout the entire painting process. This keeps the colors pure and assures they retain their chroma. To prevent the colors drying out, I cover them with plastic wrap overnight. I use a variety of brushes, mostly sable rounds, along with larger squirrel flats for big washes.

As a teacher, one tries to be the instructor one wishes one had studied with as a student. I believe the mechanics of painting are readily teachable: perspective, color mixing, rendering, light and shade, and so on. And this is what I teach, the nuts and bolts of the classic transparent watercolor technique I described above. I emphasize that in watercolor, solid drawing skills are the foundation upon which everything else is built; the transparency of the medium means the drawing will remain your guide throughout the painting process. In some cases I may recommend a drawing class before a student is ready to begin my class. My students are free to pursue any subject they choose, and to evolve their own style over time. They may use any reference they choose: drawings, still life, photos. Copying the work of past masters is a great way of gaining insight into the painting process and often may provide greater insights than I can. I do not enforce my preferences on my students' work. I have no desire to create acolytes but to help students develop their paintings according to their particular passions and interests more effectively. Because this approach creates a healthy diversity within the classroom, I encourage a mutually beneficial exchange of ideas between students. The environment then becomes an open and supportive, rather than a competitive, one.

The luminosity and nuance of watercolor make it perfectly suited for landscape and architectural subjects. Working over a preliminary graphite drawing, students are taught a classic transparent wash technique, allowing for a subtle buildup of light, shadow, and local color. The separate elements of landscape—skies, trees, and architecture—are addressed, all with the goal of combining cohesively the particulars into expressive paintings.

What I do not believe is teachable is poetry. The challenge of every aspiring artist is to acquire the necessary foundation of skills and technique, and then to develop a unique personal expression employing those skills. I can help a student gain those skills, but I cannot give a student the vision it requires to transcend technique and become an expressive and unique artist. The technique, the first part, takes time to develop, and is the requisite vehicle needed for the more challenging step, the personal expression, to have a chance to emerge.

Throughout the course of the school year, I integrate lectures, demos, and selective museum visits into the

in the seventeenth to those in the twentieth centuries, and are not always watercolorists. As much as verbal explanations help, class demos remain an essential teaching tool. My classroom demos usually are done over two sessions in which I complete an entire small-scale work. Seeing the painting process from beginning to end allows the students to understand how to sequence the layering of washes, a crucial aspect of watercolor painting. Experienced artists do many, many small or unconscious things in their painting process that can only be revealed by observing the work in progress. One demo is worth a thousand words.

On a grander and more venerable scale, this is what the Art Students League uniquely offers its students: a diverse and inclusive range of approaches, taught by an accomplished faculty of working professional artists. Whatever your aesthetic direction, you can follow it and study it in depth in an atmosphere of encouragement, engagement, and mutual respect. And it remains an affordable school to attend, located on 57th Street in Manhattan! Now that is indeed unique.

curriculum. When you admire an artist's work, it is always illuminating to know the circumstances of the artist's life. Understanding the context of the work enhances our appreciation. The artists I discuss range from those

Frederick Brosen
Astroland
2008,
watercolor over graphite on paper,
32 x 54 in.

Frederick Brosen
West 10th Street
2012, watercolor over graphite on paper,
34 x 40 in.

Opposite
Frederick Brosen
Temperance Fountain, Thompkins Square Park
2011, watercolor over graphite on paper,
38 x 26 in.

Frederick Brosen
72nd Street
2013,
watercolor over graphite on paper,
32 x 52 in.

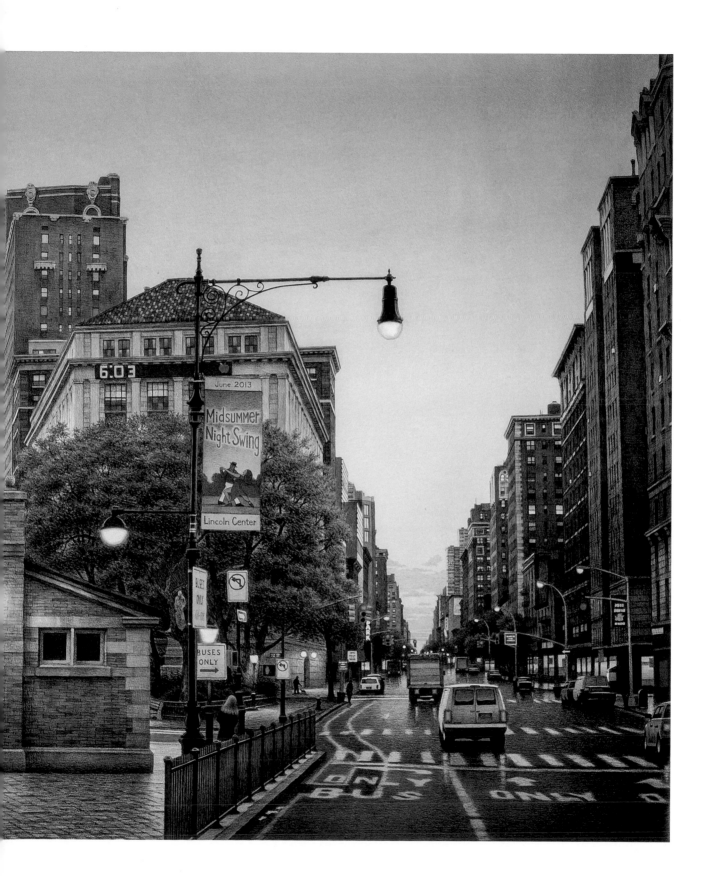

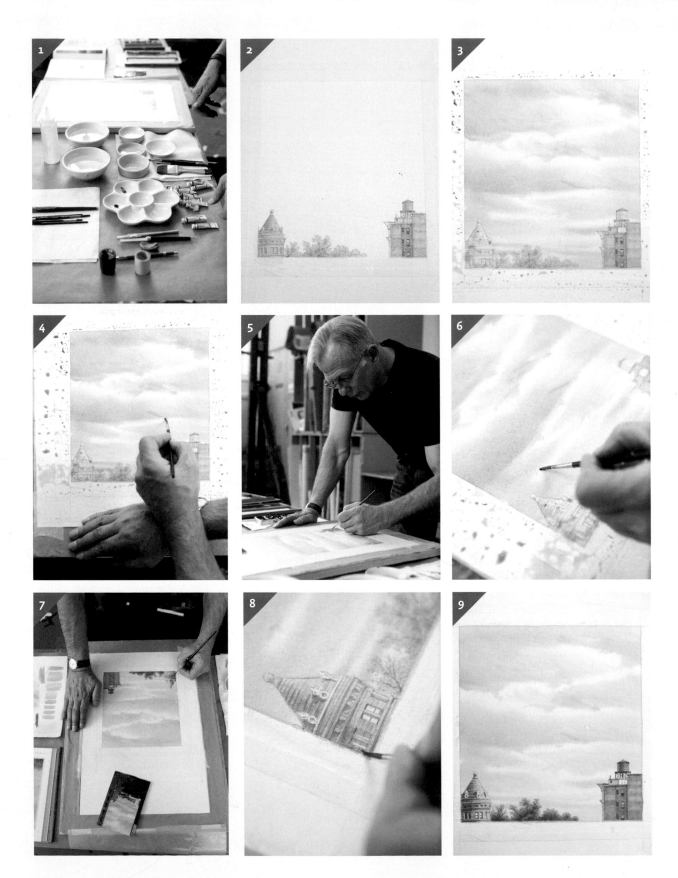

A LESSON IN PRINT:
WORKING FROM PHOTOGRAPHS IN WATERCOLOR

1. The first image shows my painting setup as I prepare to begin. In the foreground a ceramic butterfly palette, mixing bowls, and two bowls of water are laid out (note that I am a lefty). Farther back along the table is the stretched sheet of Arches paper affixed to a drawing board.

2. This image reveals a 4H graphite drawing over which I have laid a very light wash of pink (very diluted Winsor red) and taped the border with Nichiban artists masking tape, an excellent masking tool.

3. Now I am ready to lay in my sky. Working wet-in-wet with a 2" squirrel flat, I paint a warm undertone over the entire painting; purple-blue-gray is applied in descending bands to create cloud shadows. Note the excess splatter on the Nichiban tape. This will be removed once the tape is lifted.

4. The structure of the clouds is defined by the careful addition of the background blue, creating edges and highlights.

5. After the sky is thoroughly dry, the local colors of the architecture are applied using a variety of warm color: burnt sienna, permanent rose, raw sienna. Note that, as a left-hander, I have my brushes and palette to my left. Also note that I always work flat, and standing. In my own studio I work on a large architect's table, which allows me to both stand comfortably and tilt the board at different angles when required.

6. The sky is done in one initial wet-in-wet layer, the undertone applied first, cloud shadows after that, and finally the background blue of the sky itself. Given sufficient drying time, the entire area can be rewet to deepen colors and articulate edges. I have found that this approach allows for soft evocative edges when painting skies, and edges and masses are what it's all about!

7. The aerial view shown here is revealing. Think of a workspace like a musician's keyboard. Everything is in its place. To the left, the same side as my dominant hand, we see my paints, mixing bowls, water, and brushes. In the center, I work on a stretched sheet of paper. Notice the sheet of glycine tissue paper folded back. When I have completed my work for the day, the paper is folded forward to cover and protect the painting's fragile surface. A photo reference rests casually above the painting, which I am not copying but rather allowing to inspire me. To my right is a copy of my book, open to my painting of Belvedere Fountain. Below that you see a random sheet I am using for testing color swatches. To the right of that is a box of pencils, with a sheet of sandpaper.

8. Back to the details, using a fine brush, here I add deepening colors and modeling to the detail of the architecture. Note how the hard pencil drawing remains visible and becomes integrated into the color layers.

9. This image reveals the finished demo, without the taped border, showing the juxtaposition of the soft sky forms, filigreed tree edges, and the sharper contours of the architecture. The use of the cool sky colors against the warmer tones of architecture creates a tangible sense of foreground and background space. The final detailing and texture of the landscape are done in darker colors with point-of-brush, articulating detail and scumbling textures.

Christine Yost
B&H Dairy
2013, watercolor on paper, 9 x 12 in.

Top left
Stephanie Mead
The Ascent
2013, watercolor and ink on paper,
30 x 22 in.

Top right
Stephanie Mead
Seagulls and Sirens
2012, watercolor and ink on paper,
30 x 22 in.

Bottom
Molly Honigsfeld
Brooklyn Bridge Foggy Morning
2014, watercolor on paper,
14 x 21 in.

NAOMI
CAMPBELL

Naomi Campbell has worked in watercolor for well over two and a half decades. A graduate of Champlain College in Quebec, Canada, Campbell also studied at the University of Guelph, Canada, and the School of Visual Arts, and subsequently received her classical training in painting, drawing, and printmaking at the Art Students League of New York. She is a signature member of four internationally recognized organizations, including the National Watercolor Society and the Transparent Watercolor Society of America. She often contributes to art publications and is an invited guest lecturer at prominent art colleges and organizations. Campbell has won numerous national and international awards, including four honorary gold medals, for her work, which has been discussed in many international periodicals and over eighteen book publications.

Naomi Campbell
Open Worlds
2014, ink, acrylic watermedia, and graphite on Mylar,
22.5 x 36 in.

NAOMI CAMPBELL

Working Large in Watercolor

My first exposure to art began in early childhood growing up in Canada. I was free to explore the natural world, taking every opportunity to do so. I naturally gravitated toward art and science. My aunt, who received her degree in the academic fine arts tradition in England, imparted her vast knowledge to me early on in my life. Both sides of my family have included several generations of professional artists, dating back to the early 1700s in England and Japan, many of whom have had an influence on my life.

One of the important elements that came into particular focus in my work was water. As a child, I observed the refractive nature of water droplets and the physiological flow of the rivers around me. Consequently, it is no surprise that watercolor became my first two-dimensional medium. Working with water as an element is critically significant to my work as an integrative artist. With over twenty-nine years of working with watercolors, it now feels like an extension of my life.

Philosophers and scientists alike have all recognized and explained the essential nature of water. It exists as one of the sources of life. Water is both cataclysmic and life-giving. Water is often aligned with mystical aspects in cultures and with the world of science. The dichotomy of transparent washes has always been compelling to me, capable of both sensitive passages and unmistakable power. Today, watercolor is no longer a medium relegated to subjects of fragile flowers or delicate biological renderings. For me, this medium has evolved into its own distinct language.

Duchamp and Mondrian have always been two of my major influences. The computer is the third influence. It has changed time and space in a virtual way, and I use it myself in my work today. Mondrian and Duchamp were the precursors to this way of thinking.

Computer-generated virtual images are producing a visceral urban condition that is both good and bad, in my opinion. The computer has created a new language of form that exists in virtual space and real time at once. In my work, I use the computer while the subject of my artwork often investigates the body. Through this new world of virtual gaming, technology, and social networks, computers have created a new altered state of reality that I use in my work.

When I work outdoors in natural light as opposed to working in the studio, it adds to my perception of color and to the spontaneity of watercolor's process-based approach. Watermedia leave behind a footprint on the paper's surface that is clearly visible, recording the slightest hesitation in a stroke. This mapping of paint left for the viewer to scrutinize makes the mark-making process in watermedia a kind of public expression. This transposes the act of painting to a transitory form of expression that is not necessarily a means to an end. I use this process to open up an inner dialogue between form and memory, and light and time.

I am interested in the universality of color—especially how it is defined and viewed. My own work has gone through several periods of different dominances of color. I began with a dynamic range of color that transformed into a "starved palette" of neutral grays and have recently shifted to a brighter palette that moves the viewer into a newer state. I always feel the viewer should be transformed into a heightened state of awareness.

My particular approach to paint is all very personal and unique to my hand, as it is unique to one's own

identity. My personal history and its relationship to the ever-changing world constantly forms new connections with my work.

Size often enters into the equation when working in watercolor/watermedia. This becomes self-evident when dealing with gravity and organic flow of the medium. The transparent properties of the compounds, the temperature, and the humidity in the air all affect the resulting colors and their interactive properties with one another. This also includes the physical and chemical properties. The character of each particular substrate adds to this diversity of results, further compounded when large-scale surfaces come into the equation. In the past I have found that the transparent nature of rice paper as one substrate further compounds the immediate quality and flow of the paint, as does the slippery surface of Mylar, which acts in opposition to the former centuries-old surface. Watercolor is so responsive to its surrounding physical conditions and materials—yet another reason why I have come to enjoy this medium.

In the past, I have often worked large. The larger the work, the more your body's movements become a part of the history of the mark-making, and these movements lend to the performance elements that engineer your final results. The movement is all documented through the brush. There is no hiding in watercolor; everything is laid bare for all to see. The larger the work, the more water you find yourself using in order to orchestrate your ideas, and the more your work begins to resemble a scientific experiment.

My studio is in a state of constant flux. Half the time, my studio looks like a lab. I like to call it my work in progress. Its constant metamorphosis from one project to another is something on which I thrive. As an integrative artist, I find this the perfect environment for my creative process. My background in science has also permanently influenced my workspace.

My current studio is luminous with a north-northwest exposure, the type of light that allows me to explore form, color, time, and space. Like most artists, my work schedule swings on a pendulum. In my present work with Plexiglas, the light required for each project dictates my lifestyle to a great degree. When not traveling or working on site-specific public or corporate commissions or exhibitions, I am always conducting research in the studio. It is an integrated central hub—artist studio and science lab.

Water moves my work and my life and continues to move my art in new directions.

Naomi Campbell
Untitled (When Mentioning My Name)
2012, watercolor and graphite on paper, 17 x 25 in. Photo credit: K. Kunstadt.

Naomi Campbell
Erasures
2013, acrylic watermedia on canvas, 48 x 72 in.
Photo credit: K. Kunstadt.

Naomi Campbell
The Clock
2014, watercolor, acrylic watermedia,
and graphite on watercolor paper, 92 x 42 in.

Naomi Campbell
Untitled I
2014, acrylic watermedia, 48 x 22 in.

Naomi Campbell
Conversations with the Body
2012, ink and graphite on Mylar, 36 x 72 in.

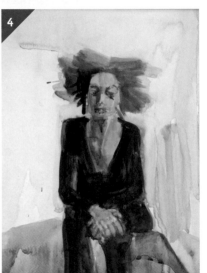

A LESSON IN PRINT:
STUDENT GALLERY WITH CRITIQUES

As a professional teaching artist at the Art Students League of New York, I keep the discourse for my students focused on painting today. The list of my past and present students includes numerous art professionals and specialists employed by renowned art museums as well as professionals in many other disciplines. This invites a platform of diversity of approaches to watercolor that I welcome in the class. The craft or technique of painting is important to beginners in watercolor. A handful of new students who join my class may lack the prerequisite experience but rapidly learn to draw with the brush and lay down shape. Painting everything from life, my students eventually move beyond the general constraints of craft while learning about art history and art theory, fundamental foundational tools of art. Initially I acquaint the beginner with composition, spatial relationships, and the malleable forms of space. I then introduce the history and contemporary ideas as a bridge. For me, the act of painting is the execution of an awakening idea. I agree with Maya Lin that for the artist the research portion is the longest and hardest part of the work.

1. Using the construction of light to track memory, Yoko Wakabayashi adeptly minimizes value and color to help carry a mood in *Light and Transparency*. The fluid transparency in the watercolor lends itself to an ethereal effect that allows one figure to haunt the other in succession.

2. In Holly Fields's *Meditation #1 (for Naomi)*, provocative, brooding, and often bright colors overlay one another in a seemingly delicate manner while boldly deconstructing the form. The complex use of neutrals and layered saturated colors creates a labyrinth of form and space through a ponderous process of abstraction.

3. Beverly Sealey's still life paintings boldly express an irresistibly rich and subtle gestural play of organic color over form that draws you into the work as it mysteriously suggests a greater depth at play in her objects-based paintings. Her watercolors typically evoke the many senses, including the sense of taste.

4. In *Pigeon*, art student Marsha Dorin's combined strong representational and abstract expressionist background yields energetic and powerful expressions of the body through passages of bold color; deft, expressive brushstrokes; and aqueous color. Making a powerful statement through psychological gestures, she looks at the body from within as well as from without.

5. Yuko Takei makes use of volume in space through strong use of negative space, composition, and an uncanny feel for color. Working with her on recent three-dimensional watercolor paper sculptures, in which she excels with the same degree of success, has moved her into thinking more abstractly.

1. **Yoko Wakabayashi**
Light and Transparency
2013, watercolor on watercolor paper, 13.5 x 17 in.

2. **Holly Fields**
Meditation #1 (for Naomi)
2013, watercolor on watercolor paper, 10 x 10 in.

3. **Beverly Sealey**
Singing the Blues
2013, watercolor on watercolor paper, 10 x 12 in.

4. **Marsha Dorin**
Pigeon
2013, watercolor on watercolor paper, 12 x 8 in.

5. **Yuko Takei**
Amaryllis I
2013, watercolor on watercolor paper, 9 x 22 in.

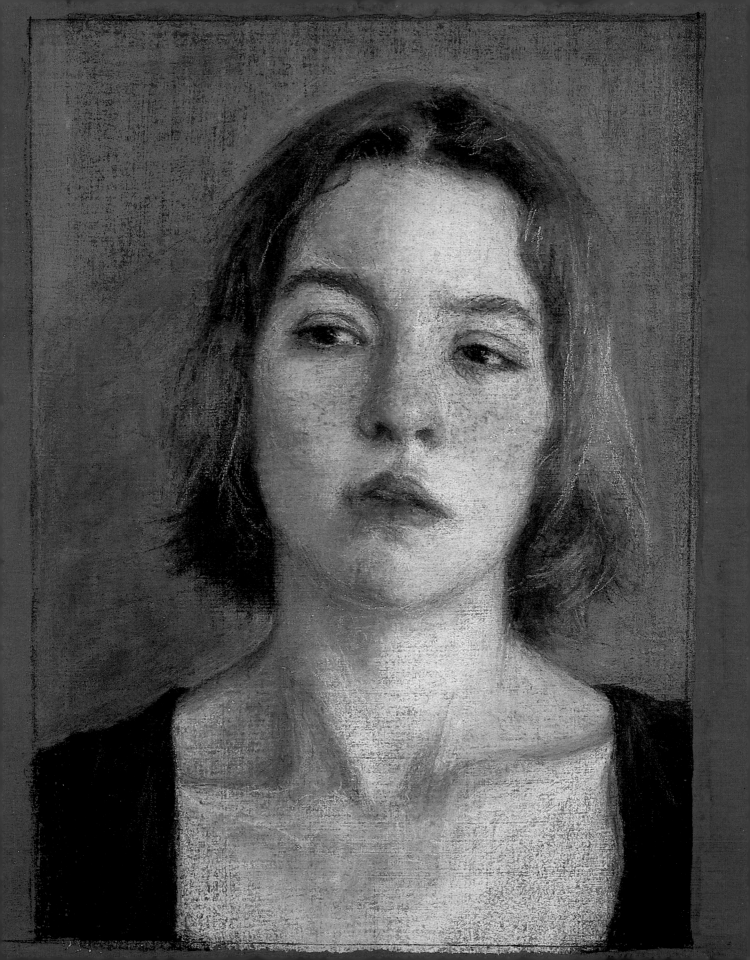

ELLEN
EAGLE

Ellen Eagle works primarily in pastel. She earned a BFA with Distinction in drawing from the California College of Arts, and studied with Daniel Greene and Michael Burban at the Art Students League of New York, later working as monitor and class assistant to Harvey Dinnerstein, who became her primary mentor. Eagle is represented by Forum Gallery in New York.

Ellen Eagle
Ashley
2005, pastel on pumice board, 6 x 4.5 in.

ELLEN EAGLE

Poetic Realism in Pastel

I did my first drawing at the age of four. I started by drawing objects in my home for which I felt affection and whose shapes captivated me. A ceramic bird, a worn pair of shoes, a book. Small items. The intense focus of looking and drawing was a sublime experience. Drawing time was unlike any other part of my day: it was preserved for private, singular, quiet exploration, and I was transfixed. The purity of the endeavor—gazing upon my subject and drawing my impressions—and the joy and connection it engendered felt absolutely sacred. Eventually, I started to draw my mother and father, and my brother. Then, my friends began to sit for me. Now that I was drawing people, my interest in inanimate objects waned. I revered my parents and brother. That they allowed me to draw them sanctioned my passion for image-making. I wanted to be in my big brother's company all the time, and I'm sure I pestered him. But drawing him while he watched baseball games on television was a way to express my love without annoying him. When I was ten, my mother started taking me to the Art Students League Saturday children's class. When I was twelve, my brother was attending City College on 137th Street. One day he called home to speak to me. He said, "Ellen, I know where in this world you belong." He was referring to the High School of Music and Art, which was on the campus of City College. When the time came, he drove me to the entrance exam and waited outside until I finished the test. These sustaining gifts from my family set the path for my life.

The main focus of my work is the human presence as revealed in natural light. At my easel, taking in my model, I feel as though, just as light is flooding my eyes, the character of the model is flooding my nervous system. I look at my subject very attentively, and I move my gaze across the form, so as to grasp an overall cohesive, harmonious design. A oneness. The strength of a representational painting lies first in the abstract underpinnings of the design. It is very important to maintain that abstract underpinning while, later on in the painting's development, adding an economy of telling details. Squinting while studying the model and the painting clarifies if the abstract design is still holding strong as the details are added.

I do not think much about technique. Though pastel can be applied in a variety of manners, including wetting the pastel with water or alcohol, my approach is a straightforward application of strokes. My focus is on my subject rather than technique. My response to what I see guides my color choices and pastel strokes. As a result, there are areas in my paintings in which the strokes are swift and slender, and others where they are wide and broad. My slender lines suit my representation of the very nuanced and incremental color shifts of flesh. I may use broader marks when laying in clothing that flows softly or hair that is unruly. My application is wholly dependent on what the subject summons from me. I've always had faith that if I pay attention to my subject and paint what I truly feel, without intellectualizing about style, my image will naturally be harmonious, because it comes from a single, true place within.

I paint with pastel, and I draw with graphite. I love the feel of the pastel stick. I love that my fingers touch the pastel itself rather than a holder of some sort. I love that the material I hold transforms into an image. I love creating my tints and shades of colors directly in the painting, rather than on a palette prior

to application. I layer color upon color, commingling strokes to create the colors I observe in my subject. I love to draw, and my drawings are done fairly rapidly and are quite loose. I used to do more formal drawings. Mostly these days, I draw in preparation for paintings.

I paint to find out about my subject. I paint to understand and connect. I see a jawline, a collarbone. It is beautiful. If, with my pastel, I can echo an angle that I see in my model, the color, a touch of light, the feeling of flesh, most important, a sense of life within the figure, I achieve connection. If the figure on my canvas could be breathing, the sense of life within me expands. It is exceptionally gratifying when viewers are stirred by the compassion my paintings express for my subject.

I experience a sense of privacy when I paint, even though I am with my model. So much of the painting process occurs on a subliminal level that I can't articulate at the time it is occurring. The process is wordless and somewhat cloaked. But portraiture is also derived from interplay between artist and subject. And while I paint to explore and connect, I am aware that my model is experiencing private thoughts and feelings to which I am not privy. While great portraiture is revealing, it also presents mystery. We wonder about the sitter and artist. A portrait is alchemy, revelation, and mystery.

From the beginning, the paintings that most fascinated me were portraits of single individuals in mostly plain settings. When we are children, so many of our experiences revolve around learning to socialize with others. Like all children, I suppose, I worried about fitting in. I found it comforting to look at an image of a single individual who was defined in the painting by nothing but the fact of his or her presence. It didn't matter what other people thought of the person. The artist thought enough of the person to want to portray him or her. The artist honored the person he or she painted. The concept

of that relationship between artist and sitter thrilled me.

My studio windows face northeast, which perfectly provides for my love of natural light. In the summer, the light grants me long days at my easel. I try to keep my studio simple and ordered. I need a peaceful atmosphere without distraction in order to access the yearnings that generate my images. The walls are a soft white. I have many boxes of pastels. I generally keep two sets open all the time, and consult other boxes when I need a color that does not appear in either of the two mainstays.

To begin a painting, I look and look and look at my model from a variety of angles. I consider how I want him or her to be situated in relation to the light. I squint while looking, which helps me to reduce the form down to the largest and, therefore, fewest abstract shapes of darks and lights. Composition is the very first consideration. When I find an overall design that resonates, I do a black-and-white tonal study in graphite in my sketchbook. The drawing either will confirm my desire to pursue this composition or may suggest a different option. Before I move to the pastel board, I have to decide what size the painting will be. My first marks on the pastel board are lightly drawn charcoal lines. I am putting in the most important construction lines—planes and angles that provide the armature of the entire composition. I lay in my pastel lightly in the beginning, and my shapes are quite geometric and flat. I layer and layer pastel strokes. As I explore further and further into the form, my goal is to create the progressively subtler value and color shifts that exist in my subject. My consideration of edges becomes crucial as the painting reaches toward a fully sculpted form. Sometimes my concept significantly evolves as I work and compositional elements may be added or deleted.

Working in natural light forces changing perception, as does the human subject. Moods shift, colds develop,

fatigue and energy stand out in high relief. Developing a painting is all about reworking the parts into harmony and balance. Every part—shapes, line, color and value, and edges—must be orchestrated into unity, corner to corner. I use a mirror to see my painting in reverse. The mirror reveals drawing and composition errors. If I need to change an area, I can usually just wipe off the pastel with a chamois or lift it by pressing a kneaded eraser to the area I wish to amend. I once had to remove a large area of very dark color. I lifted the pastel as best I could, but a dark "ghost" remained. I applied the gesso and acrylic paint mixture with which I prime all my boards prior to the application of pastel to the darkened area. The primer obliterated the dark color, and I was able to create the desired light value with my pastels.

When shapes, line, color, value, and edges convey solid form in a single condition of light, the painting is technically finished. But these elements are all in the service of conveying the artist's response to the subject. Sometimes our responses are unclear, resulting in a painting of disparate parts. Even if the forms are strong, the painting may lack the oh-so-essential poetry of feeling. Sometimes goals change as the painting takes shape and lead the artist down an unexpected path. Sometimes I think a painting is finished but eventually realize that, despite the fact that the parts are working together, I want to take the form even further. This usually entails refining or intensifying value shifts and reworking line quality. Degas reworked paintings for years. When an artist lives with a painting for an extended time, it is possible to rethink and imagine a variety of resolutions to the image. If I get tangled up in confusion, I find it helpful to wrest myself away from the painting and engage in a pleasurable, unrelated activity, such as taking a walk, reading, listening to music. Sometimes this relaxation allows one to become more aware of the surface.

It is possible for the suggestiveness of an unfinished painting to feel particularly satisfying. There are so many ways to perceive "finished." I might finish a color study in a day or just a few hours. I have worked for months on some paintings. Sometimes I feel a painting is resolved but my interest in the subject remains heightened. I will then do a second painting, exploring the subject's nature from a different angle.

Suggestions to Artists

- Don't make style a conscious goal. Don't try to paint exactly like someone who lived centuries ago or like other contemporary artists. Delacroix revered Raphael, but his own naturally occurring, very different brushwork arose from his nature. In the early days of your studies, don't make the production of finished work your goal.

- Do focus on exploration. Bring an unbiased eye to your subject. Do remember that you will be looking at your subject in a manner you have not accessed previously. Drawing teaches us how to look. Looking for an extended period of time engenders insights in different ways than short-term looking. They both offer lessons. Short-term looking forces you to simplify to the essential gesture and proportions. Long-term looking reveals both power and subtlety. Throughout the development of a painting, always return to the big forms and ask yourself if they are still holding together. The forever goal is unity. A painting can only be one painting.

- Listen to your inner voice. At the same time, be open to changing your point of view. If you study, do so with someone whose work you greatly respect. Go to museums; look at everything. Read the writings of artists, of composers, of dancers, scientists, teachers, children. There are lessons everywhere.

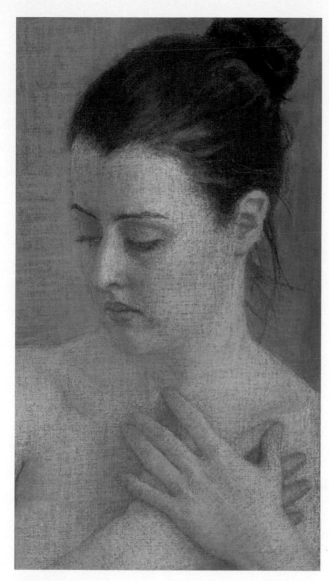

Ellen Eagle
Nude with Hands Touching
2009, pastel on pumice board, 15 x 6.5 in.

- Draw constantly. It is only by doing that we learn and progress. Every great representational painter possesses strong draftsmanship. Draftsmanship is the tool with which they express their feelings with clarity.

- Knowing art history will greatly enrich your appreciation of the works you admire and the cultural ambience of the time and place in which they were created, and will stimulate sympathy for the artists who painted them.

I rarely deliver a lesson to my class as a whole. I work one-on-one but often find myself giving certain pieces of advice over and over again, such as the following:

- Always squint and begin with the big shapes.

- In the beginning, look at the model when stepping back from the easel; then step forward to the easel and make your first marks, standing back at enough of a distance so as to use your full arm. This will enable you to make long, fluid lines. Then step back again to check your marks, comparing them to the model.

- Look at your subject carefully. Squint over and over again to check the big shapes in both the model and your painting. I squint as often as I don't squint. Move your eye around the whole subject, allowing dynamics and patterns that you may not have initially seen to emerge. Compare angles and distances of length and width.

- Compare values and color within the model to those of the background. Consider the background as seriously as you do the model. Apply the pastel lightly at first. All the colors you lay in will look different once your surface is covered corner to corner with color. A light application will allow you to be flexible in building the subsequent layers of color.

- Most of all, study your model with humility, awe, and gratitude.

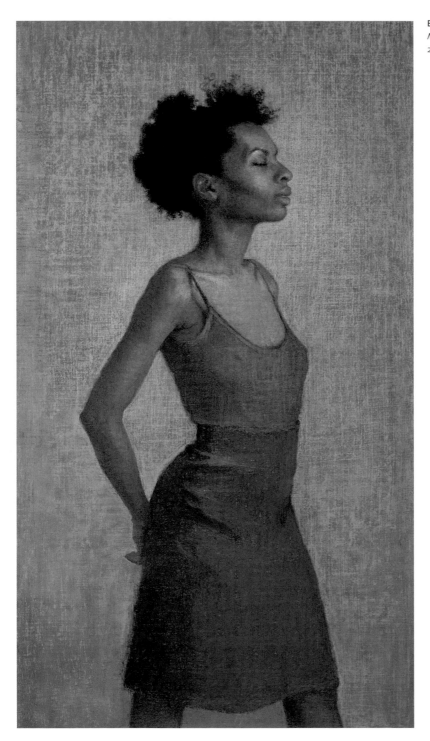

Ellen Eagle
Miss Leonard
2010, pastel on pumice board, 15.25 x 8.625 in.

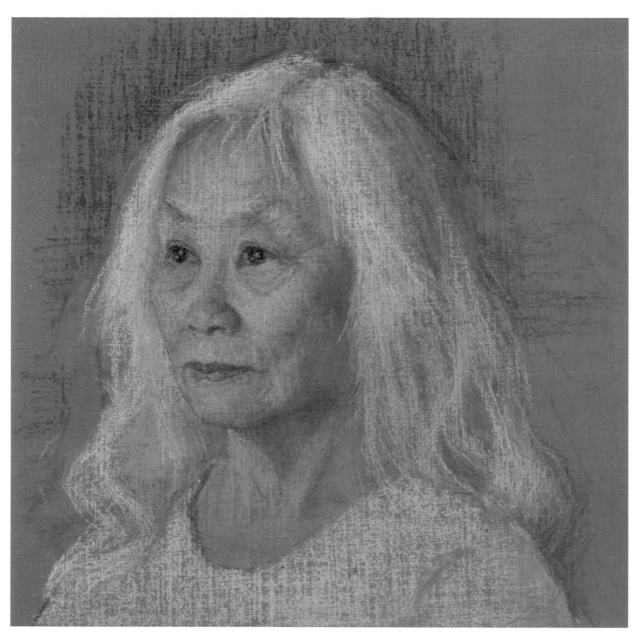

Ellen Eagle
Maxine Hong Kingston
2010, pastel on pumice board, 6.25 x 6 in.

Ellen Eagle
Winter 2006
2007, pastel on pumice board,
17.25 x 16.625 in.

Ellen Eagle
Emily in Profile
2008, pastel on pumice board, 7.25 x 7 in.

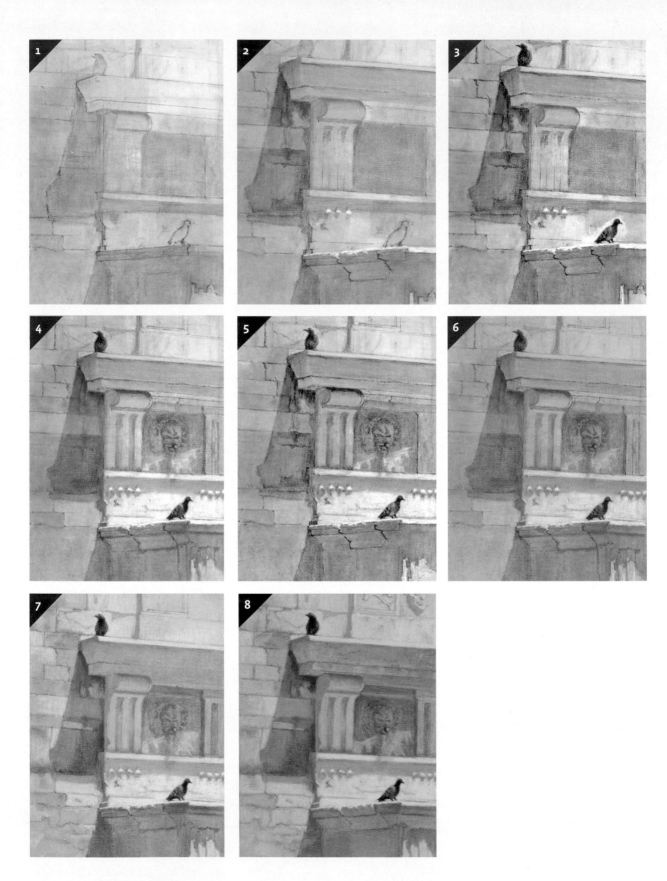

A LESSON IN PRINT:
A WORK IN PROGRESS

The subject of this demonstration is an ancient water fountain in the medieval city of Assisi and two winged residents. This is just a small section of a long and towering wall erected of various materials. The wearing away of the brick and the crumbling of the marble tell of the wall's centuries of age and endurance.

1. Ordinarily I work on boards I prepare myself. For this scene of nature and time on Via Fontabella, I decided to try UArt paper. I always work on a middle-toned support so that the surface is neither darker nor lighter than my strokes of pastel color. Because UArt is white, I toned it: I dipped pastels into water, made strokes of color on the paper, and then swirled the color with my fingers into the paper. The splotchy design of the undertone evoked the crumbly stone and marble of the fountain and wall. I put down the main, anchoring design shapes. The slender lines you see here were made in charcoal. The colors are both the undertones and the initial dry pastel application.

2. I begin to explore how much texture I wish to include. I want to evoke the age and history of the structure, but I want the large forms of the initial drawing to dominate the design.

3. Here the pigeons are developed. Edges become crisper. The shadows are darkened, and more light is added behind the lower pigeon.

4. Extending the light across the center of the fountain, I warm up all the lights, including the wall on the lower left. I also add the actual fountain relief and the water's oxidization of the surface. I considerably soften the cracks on the lower section of the structure and the brick pattern in the upper left. I lighten the tones of the lower pigeon. My goal in this stage is to create a visual balance between the story and the design.

5. I reinstate some history to the bricks within the upper shadow, cool down the wall on the lower left, and lower the value of the light in the center. I am seeking more unity to the overall color arrangement.

6. Once again, I eliminate the brick details and warm up the wall on the lower left. I reconsider a warmer lower-left wall. I simplify the pattern of the side edge of the fountain, where it meets the wall. I lighten the shadow beneath the fountain, above the pigeon. I add blue to the oxidization I cool down the light on the lower right.

7. I add a great deal of texture to the bricks, lightening the wall overall, including within the shadow. Using blues and grays, I cool down the shadow above the fountain relief. Again with blues and grays, I lighten the detail in the lower structure. I refine the shape of the upper pigeon. When I need to remove a color, I use a chamois. Pastel is more forgiving than its reputation indicates.

8. I continue to lighten the brick wall in order to maintain the power of the initial layout in which there was no detail. I darken the shadows of the fountain. Throughout the development of the painting, I am adjusting temperature and value relationships. Finally, I add the decorative touches at the very upper right corner, and recheck the edges throughout the image.

STUDENT GALLERY

Laura Bleau
Carl
2011, pastel on pumice board,
15 x 10 in.

Robert Jones
Anastasio
n.d., pastel on Canson paper, 19 x 25 in.

COSTA
VAVAGIAKIS

Costa Vavagiakis is featured in publications such as Portrait Painting Atelier and Curve: The Female Nude Now, and in articles in American Artist, American Artist Drawing, and The Artists' Artists, among others. He has been the recipient of many distinguished awards, including the Pollock-Krasner Foundation Grant and the Gregory Millard Fellowship from the New York Foundation for the Arts. His work has appeared in exhibitions at the National Portrait Gallery, the Smithsonian Institution, the Museum of the City of New York, and the Frye Art Museum in Seattle; at ACA Galleries, Salander-O'Reilly Galleries, and Hirschl & Adler Modern in New York; and at Hackett-Freedman Gallery in San Francisco, among other venues.

Costa Vavagiakis
Night Street V
2014, oil on panel, 54 x 40 in.

COSTA VAVAGIAKIS

The Evolution of a Concept

On a childhood trip to Greece, my homeland, I experienced what would become a seminal artistic inspiration: seeing the *Charioteer of Delphi*. Seeing art so powerful and realistic at an early age had a profound effect on me. This began my fascination with Greek sculpture, leading to the exploration of the human form, which has been the unerring subject of my painting and drawing for over forty years. I didn't realize until much later that through my art I have been attempting to re-create the intensity of that moment.

Ever since then, I have been drawing. I can recall that the first drawings I ever made were inspired by the many icons in my family's house. Later, when I was attending parochial elementary school, I did renderings of the pictures of sculpture busts that opened every new chapter in our Greek history books. From my early teens on, I drew all the time. I doodled compulsively. Always with a pad in hand, I drew from my surroundings and I drew from my imagination.

My very first art teacher at the High School of Art and Design was Max Ginsburg. In drawing class, Max would set up a model and ask us to draw what was in front of us. It was a wonderful initiation to drawing from life. Both Max and fellow teacher Irwin Greenberg held a painting group at the school before classes officially began. I joined the group and was immediately hooked.

Up at dawn, I would take my painting box and set out for school excited to attend the painting group. Replicating the atelier system, the teachers would paint alongside the students with a live model posing. Once or twice during a session they would go around, student to student, sit down and critique our work. Occasionally we would stand behind them while they were painting to see how they developed their paintings.

We learned commitment and discipline. We learned how to organize our materials and workstations in order to concentrate fully on the task of effectively representing the models posing before us. Many of the principles that I now teach my students come from what I learned in those early hours long ago. Max and Irwin lit the lantern and showed us the way. They inspired and motivated us, and gave us the push to be independent and have the will necessary for the lifelong pursuit of art.

These days I say that I am mostly self-taught, because I didn't go to college and by the age of twenty I was not in a classroom, but painting on my own. However, I don't think that I would have possessed the courage or wherewithal to have done it on my own if it had not been for Max Ginsburg and Irwin Greenberg.

After high school I studied for one year with Harvey Dinnerstein at the National Academy of Art and with Burt Silverman privately in his studio. They helped me further my skills and encouraged me to develop my own personal vision. But most important, I studied on my own. I never studied for studying's sake; I always had to be making something I felt strongly about. Essentially, I have learned from the experience of doing.

I have the great fortune of having grown up in New York City and was able to take advantage of the wealth of art collections in its museums. I went to the Metropolitan Museum of Art every week to study the drawings in its collection. The three months I spent copying Velázquez's painting *Juan de Pareja* was a major breakthrough in my understanding of oil painting. But I seemed to strongly respond to sculpture, which I attribute to my childhood experience in Delphi. I made drawings of Greco-Roman sculpture and drawings of the works of modernist sculptors Jacques Lipchitz, Henry Moore, and David Smith. I was fascinated by the sensation of volume the sculptures had and the space they inhabited. In retrospect, I've realized all these years I have been attempting to do a painter's equivalent of a sculpture.

The art that I came to love and study shared an aspiration of capturing the timelessness of the human spirit through the combination of formal beauty and an expression of emotion. I aspire to achieve these concerns in my work. I draw the sitter straight on and objectively, stripped of narrative content. Often, I paint my figures slightly larger than life size and place them in a shallow space isolated against a white background to increase their sculptural presence. They are lit from above to capture and record the specific qualities of the skin, hair, and vascular posture. I scrutinize my subject's physiognomy intensely, transcribing a detailed road map of the sitter. My artistic aim is to create works that come alive—as if the people might step out of the picture plane. I want the viewer to have the sensation of encountering a living, breathing human being with unique spiritual dimensions.

I don't choose to try to please everybody. If one out of ten people respond to my work in a positive way, that is enough for me to measure success. What matters most is that one person is really moved. I've had to make my philosophy and my stance clear-cut, and patiently maintain that stance no matter what.

My oil painting technique is labor-intensive. I build up wet-on-wet layers. Applying layer upon layer, scraping and sanding between layers, results in a smooth, built-up surface. I want the brushstrokes to be indiscernible so that the volume of the form and the translucency of the skin win out. The process of slowly building and layering is analogous to penetrating more deeply into what I am seeing. I am constantly researching and investigating the form and sculptural reality of the figure. Applying many paint layers is the most powerful approach toward that end.

I paint on panels (usually paper mounted on wood). The paper is a heavyweight watercolor paper sized with either shellac or animal-hide glue. I then apply many layers of oil panel primer using rollers. I smooth out the surface by sanding in between each applied layer.

I work on toned or white grounds. On the white grounds I usually do an underpainting grisaille. I work with quick-drying pigments (synthetic iron oxides) on the underlying layers and then slower-drying pigments (cadmiums) on the superficial layers. I oil out and then apply many layers of paint, sanding in between the layers. The sessions usually last eight to twenty hours (three to six hours with the model). During this time the paint starts closing. This allows for a dense, sculptural modeling of the form. The mediums I use consist of linseed oil with small amounts of a siccative (lead, cobalt, or alkyd) on the early layers to walnut oil on the latter layers. My painting process is slow and painstaking; a painting could take several years to complete.

Drawing has always played a prominent role in my life and remains an integral part of my process. I sketch for research and development, and the highly realized drawings that portray the individual's physical presence are important preludes to a painting. Often, my drawings are independent finished works with no relationship to another work.

One of the major technical challenges of constructing a highly rendered drawing of a human being is how to maintain the life spirit of the sitter captured at the initial impression. To keep the figure breathing, I sharpen my focus and develop the forms as I continually move my gaze from reference point to reference point and back again. Every note, spot, and area on a page are points of arrival and departure that I call passages. This is the basis of my drawing methodology. I teach students how to visually navigate and not stay in one area too long so that they don't get myopic, trapped, and bogged down. This helps with mass recognition and mass coordination as a drawing is developed.

At the same time, I try not to teach style. I feel self-expression is a given; one cannot help but to express oneself. My task as a teacher is to help clear the perceptive channels of the students in order for them to be open conduits, to help clarify their vision externally and internally, to draw with hand and heart.

Costa Vavagiakis
Craig II
2010, oil on panel, 32 x 25 in.

Opposite
Costa Vavagiakis
Rainbow XXXVI
2012, oil on panel, 24 x 18 in.

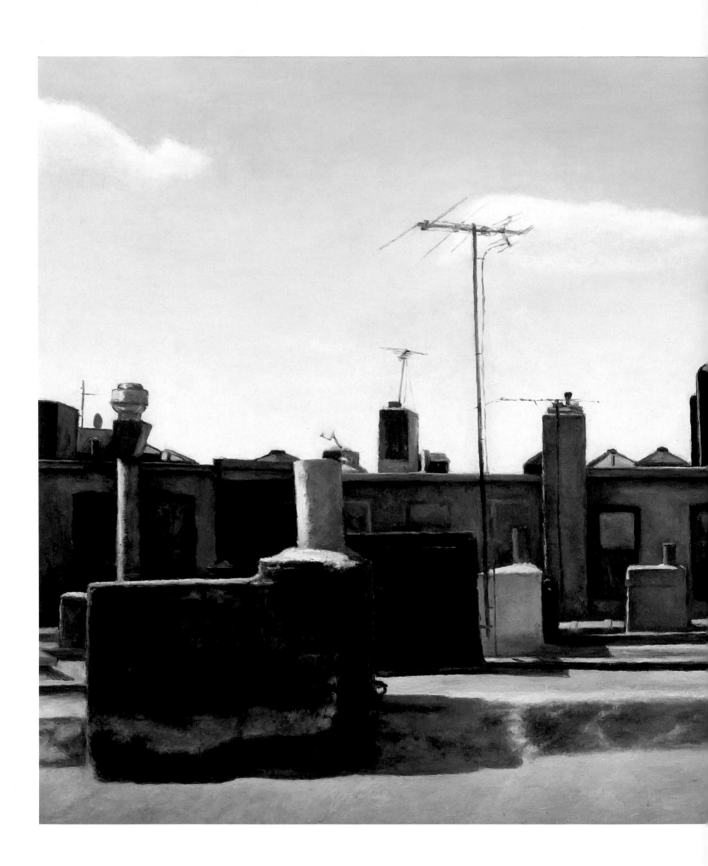

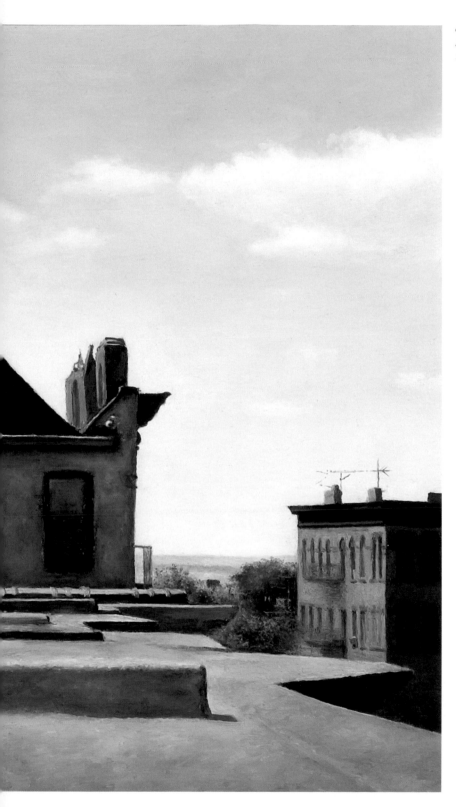

Costa Vavagiakis
Rooftop I
2007, oil on panel, 10 x 15 in.

Costa Vavagiakis
Gioia VIII
2010, oil on panel,
56 x 35 in.

Opposite
Costa Vavagiakis
Connie V
2004, oil on panel,
14 x 12 in.

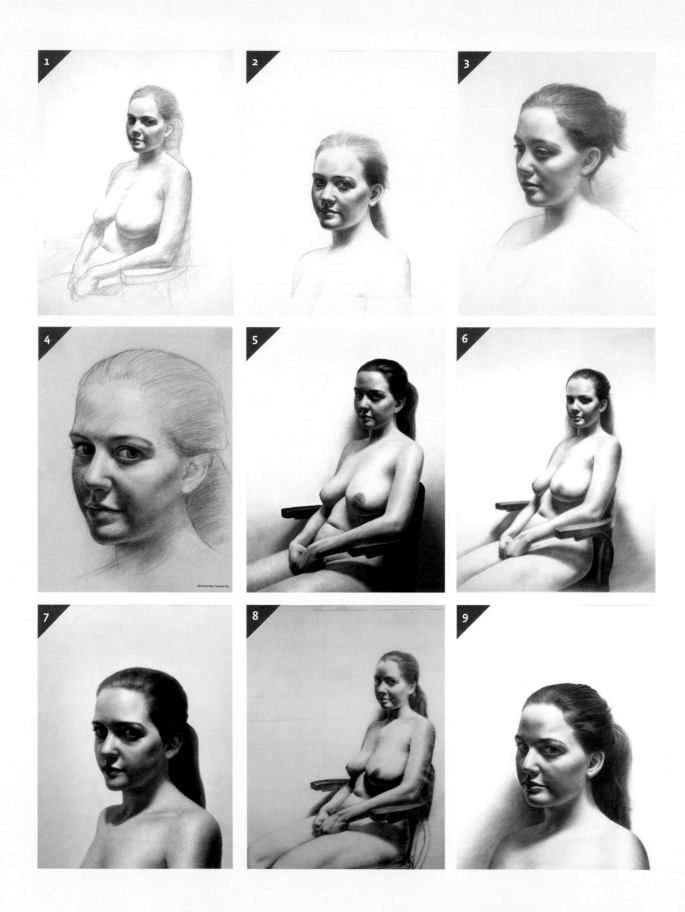

A LESSON IN PRINT:
POINTS OF REFERENCE—ARRIVALS AND DEPARTURES

I do countless drawings and oil sketches as I set out the concept for a painting. I draw from life—from direct observation and from experience. The eventual final painting is a synthesis of all these drawing and painting experiences. I do dozens of drawings and painting studies of the same sitter in very similar poses, exploring subtle shifts of axis and mood. A very important lesson for the student to experience is the evolutionary process, with its many subtle changes, modifications, and adjustments from its first idea to the final completed painting. It teaches the process on several levels and reveals how profound the experience of searching and arriving at the final painting can be. It is not just about the evolution of an image as a technical challenge but about how the subtlest adjustments of pose, light, and shadow are central to the psychological dimension of a work. I am searching for a union of pictorial harmony and emotional content where the spirit and the technique become the same single vehicle of expression.

On a trip to Berlin in 1990, I encountered Roger van der Weyden's *Portrait of a Young Woman*. I was struck by the human immediacy and presence of the painting, inspiring my interest in the three-quarter-portrait motif. This exploration led me to the *Miranda XI* painting, among many other works. In addition to van der Weyden, this series recalls the tradition of Antonello da Messina, Leonardo da Vinci, Raphael, Corot, and Ingres.

1. *Miranda I* was the first drawing that set forth the idea. I was working on a frontal portrait of Miranda. I asked her to turn her head and eyes toward me. I finished the drawing in the ninety minutes remaining in our session.

2. Then I did *Miranda III*, a more finished drawing in graphite focusing on her facial features. The tilt of the head is toward the viewer, suggesting openness and vulnerability.

3. I decided to give both the model and myself a break from the intensity of the pose. A pose where the model gazes back requires a high degree of energy and emotion. I had Miranda look away, and I raised my eye level. *Miranda V* suggests a pensive mood.

4. I was looking for a more immediate and intimate connection. I did several small-scale bust drawings on different colored papers implementing white chalk, including *Miranda VII*. This technique allows for a quicker execution that helps me explore the many subtle variations.

5. I usually work on several smaller paintings before the final painting, such as *Miranda VIII*. Sometimes I paint them concurrently with the final larger painting. They support and inform one another.

6. I executed *Miranda IX*, a mid-sized finished drawing, to serve as an information model for my final painting.

7. *Miranda X* is a bust I did before and during working on *Miranda XI*. The smaller scale helps to inform me of the color notes and transitions. It is my intention that the subtleties of emotion be contained in the expression of the sitter.

8. I gridded and scaled up the finished mid-sized drawing to create *Cartoon of Miranda XI*. I decided to include more space around the figure. I transferred it to a durable transparent Mylar so that I could continue to make adjustments before I transferred it to the prepared panel.

9. I was not satisfied with the expression and mood conveyed in the previous works. I wanted to heighten the tension and darken the mood. I worked on several drawings

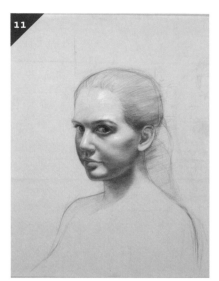

to see if I could capture what I was looking for, including *Miranda XI Study I*.

10. During the process of painting *Miranda XI*, I continued to make drawings to work things out, including the best placement of the hands.

11. I realized Miranda's expression was not subtle enough. I did several drawings to find the expression I was after. *Miranda XI Study III* struck the right balance of vulnerability and strength.

12. This slight adjustment of the tilt and axis of the head and eyes in *Miranda XI* was necessary to express the subtle emotion and provocative mood I was seeking. After three and a half years and many revisions, I had finished the painting.

Page 158 (1)
Costa Vavagiakis
Miranda I
2002, graphite on paper, 16 x 13 in.

Page 158 (2)
Costa Vavagiakis
Miranda III
2003, graphite on paper, 26 x 23 in.

Page 158 (3)
Costa Vavagiakis
Miranda V
2003, graphite and white chalk on paper,
11 x 8.5 in.

Page 158 (4)
Costa Vavagiakis
Miranda VII
2004, graphite and white chalk on paper,
11 x 8.5 in.

Page 158 (5)
Costa Vavagiakis
Miranda VIII
2005, oil on panel, 17 x 14 in.

Page 158 (6)
Costa Vavagiakis
Miranda IX
2006, graphite on paper, 22 x 17 in.

Page 158 (7)
Costa Vavagiakis
Miranda X
2007, oil on panel, 13 x 11 1/4 in.

Page 158 (8)
Costa Vavagiakis
Cartoon of Miranda XI
2008, graphite on Mylar, 51 x 42 in.

Page 158 (9)
Costa Vavagiakis
Miranda XI Study I
2009, graphite on paper, 20.5 x 18 in.

Page 160 (10)
Costa Vavagiakis
Hand studies for Miranda XI
2009, graphite and white chalk on paper,
12 x 16 in.

Page 160 (11)
Costa Vavagiakis
Miranda XI Study III
2009, graphite on Mylar, 23 x 22 in.

Page 161 (12)
Costa Vavagiakis
Miranda XI
2010, oil on panel, 50 x 42 inches

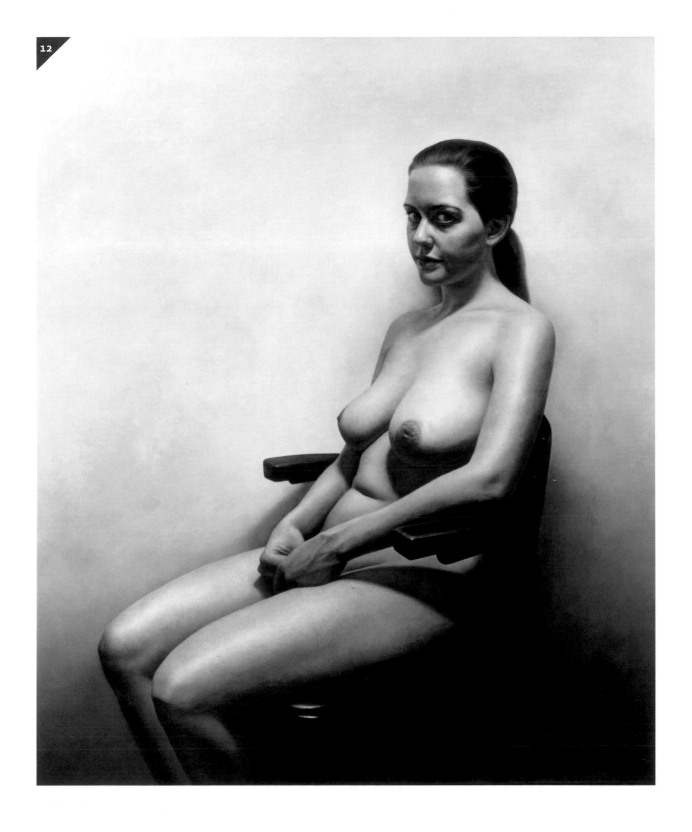

STUDENT GALLERY

Christopher LoPresti
Jun at the Light
2012, oil on canvas, 36 x 48 in.

Opposite
Isaac Pelepko
Young Woman in Snow
2012, acrylic on paper mounted on masonite, 36 x 46 in.

Part 2

ADVICE AND PHILOSOPHIES

WILLIAM
SCHARF

William Scharf studied at the Pennsylvania Academy of the Fine Arts, the Barnes Foundation, and the Académie de la Grande Chaumière in Paris. His paintings reside in the permanent collections of the Solomon R. Guggenheim Museum; the Institute of Contemporary Art, Boston; the Brooklyn Museum; the High Museum of Art, Atlanta; the Neuberger Museum of Art; the Newark Museum; the Phillips Collection; the Neurosciences Institute, La Jolla; the Philadelphia Museum of Art; the Telfair Museum of Art, Savannah; the Museum of Modern Art; Carnegie Museum of Art; the Irish Museum of Modern Art, Dublin; and the Smithsonian American Art Museum.

Opposite
William Scharf
The Weapons Become the Altar
2011, acrylic on canvas, 70 x 38 in.

Pages 148–149
William Scharf
A Mischief of Magnets
2003–7, acrylic on canvas, 38 x 34 in.

WILLIAM SCHARF

Miracles Happen

To describe what happens in a great painting I would probably need to use the word *mysterious*. At the same time, I like to think of that mystery in terms of strength and color. I gave up on painting representationally many years ago. Today I just ramble around, with brush and color, stumbling sometimes, making myself quite angry.

The tools work for me and against me at the same time. Many days, the tools seem to be winning. Paint by itself can become a marvelous, transformative medium.

I made the switch from oil painting to acrylic many years ago and since have developed a fondness for acrylic. The transition was not difficult, because I worked so much with watercolor, crayon, pencil, pen, and ink.

Growing up in Media, Pennsylvania, thirteen miles southwest of Philadelphia, art had always been a part of my life. Every Christmas, my folks gave me a book illustrated by N. C. Wyeth. They would take me over to Chadd's Ford as part of the surprise and get Wyeth to sign it for me.

As the years went on, I would go without them to see Mr. Wyeth and bring drawings for him to critique. He was very kind and supportive, and suggested that my parents take me out of school to let me go paint and work with him. My parents said that would be fine except they did not want to pick a fight with the school and the law, like Mr. Wyeth had done to keep Andy and his niece at home. That didn't work out, but our friendship continued over the years until he was killed when I was in the army during the Second World War. It was a terrible loss. He was driving and was struck by a train. After the war, I paid visits to Andy, who was very friendly and kind, and helpful to me, too.

Following my discharge from the service, I enrolled in the Pennsylvania Academy of the Fine Arts, where one of my best teachers was a wonderful man from North Carolina named Francis Speight. Daniel Garber made a big impression on me as well. Benton Spruance was also teaching there at the time. Curtis Publishing was a few blocks away on Washington Square, and it was still a golden age for illustration. I spent quite a bit of time with Walter Stuempfig and Franklin Watkins. I saw Arthur B. Carles near the end of his life but never met with him, or even spoke with him. Some of his friends had built a beautiful studio and home for him in Germantown. After Carles died, Walter Stuempfig moved into the property. I liked Stuempfig's paintings, and his portraits. He was a bit sarcastic, but a gentleman.

I thought very highly of Franklin Watkins, who produced two big murals in a huge space given to him in the basement of the Philadelphia Museum of Art. I spent a lot of time there, and one day he took me aside and he said, "Bill, I see you here quite often, and you always go to the same paintings. Promise me you'll go around and look at some of the paintings you don't like." It was wonderful advice; I tried to look right past a painting I didn't like, and I wound up appreciating what before I had not understood.

At first I was drawn to paintings of people. The museum has some very magnificent portraits. Later I switched my attention to landscape, which was less satisfying at first. And then I discovered early Italian painting, admiring its simplicity.

I came to appreciate Cézanne there, but that took a few years. I didn't understand what Cézanne was doing until Dr. Barnes helped me to see it. I took classes at the Barnes Foundation in Merion once a week. The lessons were quite good, and the collection was utterly superb. Barnes has been described as dogmatic and irascible,

but we got on quite nicely. Walking together through his museum on several occasions, we would just pause in front of a Matisse, Cézanne, or Seurat and discuss it.

In those early days at the Pennsylvania Academy I was so frightened of oil painting. I saw other fellows like me, who had just come back from war and wanted to make up for lost time, just dive in and do it. How damn good they were! I sneaked away into the corners to paint by myself, or hid out in the studios of some younger friends. I mostly made my way through the Academy on drawing.

I did not get into painting until after the Academy. I had a wonderful summer place near Valley Forge where I would paint alone in the fields and woods. That was a turning point for me. I started to feel like I could find a way to paint. My first efforts were landscapes and portraits. I did some really acceptable portraits. I continued to look at the Wyeths, and was also influenced by my former teacher Francis Speight, from whom my wife and I ultimately bought a painting.

I tried my hand at painting animals—cows, horses, and the like. They were a bit trying, but I felt the need to challenge myself if I was to succeed as an illustrator.

When I moved to New York I found some work doing illustration but soured on it fairly quickly. I had been drawing all of my life, and I had thoughts of being an illustrator because I admired so many like Norman Rockwell, Frank Schoonover, and Wyeth, who did magnificent work in the thirties. Opportunities for artists in publishing were very impressive in those days. And then cameras started taking over.

Life magazine, film, and television had less need for talented gentlemen to produce illustrations. I did some good work, but my heart was not in illustration. I began to experiment. Each day was a little bit different. It was the early fifties, and abstract painting dominated the art scene.

I wanted to be around art because I had learned so much, not just from studying at the Academy but by visiting the Philadelphia Museum of Art and the Barnes collection.

I wanted to be around paintings, and so my next job was as a guard at the Metropolitan Museum of Art. My second one was at the Museum of Modern Art. After that I worked at the Guggenheim. Eventually I moved up from being a guard to other tasks. These were important years for me.

I was inspired to start teaching in part because it paid better. I was worried about doing a good job and called a few teachers I knew. They said, "Don't worry about it at all, just go in and start talking." It worked. I took the process extremely seriously. Today I have piles and piles of notes taken from books I had read. I used to lecture to classes, and while the lectures seemed to go pretty well, I didn't think they were reaching the whole class. Because there was never a time when everyone would be trying to do the same thing, I resorted to just talking to each student one-on-one.

My first serious teaching job was here, at the Art Students League of New York. I was also invited to teach at the Museum of Modern Art, because one of the curators liked my work. MoMA and I got tired of each other after a couple of years, and I decided to move to San Francisco. Julius Hatofsky was a very fine painter who had previously been a New York City police officer. He was a very good friend. When he was offered a good job in San Francisco, he took it and then found me a job, too. By this time, my teaching method had crystallized into a person-to-person approach that proved to be effective, both for me and for my students.

In San Francisco I got to know all of the so-called Bay Area artists like David Park and Elmer Bischoff, and became friendly with Richard Diebenkorn. I discovered that art students in the Bay Area displayed more of a mixture of directions than their New York counterparts. Everyone was doing different things. I had no problem getting them to ask questions, which helped to refine my individual, one-on-one approach to teaching.

Max Beckmann was an artist I admired very much. His studio was on 69th Street, just around the block from the rooms where I was painting when I first came to New York. To illustrate a method very different from how I teach, there is a story about how when Beckmann taught in Saint Louis, he went around the classroom with a brush loaded with black paint and made corrections to the students' work, directly onto their canvases. I could never do that.

I cannot see the painting before I start it. I might do a lot of drawings, but they can lead me astray, off track. Drawings done as preparation for paintings work for me more like rehearsals than like plans to be transferred onto the canvas. I rely on these drawings to some degree but allow the painting to develop in its own way.

I like risk taking and rely a lot on intuition. Starting quickly with a brush, on good terms with one or two drawings (sometimes three or four), I can sometimes speed up the process. Some days this approach works, and other days it doesn't work at all.

A good painting follows its own timetable. It has a mind of its own. A successful painting for me is one that I can go back to, again and again, to look at many times and discover in it something different each time that I do.

The same holds true with paintings in museums or at galleries. We see too many paintings that we wish had never been painted. Successful paintings are a rare commodity. Most paintings I see today I would not care to revisit. So many gallery exhibitions are loaded with forgettable work. When I do find something that is memorable, I know it. A dialogue exists, or maybe it develops between any painting and the viewer. If it is something very interesting, it will be worthy of many visits. It is no different than if you collect pictures you want live with. Do you care about them?

When beginning-level students join my class with very little background, the first thing I encourage them to do is get into a basic drawing class. Some instructors here at the League will not admit a student into their classes without some prior training. When a raw beginner enrolls in my class, if they are also enrolled in a drawing class I might let them stay. Otherwise I will recommend that they go and take a drawing class. The first thing anyone needs to learn is how to draw something, to draw anything, and make it exciting!

Draw the telephone, a coffee cup, a pile of rags because that is the way to seeing—and certainly the way toward learning. I discourage students from latching onto any approach that might seem novel, outlandish, too hurried, or lacking some sense of form.

It was tough to get students in San Francisco to slow down and pay attention, to look. Maybe it was because the art museums they had at their disposal lacked the depth of public collections here in New York sufficient to hold their attention.

Today things certainly happen at such a fast pace that, regardless of where you live, most people might fail to notice what matters. It took me a while to understand Cézanne. Matisse was perfectly baffling to me because of the things he allowed himself to do. I made a careful study of his work, and when I eventually grasped what he was doing, it was a revelation.

Fifty years ago when someone went to an art school they knew what they were getting into. Today, not so much. You might have thirty people in a classroom and a few of them have some idea in what direction they want to go, which makes it pretty interesting for me to be able to solidify their excitement, encourage them, and then see them blossom.

Painting is a form, not a technique. Bonnard spoke about discovering how color was just as important as form—the weight of something. I found a lot of truth in that idea, but I still like color to be defined by a shape, not just to be smeared. Perhaps that is how craft becomes important. You need to know the rules before you can break them.

Students need to learn sound studio practices, such as keeping their brushes clean, washing them every night

with water and soap, not just solvents that will eventually dry out the hairs and make them brittle. Working with acrylic, one must make sure to move water through them often. Students should always use the best brushes and buy the best materials they can afford. That can make a huge difference.

I knew a portrait painter who wrote a book on painting materials and methods. He advocated painting in oils and despised acrylics. His book is still in print, but I say just the opposite, that acrylics are on par with oil.

I'm very fond of acrylic, having no technical problems with using acrylic in my own work. Conservators told me that the only thing that can destroy an acrylic painting is a fire or a quick freeze. I have not had the tiniest crack appear on any painting of mine done in acrylics. It may be a less delicate medium, I suppose, which suits me, because I am less interested in technique than in form.

My students range in age from young to old. In my class they know what they are in for, and for the most part they like it. I don't bark at anybody, and they do good work. They find their own way if they are at all curious. That is what makes teaching exciting, seeing how they do it.

My teaching style is primarily tutorial, working with each student at his or her easel. I will prepare lectures to talk about color and composition, show slides and images of famous paintings, followed by questions and answers. Color, shape, and mystery are at the core of every painting. If something bothers you about a particular painting, make friends with it and go look at it again and again.

Let's say students walk in with a few objects and say that they want to make a still life. The first thing I would have them do would be make a drawing or two, adjust the objects, and then make another drawing or two. Anything we might reveal might conceal something else. There is no way for us to look at objects in a setup and see all the way around them. Some parts are always missing.

Anyone who can draw very well but doesn't try to expand beyond what he or she is looking at is not going all the way. The best advice I could give to a young painter would be to get out and go to the museums and galleries. Look at many works of art. You begin to see that in any artist's body of work there is some sort of family resemblance, a quality that makes the work recognizable as theirs. I might tell a student to go find a couple of paintings by someone like Matisse and really look at them, to study them closely. (I am using Matisse as an example because his paintings are very accessible in terms of shape and color, and they are *revisitable*. One can live with paintings like that.)

Painting is a discovery process. When something is not working, scrape it out, reposition yourself, and start again. For me acrylic makes this easier, because it is not subject to the rule of *fat over lean*. As long as the painting surface remains thin, as long as it does not get too thick, then one can just overpaint revisions, which is something I enjoy doing.

One day a little boy was visiting my class. I gave him some paper and colored pencils to work with. He became annoyed, and I asked whether the drawing was boring him.

"What do you do when something is upsetting you?" I asked.

"I just ruin it into something better," he replied.

Picasso once said, "We don't learn painting, we find painting." Mark Rothko once told me, "We have to know that miracles can happen. We can never give up."

William Scharf
Little Angel of the Pike
2009, acrylic on canvas, 33 x 58 in.

William Scharf
Dawn Scaffold
2006, acrylic on canvas, 68 x 63 in.

William Scharf
In Heat of the Trapezoid
n.d., acrylic on canvas,
68 x 65 in.

William Scharf
The Scratched and Unfixed Air
2007–8, acrylic on paper, 9 x 12 in.

William Scharf
Trochee of Citrus
2010, acrylic on canvas, 36 x 48 in.

STUDENT GALLERY

Peter Hernandez
The Wandering
2009, acrylic on canvas,
30 x 24 x 1 in.

Shyun Song
Detour
2010, oil on canvas, 16 x 14 in.

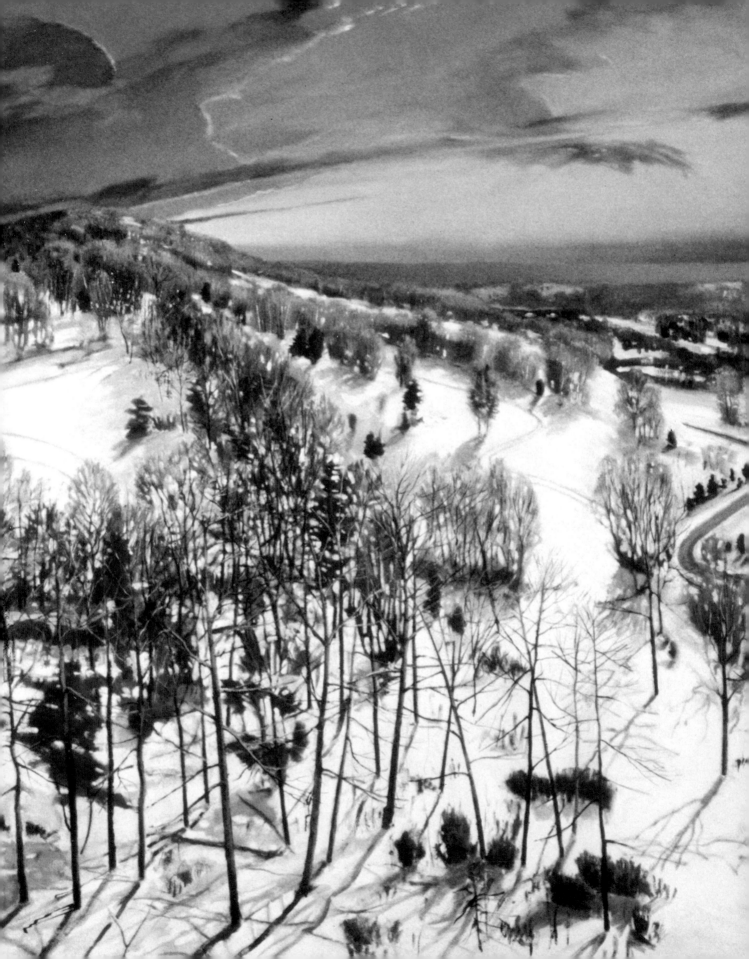

PETER
HOMITZKY

Peter Homitzky studied at the Art Students League of New York with Jean Liberté, Joseph Hirsch, and Dan Rice. He also studied at the San Francisco Art Institute. Homitzky has exhibited at DFN Gallery, Reese Gallery, Frank Caro Gallery, G. Lawrence Hubert Gallery, G. W. Einstein Gallery, Sid Deutsch Gallery, A. M. Sachs Gallery, Alonzo Gallery, Roko Gallery, and Halpert Gallery, all in New York City. He has also exhibited at the Jersey City Museum, the Aljira Center for Contemporary Art, the New Jersey State Museum, the Newark Museum, the Montclair Art Museum, the Morris Museum, the Visual Arts Center of New Jersey, the San Francisco Museum of Modern Art, the Noyes Museum of Art, the Wichita Art Museum, the Hunterdon Art Museum, the Robeson and Stedman Galleries at Rutgers University, the Jane Voorhees Zimmerli Art Museum, the Butler Institute of American Art, and other venues.

He was twice awarded the New Jersey Council on the Arts Fellowship and was named New Jersey's Distinguished Artist from 1981 to 1982. Retrospectives of his work were presented with full catalogs at the new building of the Jersey City Museum from September 2002 through January 2003, and at the Freedman Gallery at Albright College in Reading, Pennsylvania, during 2006.

Peter Homitzky
Catskill (detail)
1987, oil on canvas, 56 x 72 in.
Collection AXA Gallery

PETER HOMITZKY

Inventing from Observation

My association with the Art Students League began over fifty years ago. I was able to convince my parents to let me defer college for a year to see if a life of art-making was what I really wanted. This was in 1960. I settled on Jean Liberté's class. Jean was a decent painter and a very nice man. For the first time in my life I felt a part of a community of artists who took me and my work seriously. After a few months, Stewart Klonis, the League's director, asked me to stop by his office for a chat. He told me that Liberté and Morris Katz had brought me to his attention. This surprised me in that Morris was a nonobjective painter, who saw abstraction as human evolution and not as a movement that had run its course, as I did. We talked about representational as opposed to realist painting. Stewart felt that objective painting needed to address the human condition and have strong social content. I saw all painting as the processing and articulation of experience, real or imagined, it doesn't matter, done with a strong viewpoint and enough skill to allow the viewer to share in that experience. He told me that now that we had met, he would follow my development and growth over the next couple of years. I told him about my agreement with my parents.

He said, "You'll be back, people like you have no place else to go."

He was right, of course. College was, for me, a very sad experience. The art department, newly formed, was crammed into a building that no one else wanted with a pedestrian faculty that, with no professional life of their own, treated each issue of *ARTnews* as if it were carved in stone. I quickly realized that the program was designed to produce school system art teachers and not artists with voices of their own. I dumped my ashtray and drove back to New York and the League.

I enrolled in Joe Hirsch's class. Joe's work didn't particularly interest me, but he was a fine technician who never tried to proselytize his viewpoint, and who limited our conversations to material-handling and mechanics. During this period I became aware of a group of painters in California who used the vocabulary of abstract expressionism, with recognizable imagery. At that time it seemed to be the answer to my quandary. I decided to go there and become part of that. In the spring of 1964, newly married, my wife and I arrived in San Francisco. Our first priority was to find jobs. I had been told that conservation and restoration of paintings paid well, so I looked in the phone book; there were three listings, but only one had a display ad, so I went there. As blind luck would have it, I was hired to pack and crate paintings in addition to learning restoration with Gordon Cope and Joe Toschi. This was at the Maxwell Galleries, San Francisco's premier gallery specializing in impressionist and postimpressionist paintings, as well as nineteenth- and early twentieth-century American art. This was a priceless education in that, when cleaning a master's work, you see how each form is built and, when touch-up is required, how they achieved their chosen color and how to duplicate that color. Close is unacceptable, it must be dead-on. Fred Maxwell offered to pay my tuition, so the following fall I enrolled at the San Francisco Art Institute. Maxwell allowed me to work around my classes. He decided that I was a good installer and preparator of exhibitions, and that became part of my duties. Eventually I spent time on the floor and was able to conceive and curate some of the gallery's exhibits.

The mid-sixties were an interesting time in San Francisco, and the Institute wasn't spared. Fine art was being redefined, mostly downward. Connoisseurship was now a dirty word. It was only the artist's intent that could be considered. Any qualitative judgment became elitist

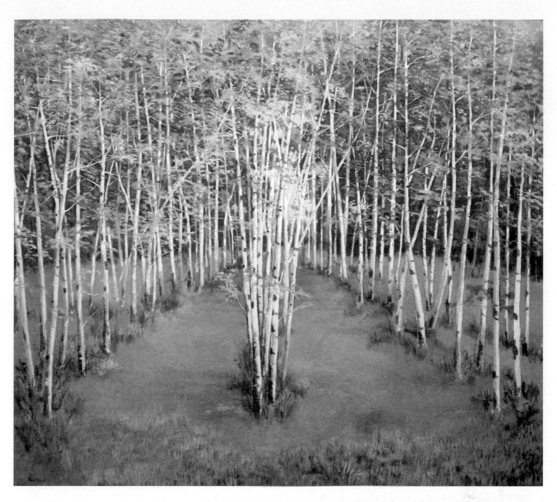

Peter Homitzky
Vossberg's Grove
1988, oil on canvas, 42 x 48 in.
Collection AXA Gallery

and was dismissed and scorned. We missed New York, and in 1967 we came back. I got a job working on a television documentary on American art from 1890 to 1950. I got to select the works included. In the process of tracking the works I wanted, I was offered the directorship of a prominent gallery, which I accepted. The only thing that I accomplished there was a Marsden Hartley retrospective, from private collections, which Hilton Kramer said was the best Hartley show since Stieglitz. It included some gold- and silverpoint drawings that neither I nor anybody else was familiar with; they were breathtaking and gave complete lie to the notion that Hartley couldn't draw. During this time, I did very little painting of my own and realized that the only way I would get anything done was to return to

the League. I went back to Joe Hirsch's class. It was as if I'd never left. Joe left me pretty much alone, except sometimes he would bring the class's attention to my painting and always say the same thing: "Peter's is a strong painting, although I can't say I agree with his approach." After a while it got a little old. At this time I became friendly with Dan Rice, who was teaching at the League. Dan was an abstract painter closely identified with Franz Kline, the only painter in the core group of American abstractionists who spoke to me, and whose work I still admire. Dan told me that if I joined his class, he would ask for models, and I would have them to myself. I stayed to the end of the year. The commoditization of art was beginning to wear on me, and this came to a head when the president of a steel company

and his wife came into the gallery and asked me if we had any paintings of "the downtrodden, my wife and I love the downtrodden."

That was the day I resigned. The one marketable skill I had was restoration, so I pursued that and was hired by a prominent restoration studio. At this time I got to know most of the conservation community and realized that every restorer I met used to be a painter. Clearly, if I wanted to paint I needed to do something else for money. I next became the director of a not-for-profit art space, but found that I was doing the same work as in a commercial gallery—for a lot less money. I was approaching thirty, and it seemed to me that I needed to commit to painting now or I would be nothing more than a recreational painter. My wife offered to take a full-time job so that I could do that. A few months later a friend told me that a job for a drawing instructor was available at his college and offered me the position. That was my introduction to teaching. The following year our landlord informed us that since the lofts we lived in were now legal residences, he quadrupled our rent. I asked everyone I knew if they heard of any work to let me know. Irving Marantz, a sculptor, told me that he was supposed to teach a drawing class that summer at the YMHA in Union, New Jersey, but wanted to spend the summer in Provincetown, so he offered me that job.

I went to an interview and the people there started describing health insurance and other benefits. What I didn't know was that Irving had died the day before my interview. He was the longtime artist in residence at the Y and was directing an extensive fine arts program there. I was being interviewed as his replacement and was offered the job. I stayed for the next twelve years. We moved to New Jersey, and I got a couple of other teaching jobs. At this time in the seventies, I started showing my work in New York City and throughout the region, where my work received considerable critical attention. I also started selling work. For the first time, my paintings were supporting me, and not me them. I was able to buy a large loft in Hoboken, New Jersey.

I now had the two things that are essential to making art: time and space. During this time, I had not given the League much thought, except to tell my students that I was formed at the League and by the League. If they were really serious about painting, they might consider spending some time there. This was the seventies, and just about every academic art department was dominated by horizontal stripes. How much mattress ticking does the world need?

This was encouraged by academic dullards who had found something even they could do. By decade's end, only the four painters who had started the whole stripe thing in Washington, DC, remained, and everyone else who wasn't teaching art at Sowbelly State or similar institutions went to work behind their uncle's dairy counter, where God meant for them to be. As my income improved, I started passing my teaching jobs to friends, until I wasn't teaching at all.

In 1983, Leatrice Rose, a very sophisticated colorist painter and friend, asked me to substitute for her class. Coming back to the League was like coming home. Rosina Florio visited my class virtually every day that I was there, and at the end of the month asked me if I would like to come to the League to teach on a regular basis. I said that I would.

At this time, I thought about my own art school experiences, what worked and what did not. Because the League has no curricula or matriculation, I tailor my instruction to each student individually. With each new student, my first task is to figure out, if they had the skill, what their work would look like. And nudge them in that direction.

I think that it is important for students to see how others deal with the same issues that they might find problematic. I do this by setting up a still life as a problem. All the elements included in the setup are different shades of the same color, or reflective objects are placed onto a mirror and backed by another. For those interested in figurative painting, those who work

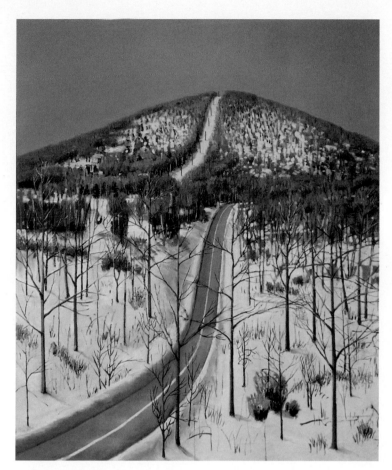

mode is not being reactionary. There is no conflict between modern and traditional works of art. In fact, the modern movement is part of the painting tradition, not just an evolution away from it. You can paint an apple photo-graphically or a circle with a stem; neither one will ever be an apple, but only a symbol for one. Of course if only you know that it's an apple, you might be talking to yourself.

I never tell my students this is how it's done. I show them several options and, based on what they have already done themselves, make recommendations.

Because I am primarily a landscape painter, a good many of my students come to my class because of their own interest in landscape. I explain to them that my approach to landscape is neither narrative nor documentary but the articulation of an experience of a certain place and time. The light, density, color of the air, and its temperature are what make that experience possible, and not a painted snapshot.

with a model, I urge them to pay less attention to what the models look like and to concentrate on forming an opinion about who they are as individuals.

I point out to them that if someone sits across from them on a bus, it takes them about ten seconds to decide exactly who that person is. They might be wrong, but it doesn't matter; it still will result in a stronger painting. As Oscar Wilde said, "Anyone who doesn't trust first impressions is a fool."

In any case, I try to group people with similar interests so that those with more experience can pull those with less into their slipstream. When a student can see different approaches to the same issues, everybody benefits. The points I stress most strongly are that mimicry is not art, that working in a representational

However, landscape painting is site specific, and must be recognizable to anyone familiar with the site, so they can add their experience to mine. All I'm doing is telling people how to look. I don't think of art-making as an academic discipline but as an applied craft—a series of color, line, and form relationships that, when articulated by an artist, can become a work of art. Everything else is just stuff.

Peter Homitzky
Woodstock Torline
1984, oil on canvas, 48 x 42 in.
Collection Dewey Balentine

Peter Homitzky
Somerset Division
1978, oil on canvas, 48 x 42 in.
Collection Dewey Balentine

Peter Homitzky
Somerset Division 2
1977–78, oil on canvas, 56 x 74 in.
Collection AXA Gallery

Peter Homitzky
Gateaway
1991, oil on canvas, 56 x 72 in.
Collection James Farley

Peter Homitzky
Catskill
1987, oil on canvas, 54 x 60 in.
Collection AXA Gallery

STUDENT GALLERY

Top left
Susan De Castro
Shaken, Not Stirred
n.d., oil on canvas , 24 x 18 in.

Top right
Marne Rizika
Harvest
2009, oil on canvas, 36 x 40 in.

Bottom
José Del Solar
Little Accidents #6
n.d., oil on canvas, 30 x 40 in.

Rick Davalos Leon
Lackawanna
2012, oil on panel, 32 x 20 in.

CHARLES

HINMAN

Charles Hinman establishes a visual dialogue between the actual space of the sculptured object and the illusory space of the painting through the use of three-dimensional canvases by exploring a play of opposites, such as hard and soft, opaque and translucent, plane and volume, light and shadow, and contrasting color. These works, without reference to objects of everyday life, have freedom of association, imagery, and scale. Hinman's work was first exhibited in a group show at the Sidney Janis Gallery in 1964, followed by solo shows at Richard Feigen, New York, Chicago, and Los Angeles; Denise René, New York and Paris; Hans Mayer, Krefeld, Germany; the Tokyo Gallery, Japan; Douglas Drake, New York; and many other venues. His work is represented in the collections of the Museum of Modern Art; the Whitney Museum of American Art; the Hirshhorn Museum; the Los Angeles County Museum of Art; the Louisiana Museum of Modern Art, Denmark; and the Nagaoka City Local Museum, Japan.

Hinman studied fine arts at Syracuse University and at the Art Students League of New York. He has taught at Princeton University, Cornell University, Pratt Institute, the School of Visual Arts, and Cooper Union, and he was Lamar Dodd Distinguished Professor of Art at the University of Georgia. Awards include a National Endowment for the Arts fellowship and grants from both the Pollock-Krasner Foundation and the Adolph and Esther Gottlieb Foundation.

Charles Hinman
Sagittarius
2006, acrylic on non-woven fabric and wood,
96 x 72 x 9 in.

CHARLES HINMAN

Painting in Three Dimensions

After completing my art education at Syracuse University, from the time when I first entered the New York art world, my philosophy of painting has been that each piece that I introduced should be something new and unique. This has been an imperative for me from the beginning of my career and has continued throughout. This has been a huge challenge to me as a member of an active international arts community—but it is this very challenge that keeps me stimulated to create work that continues to interest me. It has not always been easy to do this, but it is an inner necessity that prevails to the present day.

Early motivation was provided by the invitation to join the exhibition *Seven New Artists* at the Sidney Janis Gallery along with Shuseki Arakawa, Robert Whitman, Larry Bell, Robert Irwin, Robert Slutzky, and Norman Ives. This exposure was soon followed by my first solo exhibition at the Richard Feigen Gallery in 1964.

In the late sixties, I joined the Galerie Denise René, where I showed my work in her galleries in Paris and New York, and also the Hans Mayer Gallery in Krefeld, Germany. I remained with Galerie Denise René for about five years, until she closed the gallery in New York and returned to Paris.

From these beginnings, my work moved away from the traditional rectangular plane and has ever since remained in three dimensions. While it might be interpreted as wall relief sculpture, I continue to think of it as painting, since the constructions are of stretched and painted canvas. The canvas is stretched over wood armatures to make three-dimensional forms that often have double-curved surfaces. These forms are then painted and fitted together.

Color is an important element of my work. In my paintings, it is used in conjunction with the real shapes to create illusory spaces. The principal idea advanced in each of these paintings is the combining of real or actual spaces with illusory spaces in relationships that result in a unified work. The paintings continue to evolve through a combination of forms, using applications of various techniques and materials.

During one period, the paint applied to the work was all white; however, because of the dimensional construction, the situation of the surfaces and the shadows that formed resulted in a "many-colored" painting that was caused by reflected light and that changed over time with the angle of the light. These paintings comprised one of my last exhibitions at Denise René. It became one of my most memorable shows.

For some years, I worked with independent dealers before joining D. Wigmore Fine Art in 2008. Simultaneously, I showed with the David Richard Gallery in Santa Fe, New Mexico. In 2011, I was invited to join the Marc Straus Gallery in New York, where I remain.

It was in grade school that I decided to become a painter. Since childhood, my parents and teachers had encouraged my drawing and painting. I was blessed with superior art teachers in high school. In addition, I attended art classes on Saturdays at the Everson Museum of Art in Syracuse, New York, where I grew up. I also had the opportunity to attend figure-drawing classes at Syracuse University. By the time I finished high school, I was awarded a full tuition scholarship to study painting for four years at Syracuse. There, I was taught figure drawing and still life and landscape painting.

In my last year at Syracuse, I won a senior fellowship, which I used to study painting with Morris Kantor at the Art Students League in New York City. In the city, I was greatly influenced by the prevalence of abstract expression practiced by the artists of the fifties—Willem de Kooning, Jackson Pollock, Mark Rothko, Barnett Newman, Clyfford Still, Ad Reinhardt, and others.

In my classes at the Art Students League was James Rosenquist. We became friends and shared a studio on Coenties Slip in the early sixties. During these years, I met Robert Indiana, Lee Bontecou, Robert Smithson, Robert Ryman, Robert Mangold, and Eve Hesse—all in their formative stages. It was an exciting time to be working in the city.

Never an easy matter to find living and/or working space for a beginning artist, my address and studio location changed many times through the sixties. To finance my life in New York, I taught art classes at private schools—first at Staten Island Academy and later at Woodmere Academy on Long Island. In addition to the art classes at Staten Island, I taught engineering drawing, and at Woodmere, I taught a woodworking shop class. The teaching of these classes turned out to be quite fortuitous—the experience had a profound influence on my artwork that followed.

In the late sixties, after much bouncing from one living-working space to another, I found (with the help of an artists' real estate agent, Jack Klein) a very nice studio on the Bowery at 2 Spring Street. In the same building were Will Insley and Robert Indiana. As my need for more space grew, Jack found me a larger studio space just up the Bowery; other artists at that location were Jim Rosenquist and Tom Wesselmann on the lower floors and David Diao above. When David Diao moved out, Will Insley took his space and was my upstairs neighbor until his death last year. Robert Indiana moved from Spring Street to his current studio in Maine.

The building here on the Bowery has been home for several artists in addition to myself since the early seventies. With the building of the New Museum next door, the scene began to change. As the museum had need for more working space, they acquired our building and are occupying most of its floors. Although one by one the resident artists have left, the art scene nevertheless continues in our neighborhood with the activities of the museum and with commercial galleries finding new homes on the Bowery.

My studio occupies spaces in two buildings: one where I live and work with my wife, Jan—a "clean" space where I store and show my finished paintings; and an office space where I have my photography archives and, in an adjacent building, my workshop where I have my woodworking tools and my painting studio. There, the "serious" work is done. My studio is in easy walking distance of the Marc Straus Gallery on Grand Street, which shows my work commercially.

While paintings make up the greater part of my production, I also enjoy collaborating with master printers to produce suites of embossed silkscreen prints. Beginning with Richard Feigen Graphics in 1968, I have also worked with Sillman and Ives in North Haven, Connecticut; Don Saff and Dan Stack at GraphicStudio at the University of South Florida; Poldi Domberger in Stuttgart, Germany, in 1970; Denise René Graphics at Arkay Studios in Paris in 1974; and others. Currently, I am collaborating with Gary Lichtenstein at Gary Lichtenstein Editions at MANA in Jersey City in the production of several editions.

While my primary passion is the making of art, I also enjoy the teaching of art. I have taught for short periods with several schools that have offered classes in New York City—Syracuse University and Cornell University, Cooper Union, and Pratt Institute. Beginning in 1990, I taught for three years at the University of Georgia in Athens with one summer semester in Cortona, Italy, two semesters at Princeton, and beginning in 1995, at the Art Students League in New York City, where I remain. I have a wonderful group of students from all over the world, from different countries and cultures. They range in age from just beyond high school to retirement. Their histories cover a wide range also, from beginners to the very experienced.

Given the assortment of people and backgrounds that I deal with weekly, it is not easy to embrace a set curriculum. Every student has his or her own interest and style of painting. And so, my teaching philosophy, which seems to work well with all my students, is to guide them

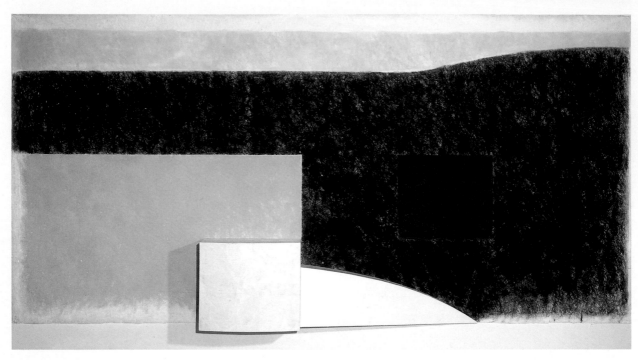

Charles Hinman
Night and Day
n.d., acrylic on non-woven fabric and wood, 90 x 180 x 16 in.

toward finding their own individual identity as an artist. This requires a strengthening of their innate abilities and talents while helping them to form their distinctive visions and aesthetic positions. I encourage them to direct their work to the highest possible level of achievement. In order to affect this, I try to get them to bring to bear their cultural background and personal experiences in such a way that they become the artists that they want to be.

In the process of helping them develop their expertise, I offer individual criticism. Also, I find that a successful method is to have the students present their work to the class. They describe their objectives and talk about how they either have succeeded or failed, what their history is, and where they hope to go. Then the discussion is open to questions from the class. Sometimes those

questions are very helpful, and sometimes students' own presentations are the most revealing about how they should proceed. There is a spirit of constructive, supportive dialogue. As each of the students presents to the class, they all get to know one another better and get to know themselves as well.

The icing on the cake is the class exhibition in the spring, in which all participate and finally see their work hanging side by side with their peers (for more, see "Concours," page 282). By this time, many have gained confidence in their own work and are already planning to have it exhibited outside the League. This is what really makes a teacher proud.

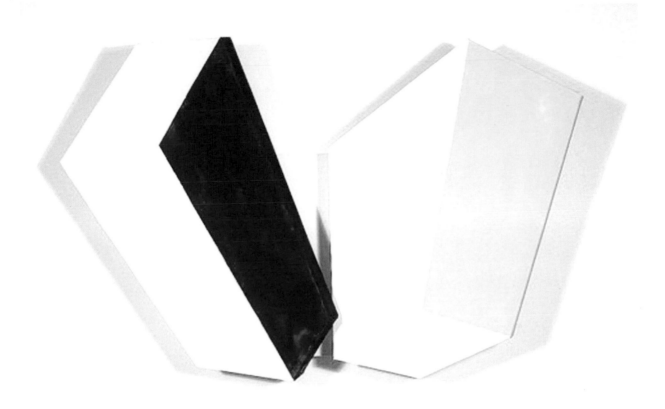

Charles Hinman
Blue Yellow
2008, acrylic on canvas, 26 x 42 x 13 in.

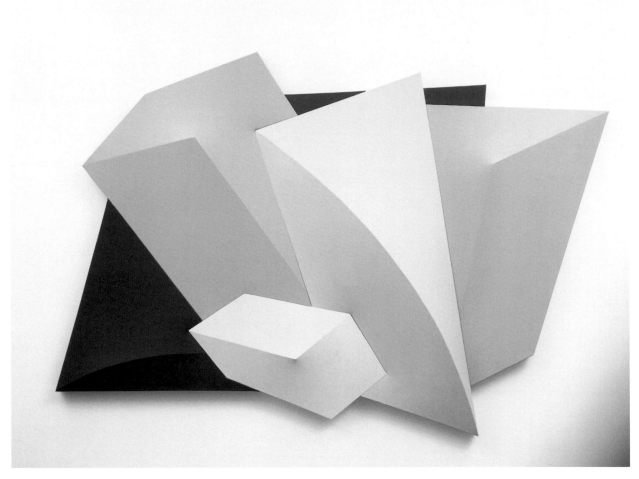

Charles Hinman
LeLande
1980, acrylic on canvas and wood, 64 x 89 x 6 in.

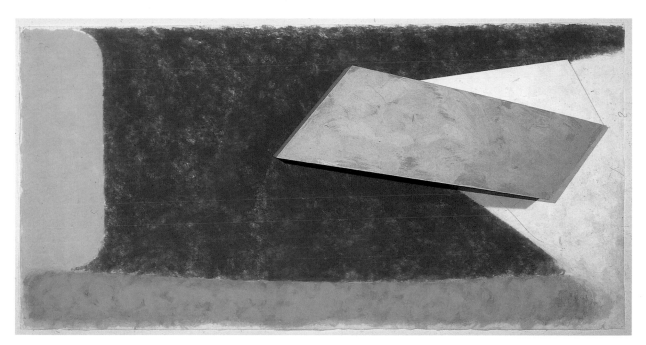

Charles Hinman
Draconios
2000, acrylic on non-woven acrylic fabric, 70 x 139 x 16 in.

STUDENT GALLERY

Aya Ogasawara
Ritual in the Courtyard
2012, oil on canvas,
72 x 48 in.

Jeanette Sura Sababa
Numero Cinco
2009, acrylic on canvas,
28 x 78 x 1.5 in.

Top
Aya Ogasawara
Her Digestion
2012, oil on canvas,
12 x 20 in.

Michelle Melo
Malabarismos
2010, acrylic on canvas,
48 x 60 in.

DEBORAH
WINIARSKI

Deborah Winiarski teaches Mixed Media, Collage, Painting and Dimensional Art at the Art Students League of New York. She has also been teaching encaustic workshops there since 2009. She has been a workshop instructor and presenter at The International Encaustic Conference held annually in Provincetown, Massachusetts, since 2012, and is currently featured artworks editor of *ProWax Journal,* a quarterly online publication for professional artists working in the medium of encaustic. Winiarski was an artist-in-residence in 2014 at The Studios of Key West in Key West, Florida. Her work has been exhibited at venues in New York City and across the United States, including Denise Bibro Fine Art, Kouros Gallery, and Viridian Gallery in New York City; Heather James Fine Art in Palm Desert, California, and Jackson, Wyoming; A Gallery in Provincetown, Massachusetts; Woodstock Artists Association & Museum in Woodstock, New York; Mount Dora Center for the Arts in Mount Dora, Florida; and Truro Center for the Arts at Castle Hill in Truro, Massachusetts.

Deborah Winiarski
Saffron I Detail
2014, encaustic, fabric, thread on panel,
25 x 20 x 5 in.

DEBORAH WINIARSKI

Painting and Encaustic

My thoughts on art and art-making are not particular to painting alone. I believe that Art with a capital A, when it is just that, it is the singularly clear expression of one human being. A work of Art is like nothing else. It may reference other things, but is as unique and distinct as its creator. The differences between what a painting is and what it may be connected to makes Art possible. The differences make a difference.

A painting should fulfill itself in its own terms. It should be what is meant. Nothing more nor less will do. Painting involves risk—counterpoint being the riskiest element of all. It is essential to art-making. Counterpoint is the assertion of self and choice within a work such that it provokes and creates tension. With every stroke, one must be willing to risk losing one's anonymity and becoming known.

To paint is to remain open to possibility. One must stay aware within the ongoing conversation with the work. It is important to look, and look again—and then perhaps look again. Concepts may lead or guide—but it is important not to be rigid and hold fast to preconceptions. One's preconceptions should never overrule what is actually happening on the canvas.

Painting involves making choices—choices about what to use, and when and where to use it. It is important to know one's materials and the possibilities they hold so that thoughtful choices can be made. Every choice an artist makes should be made with complete intention. It is within these choices that self is asserted and art is born.

I never "decided" to become an artist. I've created from the time I was a child. There was eventually a point in time when I gave myself over to what was true and right. It was then that I decided to devote my life to art-making. It was only after I took action to reflect that

choice that everything fell into place. Life became richer, fuller, and more meaningful.

My formal artistic training began during my travels abroad. I always brought paints, pencils, and paper with me wherever I went so that I could work on my own; but when spending prolonged periods of time in a place, I would seek out local studios or schools where I could work. I did this several times in Florence and during my time in Japan.

Upon returning to New York City, I studied at the Art Students League of New York with Bruce Dorfman. Working at the League immersed me in an environment devoted to art and artists. I soon came to understand that continued formal study would no longer be necessary. In a very short time, I felt I could and *should* be working on my own.

I live and work within the same space. My living space is arranged around my studio and allows me to be around my work all the time. It's very important for me to have my paintings within view even when I'm not physically at work. My work area is in a large, well-lit room. On one wall, I've built a scaffold to hang work in progress. On the opposite wall is my primary worktable. Here I keep my colors, hot-box for warming wax, tools, and other equipment. I have many smaller tables that I've put on wheels to give me added flexibility.

My current work is in the medium of encaustic. The word *encaustic* is derived from the Greek word *enkaustikos* and means "to heat" or "to burn in." In encaustic painting, molten beeswax is combined with a tempering agent (usually damar crystals) and is then pigmented. The addition of damar varnish helps to strengthen the cooled surface. This molten mixture, or encaustic medium, is applied to a painting surface and then fused, or re-melted, so that it becomes one with the

layers below. It is this buildup of layer upon layer of wax that gives encaustic work its luminosity.

Encaustic paint is best applied to a rigid and absorbent surface, so I always begin a new painting by building a sound and stable braced support. Archival mat board is my usual choice for a ground.

My process is twofold in that imagery develops on fabric via an encaustic monotype process. Pigmented beeswax melts as it is applied to a heated plate. The plate is worked by painting, drawing, blocking, and stamping into the melted wax. The fabric is then laid upon the plate, absorbing the color and imagery—becoming one with the wax. Once printed, the fabrics are cut, torn apart, sewn together, crumpled, twisted, woven. The torn shapes provide form and color—their edges, line. Additional fabrics, threads, and string add even more texture. Layer upon layer of clear wax provides depth of field. In the panel-based reliefs, the fabrics are collaged above and below the surface of the painting.

In describing my teaching philosophy, I believe that each student is a unique individual and should be treated as such. Students enter the studio with different backgrounds, levels of experience, technical expertise, and so on, so it is important to work with the individual student—each person from his or her own starting place.

We begin with a conversation. Mostly, I ask a lot of questions. Part of the conversation is talking about their preferences—in art, music, materials, tools—and finding out what it is they value and wish to convey. What preferences do they have with regard to form, color, line, texture? What do *they* need to see? Essentially, I help my students to clarify their preferences for themselves so that they can move forward in their work in a clear and intentional way.

Deborah Winiarski
On the Heights
2012, encaustic, paper, oil on panel,
31 x 36 x 3 in.

Opposite
Deborah Winiarski
Saffron I
2014, encaustic, fabric, thread on panel,
25 x 20 x 5 in.

Deborah Winiarski
Verdure
2014, encaustic, fabric, thread on panel,
21 x 24 x 4 in.

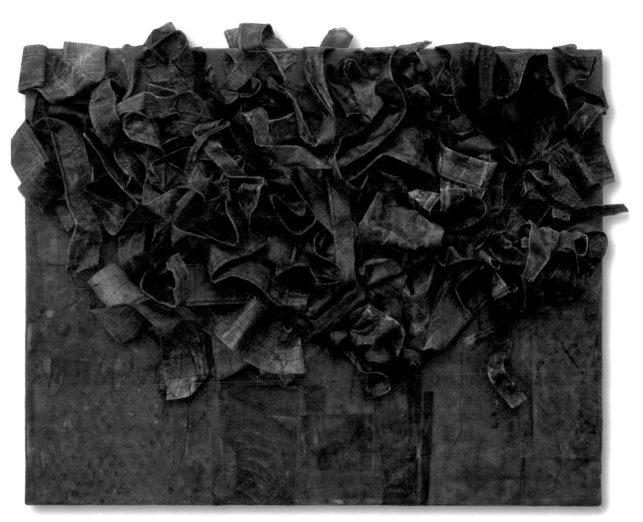

Deborah Winiarski
Sospirando
2013, encaustic, fabric, thread on panel,
21 x 25 x 5 in.

Trudi Mara Schleifer
Tsunami
2013, encaustic and graphite on paper,
5.5 x 9.25 in.

Elizabeth Velazquez
Untitled
2013; acrylic, charcoal, pigments, thread, selenite, paper;
12 x 6 x 1.75 in.

Lori Hope Zeller
Golden Moments
2014, acrylic and mixed media
on canvas, 24 x 20 in.

Carole Peck Harrison
What Goes Around
2013; acrylic, charcoal, pigments, thread, selenite, paper;
24.5 in x 22.5 in.

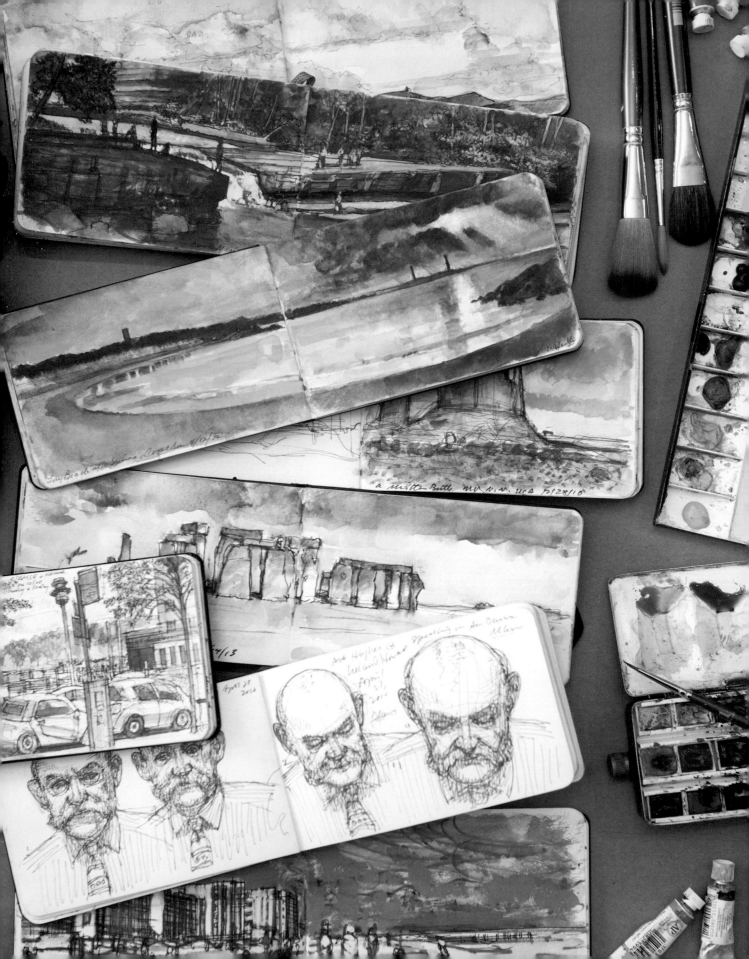

JAMES L. MCELHINNEY

James L. McElhinney has a BFA from Tyler School of Art and an MFA in painting from Yale University. His teaching career began as an assistant to Bernard Chaet at Yale, followed by appointments at Bowdoin College, Moore College of Art and Design, Skidmore College, East Carolina University, and the University of Colorado. He was artist-in-residence at Harper's Ferry National Historic Park in 1999. Since 2004, he has been visiting associate professor of drawing at Pratt Institute in Brooklyn and has taught at the Art Students League of New York since 2005.

James L. McElhinney
Selected notebooks
2011-2014, colored pens and watercolor
on Moleskine journal, 3.5 x 10 in.

JAMES L. MCELHINNEY

Journal Painting and Composition

Leonardo da Vinci is the Renaissance artist best known to most people today. *La Gioconda* or *Mona Lisa* may be his best-known work, but his notebooks are the true reason for his fame. They demonstrate his skill as an inventor and his attainments in science, anatomy, and military engineering, as well as how these fields may be practiced as arts in their own right, in concert with the fine arts of music, literature, architecture, sculpture, and painting. Leonardo shows us the beauty in knowing the world through visualization. His starting point was painting.

Artists have always kept sketchbooks. Leonardo was not the first. Villard de Honnecourt lived two centuries before Leonardo, and it would be reckless to presume that, just because his sketchbooks have survived, most artists of his day whose have been lost were not busy in similar ways.

During the medieval period, book illumination was one of four major mediums for artists working in pictorial forms. The others were buon fresco wall painting, tapestry, and votive panel painting, including altarpieces and the occasional royal portrait.

Prior to the invention of the printing press and movable type in the fourteenth century, the painted book dominated picture-making across the known world from Ireland to Japan, from Christendom through the Islamic world and India to the Far East. There is no lack of irony in the fact that as tablet readers today replace many forms of printed matter, handmade books are staging a comeback. One might observe that as old technologies are rendered obsolete, they become new mediums for artists.

When I came to the League, it was to teach painting. I encouraged all of my students to acquire small notebooks and to use them as portable laboratories. My own addiction to journal-keeping began when I studied at Tyler, and later at Yale, where I began collecting art books in earnest. One of my first pricey acquisitions was a slipcased edition facsimile notebook by Albrecht Durer of his trip to the Netherlands. Two of Georges Seurat's sketchbooks in the Yale Art Gallery inspired me with their spontaneity and informality. It hardly seemed possible for them to have been carried by the same person whose paintings are monuments to precision.

Another early acquisition was James Michener's *Hokusai Sketchbooks*. Growing up in Doylestown, Pennsylvania, I remembered James Michener as "Mitch the Witch" wearing a turban, seated at a table on which sat a crystal ball beneath a marquee at the Tinicum Arts Festival. I was too shy to go up and let him tell me my fortune.

My first encounter with Hokusai had been through Richard Callner, who had invited a few of his students to visit his home on the Philadelphia Main Line. His wife was *nisei*—second-generation Japanese-American—in consequence of which they possessed a fair number of prints, ceramics, paintings, and swords. What struck me were the volumes of the Hokusai manga, filled with woodblock prints delineated in shades of pink and black. Over the years, I myself have filled hundreds of notebooks, which I have come to regard collectively as my greatest achievement. Like Hokusai, I regard my previous work as a modest preamble to greater things.

Unexpected Detours

Almost ten years ago, I suffered a mysterious pulmonary illness from which I mysteriously recovered to find that I had become intolerant of oil paint, solvents, mediums, and even the scent of paint in tubes. In response to this calamity, I taught myself to work in acrylics and watercolor. To my delight, I found both mediums

immensely agreeable, largely because they required me to work closely tethered to the process of drawing. At first I resisted the mechanical demands of painting in acrylic, such as saving mixed colors sealed in plastic tubs, and the reverse process of painting in watercolor from light to dark. Ultimately I came to rely more heavily on drawing and organizing my basic palette according to color temperature contrasts (warm/cool) in earth colors.

This palette consisted of Naples yellow or yellow ochre combined with Venetian red and ivory black, mixed with a touch of ultramarine blue. It was not a conscious stratagem on my part to use a sixteenth-century oil painter's palette but a decision to step back from saturated color in my opening moves. Painting in watercolor is a bit like chess in that one must get control of certain key elements early in the process or chaos may ensue. Using a simple palette sent me back to the museum with sketchbook in hand to refresh my grasp of Venetian color concepts and to reinvigorate my grasp of composition.

Creative Copies

The desire to paint something is not born out of our genome. It is a conscious decision perhaps fueled by a passionate attraction to painting as a form of visual inquiry and expression. In order to make art, one must know what art is. Thus the urge to paint is sparked by having seen a painting somewhere—perhaps in a book, a gallery, or a museum. Beautiful reproductions published in bound volumes, or now searchable on the Internet, can never replace the physical and emotional effect of standing before a great work of art.

Encouraging my students to bring sketchbooks to any museum of their choice, I direct them to explore individual paintings through a measured process of drawing, not just to reproduce the image but to decode the riddles of design that underpin them. Drawing gives painting its bones, pigments and resins its flesh and blood, but composition gives it higher intelligence. Before painters fell under the spell of photo-imaging and the magic of cinema, paintings were themselves motion pictures.

To understand composition, one must grasp how great paintings coax space into becoming volumes, depth, balance, and dynamism. How color moves through space as light is how drawing becomes painting. Painting is not something that hangs on a wall or rests on a page. It is a species of visual mobility.

Visiting a Poussin retrospective at the Metropolitan Museum of Art, I recall watching a colleague remove a sketchbook from his pocket and begin to draw. The first few marks revealed very little, but within instants a figure appeared, and it was obvious that he would never capture the entire composition. The largest thing in any drawing is the page. The dominant feature of any painting is the shape of its frame.

In making interrogative copies of masterworks, that is the first thing one must draw on the page. Once the proportions of the frame have been measured and reconstituted on the page of a sketchbook, the rectangle can be divided into quadrants and ninths—the latter sometimes known as the Rule of Thirds familiar to users of SLR cameras as a guideline grid of two equally spaced vertical and horizontal lines over the frame, the intersection points of which create four points near the center of the viewfinder. The quadrants represent the symmetry, while the Rule of Thirds division of the space into ninths represents asymmetry and dynamism. Both modes of division operate reciprocally. Each divides the space into smaller rectangles of the same ratio of height and width to that of the mother rectangle.

Plotting three or four major vectors within the composition—alignments, angles, vaulting curves, or flowing gestures that overlay the armature of the rectangle—the pictorial elements thus set in motion reveal a map of the picture. Composition provides an itinerary for visual journeys through pictorial space. Cinema moves the pictures, but painting moves the viewer.

Field Studies

Journal and book painting did not die out with the advent of the printing industry, which repurposed artists' books to different uses. The physical form of the bound book has its roots in India and Asia more than two thousand years ago, and in eighth-century Europe. The printing industry embraced bound texts as its dominant format because they fit easily into the palm of the hand and could be made to be portable. The familiar artists' portfolio is nothing more than an unbound book: hinged boards surrounding loose sheets.

The great age of maritime exploration and trade began at about the same time as Johannes Gutenberg pulled his first imprints. Blank books served as ships' logs and rutters, account books, and personal journals. Expeditionary artists like Jacques le Moyne and Roanoke Colony governor John White produced elaborate drawings of exotic lands, complete with flora, fauna, and inhabitants. The sixteenth-century hunger for botanical illustration came not from the scientific community but from professional embroiderers, clamoring after source material for new designs.

Most artists who worked in books used aqueous mediums: ink and watercolor, which were already in wide use by cartographers. Expanding trade to East Asia, European merchants and soldiers encountered Chinese and Japanese ink painting, as well as a separate culture of book arts. By the mid-seventeenth century, the Dutch were the only westerners allowed to maintain a trading facility on Japanese soil. In consequence, Dutch artists like Rembrandt found a ready source for new kinds of paper, ink, brushes, and reed pens.

More artists began to work in sketchbooks as European landscape painters in Germany, the Netherlands, and Britain developed the art of picturing terrain and the effects of weather. French expatriate Claude Lorrain responded by formulating a canon of ideals for the practice of landscape painting and compiling dozens of his original compositions into his

Liber Veritatis, or *Book of Truth*, by which means he was able to copyright his designs. More than a century later, J. M. W. Turner assembled an even more ambitious taxonomy of his imagery entitled *Liber Studiorum*, or *Book of the Studio*. It was also Turner who transformed watercolor from a medium mostly confined to use by the military, scientists, and amateurs into studio practice for professional painters. Samuel Palmer, William Blake, and Eugène Delacroix kept visual journals, transforming the sketchbook from a preparatory device into a painting genre in its own right.

Starting in the 1820s, industrial transportation delivered artists from their studios into the field, giving rise to the *plein air* movement led by painters such as Corot, Constable, Rottman, and the Barbizon School in Europe, and the Hudson River School in America, where on the advice of Alexander von Humboldt, scientific expeditions were accompanied by artists.

Fieldwork in Practice

One of the advantages of journal painting over the plein air practice of carrying *chevalet du champs*, or field easels, is the lack of bulk and weight. So-called French easel paint boxes and the updated *pochade* boxes favored by legions of plein air aficionados are physical encumbrances that limit personal mobility.

A bound watercolor book together with a simple water flask, eight- or twelve-pan watercolor box, some sponges, paper towels, and a safety razor offer the twenty-first-century artist the ability to carry everything on their person. To this end, a travel vest or jacket with many pockets is advisable, as might be cargo pants.

Venturing into the landscape, one must always be mindful that one is entering Nature's realm, not an alfresco studio. Disease-bearing insects, venomous reptiles, hornets, feral mammals, and antisocial humans present occasional risks, as do the natural toxins found in some plants, such as poison ivy, oak, or sumac.

Fieldwork also requires the use of sunscreen, insect repellent, appropriate footwear, clothing, and headgear,

as well as a sufficient supply of drinking water. Depending on your location and distance from transportation, a fully charged cell phone and up-to-date maps might be useful to have. In remote locations, a sidearm might be advisable, but only after completing a hunter safety course and firearms training by a licensed instructor. Landscape painters such as the Barbizon School in France and Americans like Thomas Moran advocated the formation of parks and the preservation of wild spaces. In that spirit contemporary artists are wise to be respectful of natural places by leaving them in the same condition they find them.

Eighteenth- and nineteenth-century artist-explorers who accompanied military and scientific expeditions inspire my fieldwork more than studio artists who made grand tours of Italy in search of motifs.

J. M. W. Turner and Carl Rottman interest me far more than Corot because of their narrative approach to landscape, and of course Turner's use of sketchbooks. Le Moyne and White have been mentioned. I might add William Hodges, who circumnavigated the globe with Captain Cook on the HMS *Endeavor*, John James Audubon, Samuel Seymour, Rembrandt Peale, the Kern brothers, Seth Eastman, Karl Bodmer, Alfred Jacob Miller, George Catlin, Albert Bierstadt, and Thomas Moran.

Like all of these artists, my fieldwork includes a strong element of drawing, which dovetails with journal-painting by using waterproof pens in various colors, mostly in warm colors such as yellow, orange, sanguine, and red, which fall into a higher tonal register. Grisaille, camaïeu, and monochrome paintings are always an option. I refuse to inhabit any canon of style that might restrain my curiosity.

The art of chorographic topographical drawing—mapping what the eye sees from the surface of the earth to explore the character of terrain, weather, flora, fauna, and human presence—is not unlike life drawing in that one begins with a gesture, a grand movement through space, followed by a series of measurements.

What differentiates a sketch from a painting for me is not whether or not it is done on canvas or paper to be framed and hung on a wall, but the level to which the composition has been developed. Cézanne gives us a model for painting that is complete without being finished by working with multiple horizons and focal points.

A painting is complete when the composition has been realized. Intention, craft, style, everything else is subordinate to the visual clockwork behind any picture. Over the course of their lives, painters migrate from subject to subject, from one medium or style to another. The most compelling evidence of personal vision is not declared by force of expression but by how one envisions and navigates space—in other words, by the character of one's compositions.

Esprit de l'Escalier

Keeping a sketchbook has long been recommended to painting students in the same way that students in liberal arts and sciences courses might be required to dedicate a notebook. Research has shown that memory benefits from doodling, in effect as a way of burning classroom lectures onto cerebral hard drives. Maryam Mirzakhani, the first woman to win the coveted Fields Medal for mathematics, uses drawing to visualize and solve problems dealing with geometry and spatial navigation. Keeping a visual journal has obvious benefits for students and for working artists. One such benefit is the capacity to work with analog mediums on a digital scale—surfaces the same size as cellular phones and tablets. While many painters will continue to work on walls, paper, and canvas, they will also begin to expand their conceptual activities into digital mediums and hardware, such as sketchbook applications and drawing tablets. David Hockney is a prime example because he is neither young nor a Luddite opposed to new mediums. The greatest benefit of journal work may be that it returns painting to a devotional scale—an environment in which painting can be experienced on an individual level where painters and viewers might pursue more intimate conversations.

James L. McElhinney
Ellis Island from the Battery
2014, colored pens and watercolor
on Moleskine journal, 3.5 x 10 in.

114
Sketched in the middle of Pewits wedding

James L. McElhinney
George Washington Bridge from Fort Tryon Park
2011, colored pens and watercolor on
Moleskine journal, 3.5 x 10 in.

FORT LEE

7/5/12

James L. McElhinney
Bridges at the Hudson and Sacandaga Confluence
2011, colored pens and watercolor
on Moleskine journal, 3.5 x 10 in.

James L. McElhinney
Niagara
2012, colored pens and watercolor
on Moleskine journal, 3.5 x 10 in.

STUDENT GALLERY

Left
John Prendergast
Life Drawings
2015, Micron pens and
watercolor on Moleskine
journal, 7 x 10 in.

Bottom
Kevin Storms
Valley Farm, Pine Bush, N.Y.
2013, Micron pens and
watercolor on Moleskine
journal, 3.5 x 10 in.

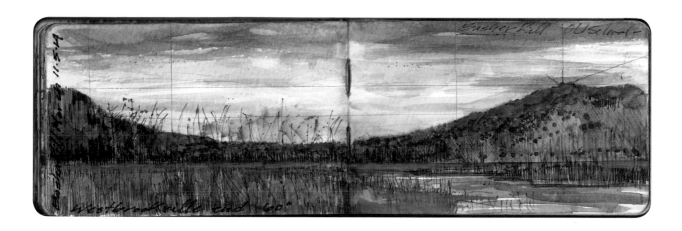

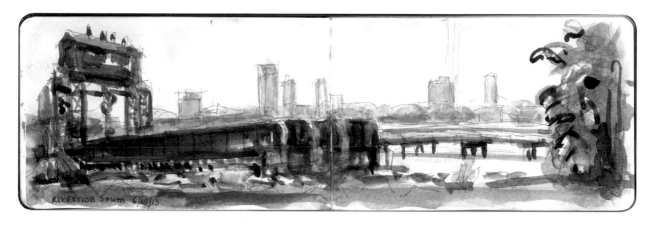

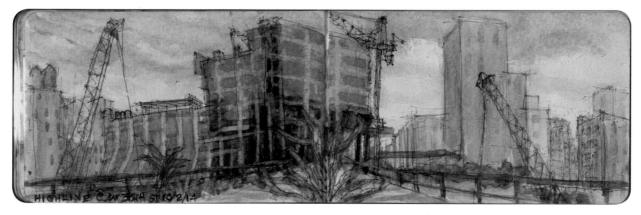

Top
Kevin Storms
Bashakill Wetlands from Westbrookville, N.Y.
2013, Micron pens and watercolor on Moleskine journal,
3.5 x 10 in.

Center
Laura Rosen
Riverside South
2013, Micron pens and watercolor on Moleskine journal,
3.5 x 10 in.

Bottom
Nora Katz
Highline at W. 30th St.
n.d., Micron pens and watercolor on Moleskine journal,
5 x 14 in.

Part 3

INTERVIEWS

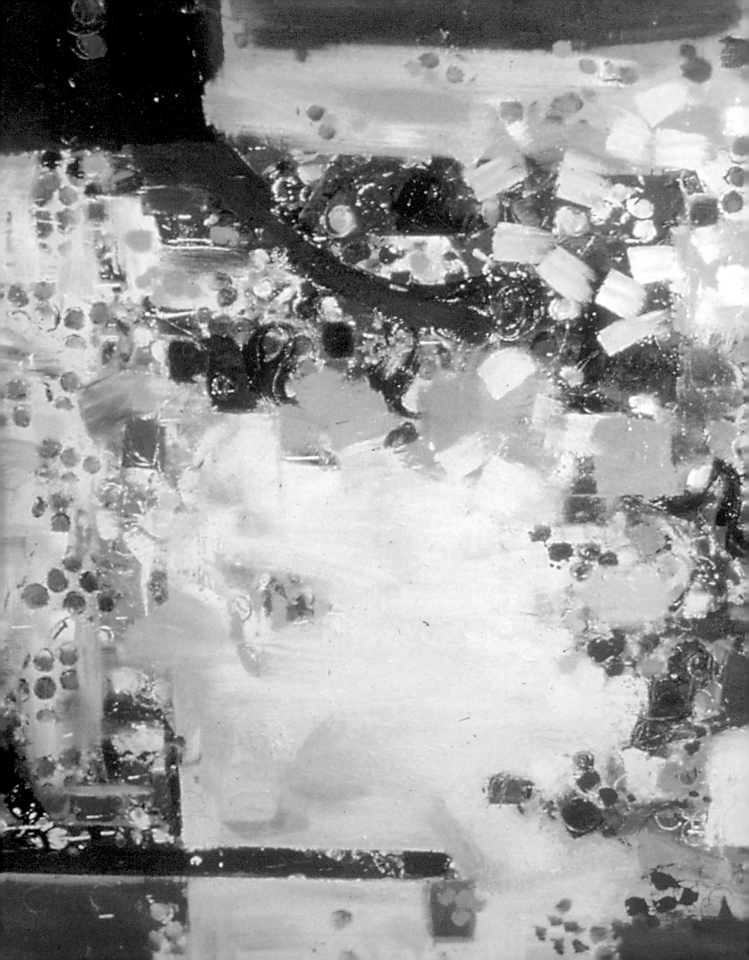

FRANK
O'CAIN

Frank O'Cain was born in San Diego. He studied at the Art Students League of New York for four years, part of that time with Vaclav Vytlacil. His abstract art derives from an elaborate study of long-forgotten fifteenth-century techniques. For a time, O'Cain's oil paintings involved no fewer than a hundred separate glazes. Recently, he has been exploring a new approach to space in painting.

O'Cain teaches the basic principles of pictorial structure. He gives his students a point of departure that enables them to push their work toward a personal, abstract expression. He has had one-man shows at Purdue University; the Miriam Perlman Gallery in Chicago and Flint, Michigan; the Princeton Arts Society, Levitan Gallery I and II, New York City; the Saginaw Art Museum; the Ella Sharp Museum of Art and History, Jackson, Mississippi; Northern Illinois University; and the Theano Stahelin Kunstsalon, Zurich. He has participated in group shows at D. D. & B. Gallery, New York City; Gallery Korea, New York City; and Gen Paul Gallery, Paris. His work is represented in the collection of the University of Michigan; the Midwest Museum of American Art, Elkhart, Indiana; and the Saginaw Art Museum. He has taught at Merrimack Valley of Music and Art in Manchester, New Hampshire, and at the Fairlawn Community Center in New Jersey.

Opposite
Frank O'Cain
Dance of Man
n.d., oil on canvas, 72 x 66 in.

Pages 228–229
Ronnie Landfield
Diamond Lake
1969, acrylic on canvas, 108 x 168 in.

FRANK O'CAIN

Abstraction from Nature

On May 18, 2013, James Lancel McElhinney sat down with Frank O'Cain to get his thoughts on how painters teach painting.

James Lancel McElhinney: Briefly, could you tell me how you define painting?
Frank O'Cain: Basically, I define painting as something existing on three levels: structure, light, and space. Structure is the priority, because it holds the other two together.

JLM: Do you mean the composition?
FO: Sure, the composition. But there are two forms of composition: the structure underneath that you build upon and there's the composition that runs across the surface that relies on that grid, the idea of movement of volume that helps to retain surface composition as a whole.

JLM: So you'd say that the substratum is purely abstract, and that the superstructure—whether it be an image or personal mark-making as image or expressive abstraction—all that rests on that substructure?
FO: Yes.

JLM: Okay, so how do you explain that to students? If somebody comes into your classroom and says, "Mr. O'Cain, I want to learn how to paint," how can you be sure they are ready to hear such a philosophical take on things?
FO: I can't. Since the League has no entry requirement, I need to speak to each student individually, to determine what level they are at.

JLM: So how do you bring them into the conversation?
FO: I don't. What I do is let them lead themselves, basically I set up a form of exercises that build an eye—their visual skills—and I can slowly show them how their eye is beginning to adjust to what they do on the surface, and

I have them do things that have very little tension at all, just play, and then I will have them try to make a form.

I try to keep it simple, black and white, using geometry, for example. And I might make them put it at an angle, which excites the negative space, putting it together with the positive shapes. Through the process of seeing how an active negative space can excite a form, the students begin to become more intrigued.

JLM: So, could you try to describe a specific assignment? Posed model, still life . . .
FO: I do it in different ways. I have a drawing-from-the-model class or abstracting-from-the-model, moving from concrete form to abstract thought to synthetic that dissolves, becoming more and more abstract in content. That's the easy way, the approach I use in my daytime class. Students in my evening class are expected to develop their own ideas from sketches. At night I force them to work like professional artists, pursuing their own ideas rather than doing assignments. If they don't know how to draw, I will send them to drawing classes like yours to learn how to build a form, control a line, and develop a sensitivity of execution. Without that they can't begin to understand what I am asking them to do.

JLM: Structure is the priority because it holds together space and light. You believe that students must understand structure, light, and space, and that the way we understand these things in the most basic way is by learning how to draw.
FO: That is correct.

JLM: Measuring space in a visual way. So why don't you describe your own training: Where were you born? Where did you grow up?

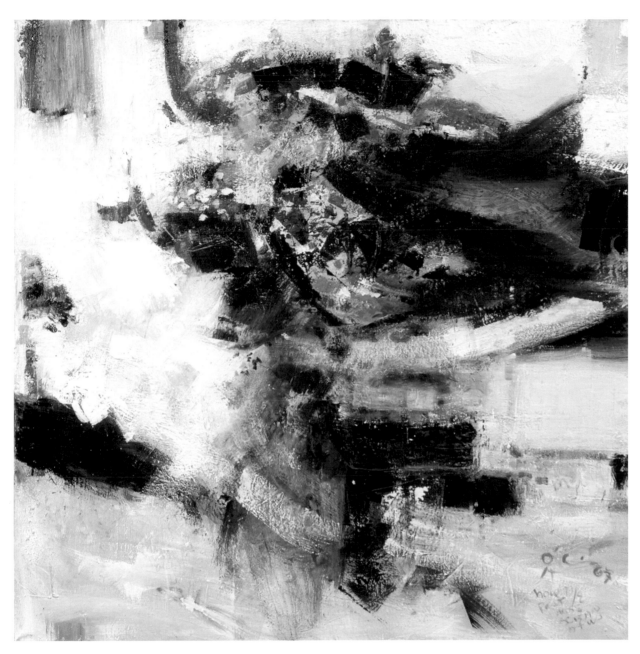

Frank O'Cain
Emerging III
n.d., oil and wax on canvas, 48 x 50 in.

FO: My life was basically complicated. I was a navy kid. My father spent twenty-three years in the navy. I was born in San Diego, and by the time I was three, I was in Hawaii. When Pearl Harbor was being bombed, my family was disembarking at San Francisco. From there we went to Chicago. Between the ages of five and eighteen, I had lived all over the country, and because of this, I never had any roots.

I don't look at this country as north, south, east, west, but just as a country that I participated in. A roaming life suits my nature—very gypsy-like, not very settled. I am seldom comfortable being in one place, except New York, because it changes constantly and so, in a way, feeds that hunger for energy.

JLM: It's a fluid environment . . .

FO: It is a very fluid environment. As for my education, I got started with a group of painters and writers in Richmond, Virginia. When I wandered into that place, I had no sense of what I was going to do. I was not in the habit of going to museums, which were not the kind of places my group frequented.

JLM: How did you end up in Richmond?

FO: It was a pure fluke. When I was out of the service, like a lot of vets, I went looking for work.

JLM: Were you also in the Navy?

FO: No, I went into the Air Force. I was smart enough to stay off ships. In the armed forces, the Air Force was the closest thing to being a civilian, but I still served my time, and did well by it. After being discharged, I was wandering around looking for a job.

I was in the South. My father had settled in Florida. In the South, there was no work due to there being a depression at that time. I saw an ad for teaching people how to drive buses, so I went to Richmond. They put me up for a couple of months until they realized I was dangerous behind the wheel of a bus.

By then I had become part of the community, which was probably the first real art community I belonged to. It had everything, from dancers, actors, writers, painters, and poets. It was an amazing . . . it saved my life.

JLM: The Fan district is still the residential adjunct of Virginia Commonwealth University. There is the Virginia Museum and Battle Abbey on the Boulevard, Victorian houses . . . a lot of artists live there today. Who were the leading artists when you were there?

FO: The big one was a guy called William Kendrick, still life painter and portrait painter, who was tremendously generous toward me. There was another Irishman names Bill Amblong who went wild out of the season. There was William Fletcher Jones, who was more successful, a very finished kind of painter, who traveled back and forth from New York. Lester Blackston and William Walker, both who were writers and friends of Norman Mailer up in Provincetown. Mailer was at that time helping writers, artists, and such. There were a few others like John Slater, who was more of an illustrator who painted portraits of W. C. Fields and old film stars like that. They were all generations ahead of me, all much older than I, and well established.

JLM: Was there anywhere in Richmond at that time to take classes?

FO: Yes, there was the Old School—the Professional Art Institute in Richmond, which has some really good teachers. I used to wander over there and listen to all the lectures and go to the classes; I never registered, I didn't have the money, so I would just wander in and sit and they would critique my work. They didn't know I wasn't a student. Nobody asked. I spent a lot of my time in the library and over at the Virginia Museum. That was my beginning, a raw beginning that lasted up until the time when I came to New York in the sixties and entered the League. People here have no idea, but Richmond was a great place for artists. Cultural institutions there do really

well, because there is a lot of money in Richmond. One of the major patrons was a big proponent of restoring the Musée Picasso in Paris, the Lewises, also the Reynolds family who were into aluminum, the Gottwalds who owned Ethyl Corporation. They all had the estates along the river. I spent a lot of time painting along the river, but it drove me crazy after a while. It was more limited than New York for sure, but for a guy coming out of the darkness and entering into something that was totally foreign and exciting, it was like heaven.

JLM: What inspired you to come to the League?

FO: Actually everybody in Richmond who helped me learn to draw. They said, "You're serious, you've got the passion, you've got to go to the League. As soon as you get to New York, get to the League." So that's what I did. I got settled, got my VA benefits, and off we went.

JLM: So what was it like when you came to the League? What year was it?

FO: It was 1972. Morris Kantor and some of the other older guys had passed away, but the artists teaching there still had the craft. Sidney Dickinson was here, cutting and slashing paint, and his cousin was still here—Edwin Dickinson. He was still playing chess . . .

JLM: And Will Barnet.

FO: Yes, Will Barnet. And also Marshall Glasier, who was a wild man, Robert Philipp, Robert Brackman; of course, George Bridgman had gone by then. And then it was back to the fifteenth century with Frank Mason and David A. Leffel. Knox Martin and Bruce Dorfman were teaching there by then. The instructor I ended up working with was Vaclav Vytlacil, who had been Hans Hofmann's favorite student and monitor.

JLM: What did you do as a student with Vaclav Vytlacil?

FO: Same thing as I teach now. He would set up exercises and sit on a stool. We would set up these big sheets of paper, and starting with black and whites, and we would discuss what was happening . . . sitting on his stool, he would ask why this was happening, why this works, why this does not. And then when you got a sense of what the language of volume really meant in painting and how you could evolve it, you began your paintings. And you would go after those. He was a good man, truthful, but not brutal. I never saw him say a bad thing or utter a mean word. He might say nothing, which could be the most devastating thing.

JLM: That was like at Yale, one of my teachers at Yale was named Bernie Chaet. Unlike people like Al Held, who would bully students at critiques, make them cry, or get into screaming matches, Bernie might look at a piece and say, "I'm sorry but I don't have anything to say about this piece. There's not much here to talk about." That was worse than being insulted, that gentle dismissal. When we spoke before to get information for the second drawing book I put together, you shared that studying under Frank Mason and David Leffel you learned historic, classical techniques.

FO: Yes, indeed. Frank Mason and David A. Leffel had already learned recipes for painting mediums from reading Donner and Maroger. I made experiments into fat mediums and lean mediums and egg mediums. I was already heavily involved in that, but Vytlacil cut my time really short because he got right into it. Of course the big mistake was Maroger, which turned out to be a disaster because it turned most of the colors black, and the surface attracted every bit of dust and insects in the universe.

JLM: Yes, Jacques Maroger, who taught here at the League and was working at the Metropolitan Museum of Art, trained at the Louvre, and was convinced that the mediums used by van Eyck, Titian and Rubens contained a drying oil made by heating it with a small mixture of lead. Who was promoting it?

FO: Leffel did, and still does.

JLM: Fairfield Porter used it, Paul Georges, a lot of painters of a certain generation.

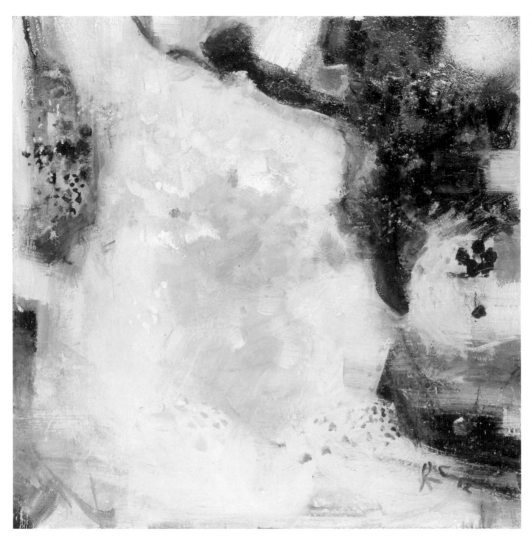

Frank O'Cain
Untitled
n.d., oil and wax on canvas,
50 x 48 in.

FO: They liked it because it was like a cream, a paste that was really easy to use.

JLM: It was replaced by alkyds. Arthur DaCosta was a traditional painter who taught at the Pennsylvania Academy of the Fine Arts. He approached a company that manufactured oil-based house paints in historic colors, with the idea of simulating Maroger medium with Alkyd resins. For a while Turco Paint Company was the only place one could buy it. When the patent ran out, everybody from Winsor & Newton, Grumbacher—everybody took the formula and started manufacturing it as a replacement for Maroger medium.

FO: And by and large, it's a lot better.

JLM: True enough, but overpainting is tricky. I used the Maroger medium as a student, and as a young artist, because I made a lot of *premier coup* one-shot paintings. For that, it was fine. But as you said, if you're building up colors by overpainting and glazing, it turned yellow in peculiar ways, almost as if the painting were suffering from jaundice.

FO: That's right; you couldn't control it. And it reacted differently to different colors. I used it to control my paint. I used poppy seed oil to slow the drying.

JLM: When you buy commercially manufactured artists' oil colors, it's generally ground in poppy seed oil or soybean oil. It seems that you received a fairly thorough training in traditional painting methods.

FO: Yes. I understood the importance of luminosity and light. What I did not understand was the control of the surface, control of the volume, or the idea of movement of planes in space. The movement of planes into position—over, under, up, down, and across the surface. Cézanne and Hofmann, through Vytlacil, led us all into the space and structure. I owe a lot to Vaclav Vytlacil. Some of these guys who taught representational painting didn't understand design at all. It was all about making it look good on the surface: let the light move in a convincing way, and that was the painting. I kept looking at Rembrandt and saying, "No! He's doing more than that."

JLM: You see in a lot of the concours exhibitions, paintings based on a simple figure-ground relationship, with dark-colored background against which the figure is privileged above everything else. They seem to be all about making light move across the surface of the body, as if that's all there is to painting.

FO: There's more to painting than just that. That's just scratching the surface. Two painters who showed me the way to go were Franz Kline and Bill de Kooning. The only thing I didn't like about them was the stance they took about divorcing themselves from knowledge. To that I just said no. I wanted to take some of their pictorial ideas, experiment with them, and see where it took me, which is what I've been doing for the last forty years.

JLM: What kind of pictures were you making when you studied with Frank Mason?

FO: With Frank I was doing self-portraits, regular portraits, and representational paintings, from figures to still life. I sold every still life I ever did except for the six I still have. They all were full of light—inner light, because that was the basis of the class.

It wasn't just light hitting surfaces, which is what any student can get. What I wanted, what I found, was the light under the color, under the surface. I found that valuable and brought it into my own teaching. The hardest subject on earth is the human figure.

A rhinoceros is easier to paint than a nude because of our relationship to it—we are all walking around in the same bones, and because of how it is put together. You can take a bowl of fruit and throw it on a table and get a composition, color, and you can study, maybe use that as a way to rehearse how to approach a figure. When you finally do get down to painting the figure, when you have developed enough of an understanding about the inner working of the figure, and how to paint the damn thing, then you can then use still life setups as testing grounds to push your skills at execution. The real problem is that while most painters might have great ideas, they can't pull them off, and that takes training.

JLM: At what point did you decide to push your work in a nonrepresentational direction?

FO: I always wanted to work nonrepresentationally. I forced myself to do the exact opposite for the first ten years or so, because somehow I knew that, way before I got my paintings where I wanted them to go, I needed to be able to understand and develop abstract concepts, and you get that by working from nature. Abstraction promised me a way to be different from everybody else, a way of personalizing my response to nature and to painting.

I was not concerned with fashion or ideas about style that fit into a certain way of thinking like someone Clement Greenberg or other critics might support. I wanted to get at the real thing.

JLM: You mean the formalist cant that was constructed to describe abstract expressionism?

FO: Right. I did not identify with the weakness and strengths I found in painters like Rothko, who on the surface look like they should be my heroes. In some ways, those guys represent the total opposite of what I want to do in my work, but I look at them, and plenty of other

artists, as possible sources of information and direction. I try to consider it all, and then take whatever I can use.

JLM: So whatever ideas you could borrow, you'd borrow, what you couldn't borrow, you'd steal . . .
FO: That's right.

JLM: You just found your own way. So when you first started working abstractly, did you derive elements of the image from the human body or from landscape?
FO: At first, it was mostly theoretical. I did a lot of red on red, blue on blue. How simple can a design be? A cerulean blue on a turquoise blue ground, a touch of orange . . . until I had done as many theoretical ideas about color and space that I could possibly stand. But as soon as I wanted to direct this more personally to get more involved with the subconscious, involving light and a concrete idea and pushing it to the limit, I went to nature, right away.

JLM: How did that work? What was your work in progress?
FO: That meant looking for shapes and forms that I could control, manipulate, and develop: piles of rocks, movement of trees, simple things that painters have been using for thousands of years.

JLM: How do you do that . . . do you carry a sketchbook?
FO: Always. I always have a sketchbook; if I don't have a pencil, I always have a brush and a little bit of water and my watercolor kit so I can make my colors. And I always believe in the unfinished idea. I believe drawings and sketches can be complete without being finished.

JLM: You're trying to respond to that experience as a painter, take a look at drawing done in the field, and begin to extract ideas about composition. In your own classes, do you try to get students to paint a certain way or do you let them follow their own desires?
FO: In a way no, I let them have their own ideas, but force them to focus on the importance of craft, to develop a good foundation, to understand inner light, and what kind

of light they're trying to get. That is not about haphazardly throwing one color over another. As paintings age, they become richer . . . brighter. Strangely, it has gotten more difficult to explain that today than when I first started teaching.

JM: How so?
FO: Well, today we have this misconception that everything in art represents some kind of attitude, combined with salesmanship. This has permeated our thinking to the degree that we see lots of people who want to be an artist for thirty minutes. They come in and throw around a lot of paint and end up with mud, which they might be able to sell for a while, and then they come up with a new kind of mud. I have been lucky as a teacher, because there always seem to be five or ten serious artists in my classes who work with me for maybe three or four years before they are ready to move on to start developing on their own.

JLM: You don't want to keep people in your class forever? One sees that here and there, classes that operate more like cults of personality than like real education.
FO: No, I encourage them to move on. I'm a big believer in this—especially at the League, which is unusual in the sense that a student can go take sculpture, etching, and all kinds of metalworking techniques, like welding and bronze casting. They can experiment with found objects, collage, assemblage, and drawing. To the serious students, I put it this way, "Right now, all you love is the moment, but let me tell you, down the road you're going to want a press to print the money you'll need to pay the rent. Get real."

JLM: A while back, you did a demo (*see opposite page*). Actually, we shot a couple of demos. The second was a kind of reenactment of the other. The second one is published in this book. Why did you pick that particular concept to demonstrate?

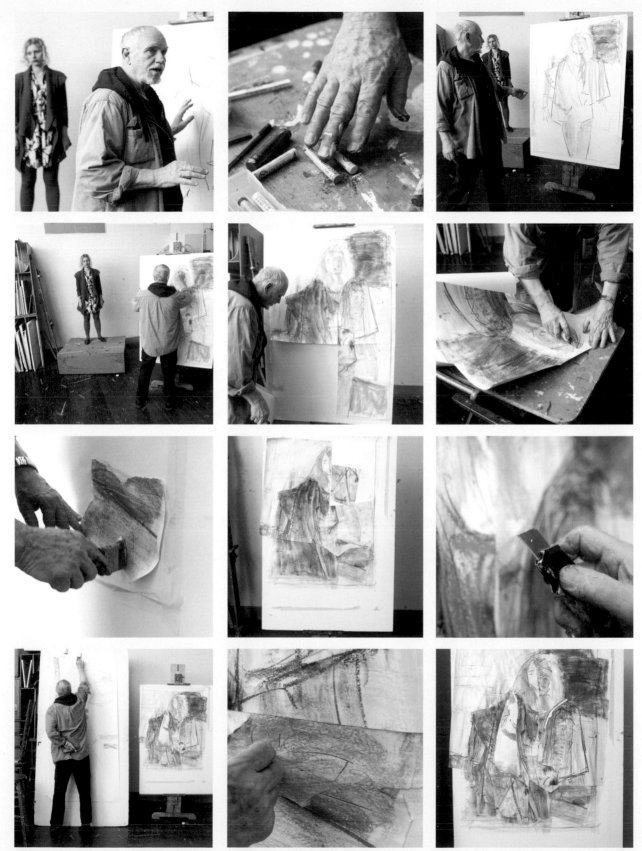

FO: Mainly because everything that happens with my creative mind is whatever happens on the surface, so the surface tells me what to do. I don't tell it. I set it up with a premise, but with that premise set up, things begin to happen, and once they happen, I begin to react. Every demonstration, every exercise done in front of a class is a point of information, not a work of art. Sometimes demos are total failures, but that's also useful information because it tells me that I need to take a different approach. In other words, I might be explaining the same concept again and again, but never twice in the same way. One thing I saw in that demo was that I could push it to another level by showing what you can do with just a line, and what can be done with a small amount of color. Cutting the paper and shifting around creates a whole total different sense of how to break out of a concrete form into an abstract concept.

JLM: So, how did you decide how the model ought to be posed? Did you just leave it up to her?

FO: I leave it up to her mostly. Unless there is someone who has never modeled; then I explain the priorities of the task at hand and what they need to do.

JLM: You let the model choose his or her own pose, and then you worked on a large piece of heavy watercolor paper stretched on a foam core support. You often work that way?

FO: Yes, because I like the way the weight of the paper allows me to establish different levels with different mediums. If I want to move from acrylic into the watercolor, and I realize I can push this into another idea, I can gesso it out, I can run it over again, and sometimes I end up painting oil over there.

JLM: So, working over a piece of foam core obviously is lighter than working on wooden stretcher bars.

FO: That's right, and in the old days we would use Masonite as a panel . . . this is much easier, and you can work both sides, work five or six drawings at a time, and I can flip them, because they are so light.

JLM: So, you're not just doing one piece at a time, you have maybe half a dozen at once? So there must be a dialogue between the different paintings in progress. In the demo you started working out the exercise by noting elements of the model's pose?

FO: Yes, that gave me action lines. A lot of models will throw out one hip, and put the weight on one leg, because it's more comfortable. So I will run that line and that will give me a point of reference on that page—because I'm always trying to be alert to where my first stroke is, because that dictates the strength or the weakness of the piece. I try to keep it left and right of that center line as much as possible.

JLM: Right, so the model is there. You're looking at the model, but at the same time you're not trying to draw her in a realistic way, just trying to extract forms.

FO: I'm extracting forms, and tension and often her attitude will take forms into the painting, a certain kind of seriousness, or frustration or anger or exhaustion . . . you draw right out of the model, and it ends up on the surface when you begin to look at it and say, Oh yeah, I can see what he or she felt. Because to me, that is what art is.

JLM: The embodiment of one's . . .

FO: . . . total feelings.

JLM: The embodiment of emotional response. Once you establish an image, once you have worked on it for a while—say, twenty minutes to half an hour, resulting in a collection of shapes and colors derived from the model—then what? You started cutting it up? Talk about that.

FO: Well, that to me is the easy way to push it into abstraction. Because that changes one's relationship to the real world, by forcing a concrete form like [the model's] body into moments of tension. You're thinking of the

form more as something shifting against itself and its environment, rather than as a discrete, volumetric object. I suppose one could say it's a kind of cubism. The other thing it does is help you make the surface an integral part of the idea rather than a substance covering something, you know, like skin over muscle, over bone, and so forth. It starts to develop a fresh sense of shape in and out of that. Cutting and collage is the quickest, easiest way to get to that point, with the added benefit that you don't have to worry about drying time.

JLM: When you start reassembling your cutouts, will you use acrylic matte medium as a kind of paste?
FO: Yes. It's more than just a paste but a single material that ties the whole piece together.

JLM: So you just apply some to the surface and apply it to the reverse side of the collage element, lay it down, and paint over it. It's like hanging wallpaper. Braque and Picasso are credited with inventing the technique in the days before acrylic. De Kooning did something similar, but with oil paint.
FO: In fact, acrylic is perfect. It dries quickly and transparently.

JLM: At what point then might you go back and have another look at the model?
FO: Sometimes I will, and sometimes I won't. If there is enough going on in the piece, if I have given myself enough to work with, then I won't want to look at the model again. The reality has jumped from the model onto the surface of that paper, canvas, whatever. She can go home, she has done her job. My job now is how I relate what the form suggested by the leg to what used to be the torso. I have to figure out what are the relationships between all the extracted forms to where they all come together—how to develop it into a new, energetic form that is removed from how pretty, sexy, or bored the model might have been. The challenge is to move the image onto

a different level, where you're now dealing with a whole new reality, taking art to a place where it can meet up with philosophy. This is something I encourage my students to address every day.

JLM: And how do you do that?
FO: Literally, I come in and read philosophy to them. I might show up one day with Schopenhauer and ask them what do you think about that? I might quote Kant saying that you can't give rules to art . . . what do you think about that? I do this because I am trying to get them to understand why painting is always a new adventure for me. It always has been, in subtle ways. I believe that it is really important that painters go beyond painting superficial reality. They have to go after something deeper, follow the example of the Chinese poet-painters of the Song Dynasty. Many people mistakenly believe that technology today drives ideas. Technology can mass-produce ideas by the ton, but what kind of ideas? I can tell you this. Such ideas are of no use to real artists.

JLM: Yes, that's true. Have you seen *The Artful Recluse* show at the Asia Society?
FO: Yes. That is probably one of the greatest shows I've seen in the city in a very long time.

JLM: The hand-scrolls and the wonderful paints . . . so how do you know, for example, with the demo piece, how did you know that it was safe to step away from it? How do you decide when a painting is done, or you're done with it?
FO: Well, that is probably the most difficult thing because you can have a complete painting in ten minutes, and five minutes after that decide that there is more to do. I look at every painting as being unfinished. The important question is, In what way is it complete? Paintings are different because paintings are supposed to represent a whole idea—one of a kind. I approach each painting as something never to be repeated. A demo is something else. Like I said,

Frank O'Cain
Untitled
n.d., oil and wax on canvas, 50 x 72 in.

Opposite
Frank O'Cain
Songs My Ancestors Sang
n.d., oil and wax on canvas, 50 x 72 in.

it's a point of information. If I finish that demo—then one I did for this book—I may never get to make the painting that might come out of the demo.

JLM: The painting that comes out of the demo?

FO: Yes. Well, a painting might come out of it. I can't say until I see it. If something tells me, "This needs to be a painting," then I will take it to the next level. The demo was of a moment. You have to respect that.

JLM: What about your own paintings, the ones you do that you take in a serious way that you do in your own studio—how do you know which of those paintings are finished? You already shared that you start half a dozen paintings at the same time. If your paintings are always in conversation with one another, how do you tell students when it's safe to step away from painting?

FO: When I have all the elements intact. In other words, if the space moves, if I feel that transparent and opaque passages work together, where the volumes and negative spaces are not too similar, when the color works as light—when all of the elements in the painting create a kind of unity, that tells me I can step away, let it fend for itself. If I want to explore the subject further, I have to start a new painting. That tells me everything.

I tell my students that it is essential for them to know what they are after. When it begins to bear fruit—and while you might feel that something is not quite right, something in the painting bothers you, but the big idea is there in the work—then it's finished. You can't base that kind of decision on technique, because if you try to be too much of a mechanic or try to make it too rich, too perfect, you're going to lose the essence of your drive.

JLM: Yes, the juice, the fire in the belly.

FO: That's right. The life, the energy, the spontaneity, the real beauty of it all will be gone. An expression that Vytlacil used to tell me was, "Well, there you've done it again—one shoe on and one shoe off."

JLM: That's pretty funny. So, do you impose any requirements on people coming into your class?

FO: Not really. I've tried to run the class according to the spirit of the League—it's an open door. It's becoming a bit harder because our enrollments are up. I may have to start screening students. I'm seeing an influx of people who are not really interested in art but think that art is going to fix something in their lives. I'm not saying it won't, or can't, but I think those folks might do better in someone else's class. Maybe they need to take a couple of years of drawing first, figure out what they want to do. In the past I always felt that just by being around the energy of serious, motivated painters, others would be forced to become more serious, but it's better when someone comes to painting with some fundamental knowledge of art. If they do, then artists like me stand a better chance of helping people encounter art on a deeper level.

JLM: That makes sense. Anyone who comes in who's a really raw, inexperienced beginner, you'll tell them to take a drawing class?

FO: Right away.

JLM: Do you talk about color theory?

FO: We do explore color theory; of course, I use Arnheim.

JLM: *Art and Visual Perception*?

FO: Yes, we've been reading him.

JLM: Rudolf Arnheim.

FO: He's a great introduction for people who never studied art theory. Those struggling with color can go read up on Albers. I see a lot of students who are good with color. I tell them not to listen to me.

JLM: That's funny. So how do you teach? What methods? At the easel, lectures, demos?

FO: I do demos once a month, usually.

JLM: But they are not technical . . . you're not technically demonstrating a "how to" technique. Your demos are demonstrating concept.

FO: That's right. They are free to follow their own aesthetic. I don't want anybody to get into imitating my work, because that would be detrimental to developing themselves. I don't want to see another generation of students suffer the pain I went through.

JLM: I conducted an interview with William Bailey a while back, and he said that when he was at Yale there were always a few students who thought they could curry favor by painting like Albers. Albers would march in and bark at them, "Don't paint like me—be like me!"
FO: Perfect! Just perfect!

JLM: So you're not invested in the idea that the students are going to follow some kind of stylistic identity that's associated with you . . .
FO: No, I want them to pursue their own directions, but I want them to proceed with a sound knowledge of the principle, theory, and craft of painting. Once they have that under control, I don't care what they do, as long as they keep painting.

JLM: Craft . . . composition . . . judgment . . .
FO: And good line, constantly—a good strong line! Don't fuss. Don't hesitate. Make a commitment and stick to it.

JLM: And how do you conduct critiques in class . . . individual, together?
FO: No, no, it's always en masse; I started that long ago. It is impossible to deliver easel tutorials to twenty, thirty, or forty people in a classroom, or maybe even just fifteen people. You'll never get around to everyone, and nobody will be happy. I find it most effective to teach en masse. I have learned over the years that if you say something in a critique about one particular painting, all of a sudden five people will head to the easel and find something you missed, or take the idea and use it to address another piece being discussed. They're learning all the time, and I discourage them from thinking that anything they do in class is precious. If you're taking a class and you think what you're doing is making art, you're done. Go out and find your own studio.

JLM: So in other words, what you're trying to get them to do in a class is not to make art but to experience concepts . . .
FO: And practice visual realities.

JLM: You do your monthly demos, you read philosophy to your students, you conduct large group critiques. You must do lectures from time to time.
FO: I deliver lectures and sometimes slideshows. Putting an image up on the screen, I can break it down to show the students how the space is divided up, how someone like Rubens controls the circular movement by framing it with horizontals and verticals along the outside edges. I do programs like that less frequently, about once a year. Every month I do a lecture on topics like black and white, tonality, or color; exploring abstraction and imagery, or how that imagery is transposed, manipulated in abstract ways. Every year or so I might have the whole class set their paintings out and go from painting to painting, discussing the strengths and weaknesses of each. They all sweat a little bit.

JLM: So, apart from "tough love," how would you characterize your teaching?
FO: It's more personalized instruction, even if I am addressing the class en masse, in the sense that I'm trying to get each student to think for themselves, to be their own person. I don't want anyone to walk into my class, or leave here, thinking that it changed who they are. My goal is not to change them but to help them make the most of what they have, to better appreciate their own value as a human being, which will help them to become better artists. That is the best I can do for them as a teacher.

JLM: So apart from learning skills that allow one to become an artist, what is the most important thing a student can gain from studying art?

Frank O'Cain
Untitled
n.d., oil and wax on canvas, 50 x 72 in.

FO: Well, that's a multilevel question, because if you stay with the art, that in and of itself . . . your life is better. You feel richer, stronger. No matter what the world does, you can survive because you have built a civilization of your own. If at some point you decide that art is something you will always do, but for some reason you find yourself earning a living in other ways, artistic practice will enhance everything you do. For instance, if you were to go into any kind of science, it will make you a better scientist. Having some interaction with art will open your mind in ways that nothing else can.

JLM: **That's Robert Root-Bernstein's argument. Scientists who make art make better science than those who do not make art. You're saying that art provides one with an activity that exercises parts of the mind in ways that nothing else can.**

FO: Yes, I agree with that.

JLM: **And what would you say teaching at the League versus . . . have you taught anywhere else?**

FO: I've taught at some other places, but the League is much easier to deal with. It's unique in that it is the only place I know that lets students design their own training program. It lets you find your own platform and doesn't interfere. This is the easiest institution to walk into, bar none. There is nowhere else like it. If you don't like a class, you just walk away and sign up for another. You haven't lost more than a nickel.

JLM: **Any advice to people who will be inspired by reading this to seek instruction in painting? What should they do?**

FO: I say spend more time visiting the museums, quit competing with the masters, enjoy them, and see if you can absorb some of what made them great into your own life. Bring a sketchbook to the museum. Learn to draw. I'm a big fan of drawing because of how much I learned by going to the Metropolitan Museum of Art and drawing all those sculptures. You know what? I still go back and do it every once in a while.

JLM: **It must be like a reunion with old friends . . .**

FO: They are old friends, and in this crazy world, they calm me down. I recommend it to everyone.

STUDENT GALLERY

Alison Causer
As We Move Forward
2014, acrylic on canvas, 55 x 55 in.

John Parnell
Figure in Motion
2012, mixed media, 40 x 30 in.

Maureen Guinan Fitzgerald
Untitled
2015, acrylic on paper, 17 x 11 in.

RONNIE
LANDFIELD

Ronnie Landfield has had more than sixty-five solo exhibitions of his paintings, including twenty-seven in New York City. A retrospective at the Butler Institute of American Art explored five decades of his work, which has been included in numerous international group exhibitions in such locations as Beijing, Manila, Havana, Paris, Cologne, Munich, Sapporo, Gubbio, and Udine. His work has been included in three Whitney Biennials and group shows at the Metropolitan Museum of Art, the Museum of Fine Arts Houston, the Museum of Modern Art, the André Emmerich Gallery, and the Leo Castelli Gallery. His paintings reside in many public and private collections, including the Metropolitan Museum of Art, the Museum of Modern Art, the Whitney Museum of American Art, the Art Institute of Chicago, the Hirshhorn Museum and Sculpture Garden, the National Gallery, the Seattle Art Museum, the Norton Simon Museum, the Walker Art Center, the Stadtmuseum in Munich, the Federal Reserve Board, the U.S. State Department, Charles Schwab, Mobil, GE, ARCO, Prudential Insurance, Chase Manhattan, New York University, and Stanford University. He is the recipient of grants from the William and Norma Copley Foundation and the Pollock-Krasner Foundation. Landfield was a guest instructor at Bennington College and taught at the School of Visual Arts before coming to the League in 1994.

Ronnie Landfield
Bluebird
2000, acrylic on canvas, 89 x 76 in.

RONNIE LANDFIELD

On Learning and Teaching

On March 23, 2012, painter and League instructor Ronnie Landfield sat down with James McElhinney to discuss his life, art, and teaching.

James McElhinney: How do you define painting?
Ronnie Landfield: It's what I do.

JM: How would you explain to someone exactly what you mean by that?
RL: I don't think I would even try; I'd tell them to look. Use your eyes, and learn how to see.

JM: Let's say a person wants to make a painting. They want to understand what painting is, and they want guidance. Let's say they decide to go to a museum, how do you tell them what to expect from looking at things hanging on the walls?
RL: An experience. I would expect that the people I speak with generally tend to know things, more than, let's say, someone with no experience looking at works of art. For instance, I know someone whose view of nudity is purely sexual, even going all the way down through antiquity. To her it is all just sex. I try to avoid conversations with people like that.

If I'm speaking to one of my students, I might suggest that they go to the Metropolitan Museum of Art and visit the Matisse show, or explore the impressionist galleries or the American collection.

It generally boils down to individual preference. I know to whom I'm talking, and I know why I'm suggesting that they go look at a particular painting or artist. How can I explain painting to someone who has never seen one and has no clue what a painting is? I wouldn't even bother. It would be a waste of my time and theirs.

JM: What about someone who may have no knowledge but great passion?
RL: I would love to talk to a person like that. My view of painting is that it's a language. You need to learn how to read paintings, how to look at them. First feel the message and then see it, if you can. My suggestion to someone who has any visual sense for things like paintings is to compare landscape painters like Church or Bierstadt with Cézanne, and try to figure out how what they try to do is different than Cézanne, whose work I prefer. Still, I like Church and Bierstadt, and even Monet, in relationship to the landscape. How they interpret landscape becomes a metaphor for their own passion.

JM: Church or Bierstadt would be more of a spectacle, more about data and less about poetry?
RL: It seems that their works depend more on data, viewing literal facts as opposed to revealing what may not be visible to your eyes but through a kind of feeling. When you look at a Cézanne, you learn to read it by understanding yourself. It's more than just an image.

JM: Isn't that a definition of the "Sublime"? So you prefer the hidden reality or the implied reality to literal depiction?
RL: That is the intrinsic quality of great art. There is always that element that tips you off to when you are looking at a great painting, say, like a couple of Dutch pictures from the 1600s. You already know there is a difference between Rembrandt and Frans Hals. There is a difference between

Opposite
Ronnie Landfield
Rite of Spring
1985, acrylic on canvas, 79 x 112 in.

Vermeer and Rembrandt. The question is why they did what they did. How did they interpret what they did? Both Vermeer and Hals painted guys sitting at tables. You can see in the one a certain precision and perfection, while in the other there is a certain verve and glee.

JM: Frans Hals supplying the glee . . .
RL: Yes, that's right. In Vermeer you find precision and in Rembrandt a certain insight and passion.

JM: So Vermeer, Hals, and Rembrandt. All are doing basically the same task in three different ways, perusing three different ways of seeing. So is painting about revealing a truth or a reality that without painting would not be visible?
RL: Painting embodies a truth that is miraculously communicated between human beings, and it's the visual form of that truth. I wouldn't say that it's indispensable, because in a sense writing does the same thing. Theoretically, other art forms do similar things, but painting is one form of communication that goes back several thousand years that can give shape to very subtle nuances of human intelligence and feelings. I relate to my students by getting them to look for these nuances.

JM: It gives structure to an experience in ways that reveal things that might otherwise be inaccessible, and form to an emotional quality.
RL: Well, that's true, James, which also makes it very difficult to interpret. If somebody goes and looks at a Matisse, they are not going to necessarily get anything out of it. They have to be open to it, and know how to look at it.

JM: Why did you send that student to the Matisse show?
RL: Primarily because I thought this particular student, who is extremely visual, and she is extremely capable of faithfully recording what she sees, needed to see all those flat paintings, the language of color, with a kind of expressivity not based on Matisse just recording what he

was looking at. She was sensitive enough to be exposed to this vast amount of information that she wasn't getting elsewhere. I think it worked, because she went to see the show and it blew her mind.

JM: What was interesting about that exhibition is that it showed Matisse's process in troubleshooting compositional issues. A lot of that comes out of Cézanne, who proposed a genre of painting that was non-mimetic, not about copying what was before him but constructing a different reality. It may have been a rejection of photo-conditioning that became the hallmark of impressionism, but that's a whole other conversation. Look at El Greco or Poussin, two very different painters. Their work was also non-mimetic, constructed realities and not the duplication of optical sensation.
RL: Or Picasso who saw the possibilities of a revealed or constructed reality and knew how painting can do both. But I think in a way that goes without saying. Nowadays, because we're a hundred years past the turn of the twentieth century, and we're into the twenty-first century, I have faith that truth in painting will hold, and that the best artists are those who have created their own reality, their own vision. That's what I was saying about Vermeer, and Rembrandt and Hals. Everybody can see the differences. That's what's interesting about the expressivity that a serious painter can achieve in their work.

JM: One definition of originality is something everyone can recognize in a way they have never seen before. So what was your own training like? Where did you go to school?
RL: I was more or less self-taught. My training began when I was a kid. I'm a New Yorker who grew up in the Bronx, and I liked to draw. I had a cousin who went into commercial art. He would go on and on about it. He was an older cousin, and I admired him. We used to go on, talking about art, and I wanted to be like him. When the time came

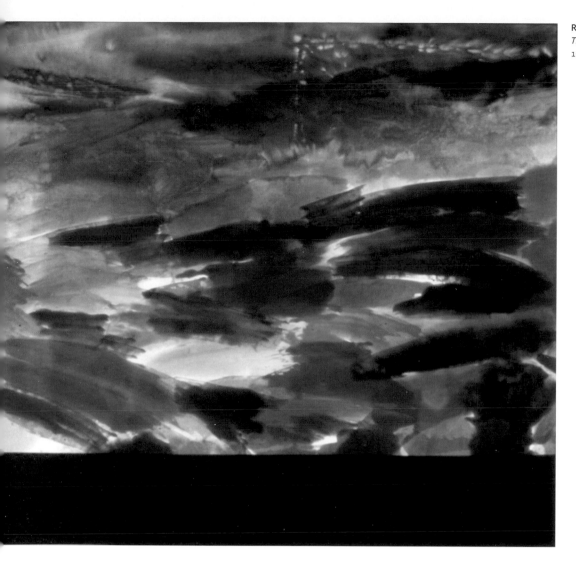

for me to go to high school, I wanted to go to the High School of Industrial Arts, but my parents wanted me to go to college and it was a vocational school. They suggested that if I wanted to make art, I should try out for Music and Art. I tried out for Bronx Science [and] the High School of Music and Art and Industrial Arts; this was 1959, 1960. I got into Music and Art and Industrial Arts, but I didn't get into Bronx Science.

The notion of going to my regular high school was, for me, not going to happen, not ever. I was somewhat of a nonconformist. I had long hair. I was a bit of a rebel who was very independent. I didn't, couldn't identify with the kids I grew up with. I had a lot of friends, a girlfriend, I was happy and all that, but I wanted out.

So it was a matter of Music and Art or Industrial Arts. I promised my parents that if they let me go to Industrial Arts, I would then go to college. They relented and agreed that I could go to Industrial Arts.

As it turned out, I wound up in the first class of students in the new High School of Art and Design. I had tried out for Industrial Arts, got in, and the city closed the school and then reopened it as Art and Design on Second Avenue at

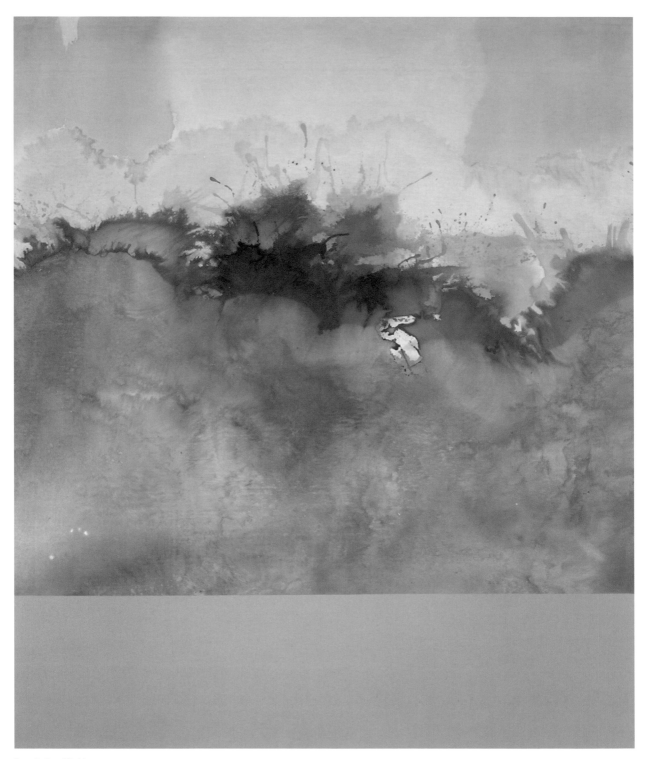

Ronnie Landfield
Isidiris
1969, acrylic on canvas, 108 x 93 in.

57th Street in September of 1960, when I was thirteen years old. As a sophomore, I was younger than everyone else.

In the beginning I had a miserable time, partly because I was thirteen and looked like I was eleven. Within six months I was still thirteen, but I looked fourteen. Then I started making friends and realized where I was.

Where that was, on 57th street in 1960, was ground zero for the New York art world. I would leave school at 3 o'clock with some of my friends, and a couple of cute girls. We would walk to 60th Street, where there was a little gallery called the Bodley Gallery right across the street from Serendipity. We went into Bodley, which at the time was showing minor surrealists. David Mann was the gallery director. He became a kind of tutor for us. He showed me for the first time works by Rauschenberg. He told me about some artist we would hear about soon; David gave him his first show, a guy named Andy Warhol. I started going to Pace, to Sidney Janis, Knoedler, Staempfli, and Castelli. Some days I went to Tibor de Nagy.

I was fourteen or fifteen years old and I was at ground zero, looking at abstract expressionism as it was happening. Pollock had died, but I had read a *Life* magazine article about him. I got out of school every day at 3 o'clock and went to the galleries, or to the Museum of Modern Art, where I saw an Arshile Gorky retrospective in 1962, the same year Sidney Janis Gallery exploded the New York art world with this thing called new realism. Sidney Janis was still ground zero for abstract expressionism. He showed de Kooning, Pollock, Kline, Motherwell, Gottlieb, Rothko, and Guston. The gallery rented a storefront and did basically the first pop art show that any uptown gallery had ever done.

Suddenly there was Andy Warhol and Roy Lichtenstein; Marisol was in that show and an assortment of new European artists. A lot of the abstract expressionists quit the gallery. The art world exploded. Suddenly Sidney Janis, who was the bastion of abstract expressionism, was showing pop imagery?

As a kid I saw all this stuff. I was a little disturbed by it because I liked abstract expressionism a lot, and I think I was really into the verve. In 1963 I applied to colleges, Cooper Union being at the top of my list. I got into everything I tried for.

I was taking classes at the Art Students League. It was just a short walk from Second Avenue to here, where I was doing figure drawing. I hung out in the cafeteria here and met Stamos and various other artists.

One of my favorite galleries in those days was the Green Gallery, where I met Dick Bellamy. I was sixteen, and Tom Wesselmann was teaching at Art and Design. I used to go with this friend of mine to the Green Gallery and ask Dick Bellamy to take out the Wesselmanns, and he'd plug them in for us. I saw a lot of major artists getting their start. Robert Morris, for one. I went to Donald Judd's first show in 1964.

I decided to go to the Kansas City Art Institute. I had planned to go to Cooper, but it was boring. My parents got upset, but I had a scholarship, so I went there for about two months. I was painting big abstract expressionist paintings at age sixteen. I was really never happy in Kansas City, which for a New York City kid in the early sixties was very redneck to say the least. I had friends whom I liked, but my friends, including a guy named Tom, were a little strange. One day I asked him if he had been in the boy scouts. "No," he said, "I was in the Ku Klux Klan." That was serious. I was thinking, "Holy shit, man, I have got to get out of here." There were all these kids from all over the South in Kansas City.

I didn't want to stay, so I went back to New York City and rented a space with a friend of mine. We sublet a loft on Bleecker Street and the Bowery from Leland Bell. I had my own studio where I was doing my own big abstract expressionist paintings.

But I soon realized that I needed to show my work, and I invited painter Stephen Greene to visit my studio. (I thought that I was the best abstract expressionist in the

country, except for a few like de Kooning and Guston. Kline was already dead and so was Pollock.) I showed Stephen these huge paintings on paper I did in Kansas City, big sheets of paper that I had taped the back so when I put them together they were eight by twelve feet.

I showed Stephen, and he told me they were good. Then he asked me, "What are you going to be? A twelfth-generation abstract expressionist? That's all you can do?"

I was stunned. He said, "You have to find your own voice."

And that was what it was all about, finding your own voice. And it just hit me; it hit me real hard because I agreed with him. At that point, I stopped making action paintings and started looking for something else to do.

I went to Los Angeles as soon as I turned seventeen. I was making hard-edged drawings with gesture, which nobody was doing at the time, or maybe I was just not aware of it. I met Hans Hofmann in 1963 before I left New York City and talked to him briefly. When I got to LA, I didn't like it. I went around the scene and finally got in a fight with Billy Al Bengston at UCLA over LA art versus New York art.

I hitchhiked up to San Francisco and after a few days of being bored by San Francisco migrated across the bay to Berkeley. For a seventeen-year-old kid, hanging loose in Berkeley was like there were parades every day. So I moved into my cousin's house in March of 1964 and set up my studio in a back room. I was living in a house with a beautiful Japanese pianist who performed with the San Francisco Philharmonic and her boyfriend who was a strange mathematician. The two of them played together on the grand piano in the front room. I would wake up to Beethoven and start painting.

After a few months, a lot of their friends kept telling me, "Kid, you gotta go to school."

San Francisco Art Institute gave me a scholarship, and I went there in September of 1964, but again, the same thing happened. I met a few people, made some good friends, like Peter Reginato, with whom I shared this huge loft in San Francisco that we literally built. We paid forty bucks a month each. At one point we made a movie. Acrylic paint had come on the market. I was doing these hard-edge paintings, very complicated hard-edge paintings, partly because I was trying to get away from abstract expressionism.

To make a long story short, I turned eighteen living in Berkeley, doing my hard-edge paintings, when I realized that I was old enough to deal with New York City. So I quit school and went back to New York City, sharing a whole bunch of studios first with my girlfriend on Park Avenue and 27th Street, then with another friend on East Broadway. When he decided that the East Village was no good for him, he split back to California and left me holding the bag. I then shared a studio on Broadway and Broome Street. That building burned down, and I moved in with my girlfriend way over on East 11th Street in February 1966. I wrote a letter to Philip Johnson: "I'm a great painter, and my studio burned down. I don't know what to do, and I really like your work."

So Philip's secretary called me up, and they invited me to come see him, Philip; and I put on my only suit and left my East Village apartment on 11th Street and went up to the top floor of the Seagram Building on 52nd Street. We met in one of his boardrooms, with Giacometti sculptures walking down the table, Philip at one end, me at the other.

He said, "Okay, kid, what in the world do you expect from me?" I told him my story. He said, "Look, get a job, and when you make some paintings, you come back and see me."

Talking to Philip was the most inspiring conversation I ever had in my life. I was thinking about that before this, because he gave me the sense in that brief meeting that being an artist was a great thing to do. Everyone else I knew, my rivals, my friends (we were all competitors), my parents, the older people, they all said, "Oh, you're an artist . . . oh, you can't make a living."

Here was this architect giving me a sense that it was absolutely great if you were an artist and there was nothing

wrong with that. But I was inspired to talk myself into a job. About an hour after I left his office I went to an advertising agency in the Fuller Building at Madison Avenue and 57th Street because having gone to Art and Design, I knew how to do commercial art. They hired me on the spot. So I got a job an hour after I met with Philip, and about two weeks later my friend who I knew from Kansas City, Dan Christensen, called me up; he needed somebody to share his studio on Great Jones Street because another artist friend's father had just died and he went back to the Midwest. So Dan, who was storing everything I could salvage from the fire, needed someone to share his loft with. It made sense to move into the place on Great Jones Street, where I painted a series of fifteen 9 by 6-foot paintings, which I had begun in my old studio on Broadway.

I finished the series, called Philip, and he bought one of my paintings. As soon as I got the check, I Xeroxed it, quit my job, and have been painting ever since. That was my education.

JM: That's impressive. How do you conduct your class? Is it open to everyone, or do you screen people first? What kind of students do you allow into your class? Are there any prerequisites?

RL: There are no prerequisites. But I let people know that mine is not a class for beginners. If a beginner comes in and they ask too many questions, and they are really, really raw, I will very politely suggest that they take somebody else's class. I've been teaching here for twenty years; generally, it's to people who have a solid background.

JM: How important is drawing?

RL: Very important. We have a model posing in the studio at all times. I've always had a model, and I always suggest to students who work abstractly that they spend some time drawing from the model. It's not about style. It's about hand-eye coordination; practice.

Kenneth Noland once told me in the late 1960s, "Art is all about practice, it's all practice. You've got to practice."

I agree with that. I suggest to people that they practice. We have a model. I suggest, if someone is not sure what to do, I suggest they draw the model and then go back to the painting. They don't have to, but that's what I've always believed ever since I went to school. That's what I would do.

JM: And the revelation about people like Richard Diebenkorn and Jules Olitski working with a model . . .

RL: Absolutely! Jules worked with a model through his career until the end. I did that, I used to have models come to my studio until I was about forty, even though I was making abstract paintings. It's practice, and it's practice. And it's important.

JM: Someone has compared that to a musician doing his or her scales . . .

RL: And up and up! Because it's not just scales, you can really lose yourself. A very important thing about making art is the ability to get lost in the work—to get so engrossed and so into it, and with it, that you completely stop thinking and you just act, you just go and paint.

JM: How do you teach? Do you teach mostly in a tutorial way, one-on-one? Do you lecture?

RL: No, I allow people to do their own thing, and I go around to everybody, look at what they are doing, and give them individual critiques. Sometimes I don't say anything; sometimes I say a lot. I try not to tell people what to do, unless I must. Basically it's about my students experiencing self-discovery. Before, I taught for fifteen years at the School of Visual Arts. That was a whole different experience, which today I can barely remember, except that all the students were the same age. The novelty of the League is that I have students in their teens and students in their eighties, people in their fifties and in their twenties, meeting in the same class. I am not going to tell the whole group the same thing, because everybody is coming at it from a different perspective and place. Each takes my class for their own reasons. That's what's so remarkable about this school.

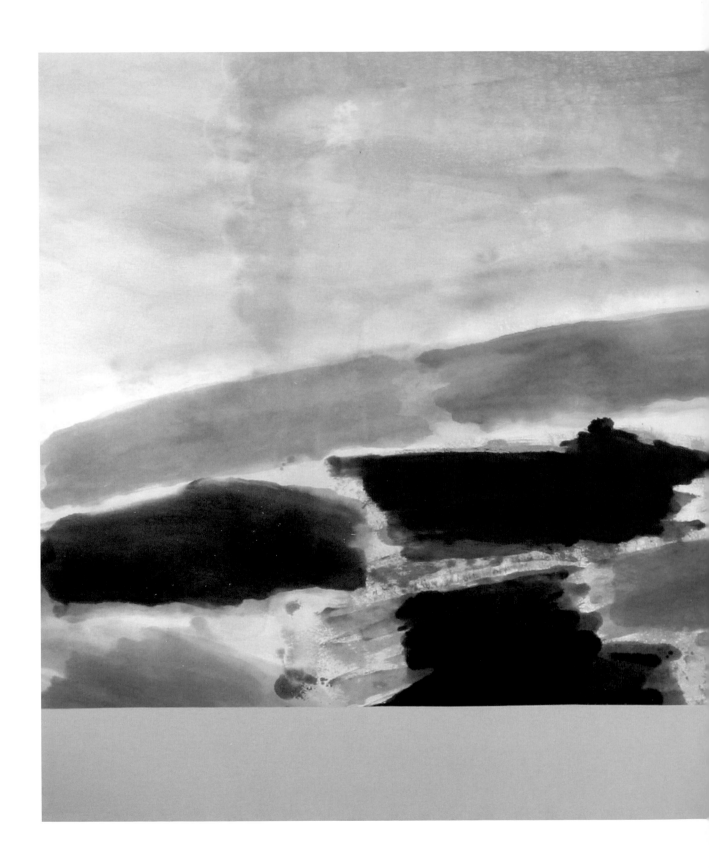

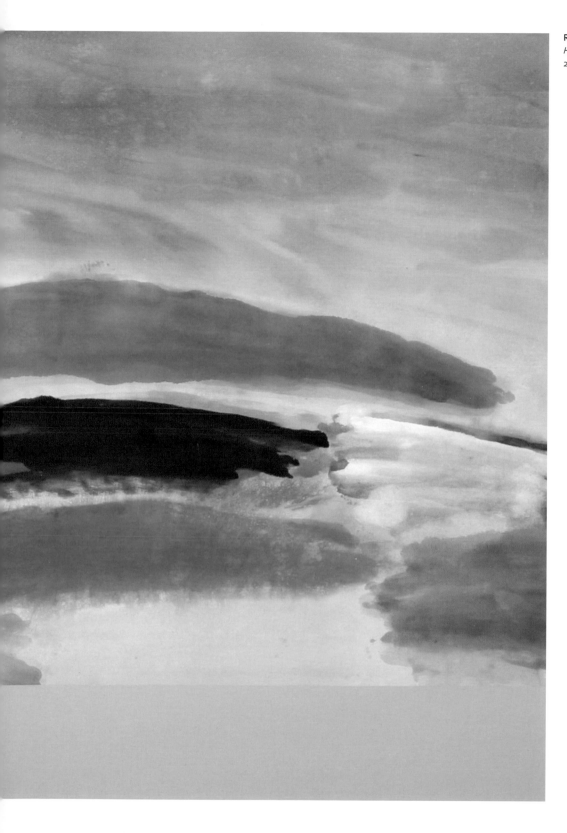

Ronnie Landfield
Hurricane
2004, acrylic on canvas, 76 x 126 in.

I think that whatever style I have developed as a teacher needs to be adjusted to accommodate individual students.

JM: So you adjust to each student, and also to the group. Does that mean you think that the diversity of goals for students of differing ages creates a richer environment for learning?

RL: Absolutely yes. And I believe that. Then, of course, there are other exchanges. I meet the class twice a week. In some cases, students attend class five times a week, so they are in dialogue with each other, exchanging ideas. I might have a fifteen-year-old who is talking with the fifty-five-year-old who is getting feedback from the seventy-five-year-old. And that's all good.

JM: It sure is not like going to a conventional art school where you get the eighteen- to twenty-two-year-olds and everybody having similar life experiences. In your mind, is that a less enriching environment to learn?

RL: I remember my own experiences, like when I went to the Art Students League Woodstock campus in 1962. I was fifteen years old, and there were all these older people around. We would sit at the lunch table, and it was fantastic! I learned more from mealtime conversations with Mr. and Mrs. Herbert who were shrinks from the city than I ever did from Arnold Blanch, who would come down once in a while . . . I learned things from him, too, but I think the environment, the feeling, the sensibility, to be around other people is an important part of it.

JM: So you don't generally do lectures?

RL: Very rarely, I try to get out of the way sometimes. I've done them, but not for a long time. I used to do lectures. Not so much these days.

JM: It seems like one of the ways you teach—if we are to identify a "Landfield technique"—might be how, in a conversation with a student, you see something happening in their painting and you send them to the museum to study a particular artist's work. Is that a fair statement?

RL: I suppose. I might also tell them to look at a book, or

find examples of an artist's work on the Internet, or go visit a gallery. If somebody's work reminds me of Velázquez, I might ask him or her if they know Velázquez's work. If not, I tell them to go look him up.

JM: Research and understanding the history of art is a big part of it?

RL: It's a big part of it for me.

JM: It's a big part of what you value as part of a painter's skill set.

RL: Yes, absolutely. It's very hard for me to integrate someone who doesn't.

JM: So someone who comes to your class and says I just want to learn this technique, you would send them to someone else?

RL: Depending . . . maybe.

JM: For instance, have you had a student who says, I just want to learn how to paint a good portrait, how to capture a likeness?

RL: I would say good-bye. I'd say this is not the right class for you.

JM: You are interested in helping people build their own vision, get a holistic, integrated understanding of the history of art as a way for them to imagine their place in it.

RL: Yes, yes.

JM: And a critical method that they can use so they can be the first member of their own audience and not just have taste-based judgments. Feeling good about something does not automatically make it good.

RL: I'm not so sure about that. I think taste-based judgments are hard to define. They might not be so bad as long as you have good taste. That can get pretty subjective.

JM: How would you respond if a student approached you and asked, "Ronnie, Mr. Landfield, when I look at a painting—my painting—when do I begin to judge it? I know if I'm happy with it, and I know if it looks okay to me, but I don't really know enough to be sure if it really is

good or that there might be problems and I just can't see them. Can you give me a critical method?"

RL: I would say no way. I would say the first thing you have to learn to trust is yourself. If you like your work, don't second-guess yourself. Show it to me and I'll tell you if I like it, and I can tell you why. I was just telling a student on Thursday, "First you've got to like it, but it doesn't mean anything unless I like it, because I'm looking at it."

That extrapolates something I remember hearing at Max's Kansas City or in the Spring Street Bar with a whole bunch of art critics. One of them who didn't know me asked what I did. I said, "I don't know . . . I paint."

"What do you paint?" he asked. "I paint what I feel," I said. He replied, "Who gives a shit what you feel? I only care about what I feel."

I thanked him because that was so, in a sense, profound. When you look at a painting, it matters a lot how you feel. If I make the painting, I want you to feel something. That's the trick, in a sense, to express yourself and be responsible for what you put on canvas.

JM: You might be right, you might be wrong. You'll only know if you have these conversations a lot and all the time and with a lot of different people. And you have to get what they are feeling, too. It's a sense of understanding based on how somebody responds to what the painting does to them. When many people think about painting, they want to figure out the recipe.

RL: There are no recipes!

JM: So what you're saying is that anyone who wants to learn how to paint must first learn how to see, how to feel, and how to trust their own judgment. They must be prepared to make mistakes. How important do you think it is for people to take risks?

RL: Yes, absolutely necessary. Sure. Another story, one of the most profound I ever heard, was told by Jules Olitski talking about when he was on the GI Bill. He went to

Paris, set himself up in a studio, and was trying to paint. The work bored him. He couldn't break out of doing the same thing over and over again. He painted blindfolded, and that, he said, changed his life. Wow! Take risks. Make things happen.

JM: Because a lot of students—especially adult self-learners and personal-enrichment types—might want to see a book about painting at the Art Students League of New York that they can use like a cookbook. It can't be. Like you said, there are no recipes.

RL: It can't be a cookbook, but it can present other options.

JM: It's not a collection of "how to" painting exercises about painting seagulls and lighthouses. It should discuss how paintings could move you. Earlier you said that painting is a way to convey an experience, so you have to learn how to . . .

RL: How to be. Painting is a way to be. It's what I do. We also spoke earlier about Frans Hals, Rembrandt, and Vermeer—three artists who on the surface are all doing the same job: painting portraits. We've got three great painters, each one different from the other, doing the same thing in ways that differ from one another in subtle ways. And that's what's so amazing about creating art. That's why painting is hard to teach and why it takes a lifetime to learn.

Ronnie Landfield
Evening Music
2004, acrylic on canvas, 79 x 120 in.

Md Tokon
Don't Let the Sun Go Down
2013, acrylic on canvas, 56 x 56 in.

Top left
John Kneapler
Blue Beach #1
2006, medium and support/ground, 48 x 48 in.

Top right
John Kneapler
Tropical
2007, medium and support/ground, 48 x 48 in.

Bottom
Dee Solin
Stairway to Heaven
2013, medium and support/ground, 50 x 50 in.

KNOX MARTIN

Knox Martin first became interested in studying art while recovering from injuries sustained in a motorcycle accident shortly after participating in the Allied invasion of Normandy in June 1944. Upon his release from the Brooklyn Naval Hospital, he enrolled at the Art Students League of New York. Knox Martin joined the faculty at the Yale School of Art at the invitation of Jack Tworkov and later taught at New York University, the International School of Art in Italy, and Raigad Fort in Maharashtra, India. His work has been exhibited internationally, and he is the recipient of numerous prizes, grants, and awards. At times Knox Martin shares famous quotes with his students. One of his favorites is by Jiddu Krishnamurti: *"The grass looks startled by the sky. Beauty is fury."*

Knox Martin
Woman with Wonderbread Breasts (detail)
2011, mixed media on canvas, 49.5 x 44 in.

KNOX MARTIN

Learning from Old and Modern Masters

Chelsea Cooksey, registrar at Dorsky Curatorial Projects in Long Island City, had helped me with many projects. I was called out of town on the very day I had scheduled my interview with Knox Martin for this book. Because Chelsea had assisted me on oral history interviews for the Smithsonian Archives of American Art, I asked her to stand in for me. The following is a transcript of their conversation.

Cheslea Cooksey: When was the first time you knew you were in the presence of a great work of art?

Knox Martin: The first encounter I had with art as art was at the Metropolitan Museum of Art when I ran into a Eugène Boudin seascape. It was an intellectual surprise, and that's the way it has been each time I made a major jump in cognition. I saw the Eugène Boudin and I understood what brushstrokes in a painting could be. I was a student at the Art Students League at the time.

CC: How old were you?

KM: I was twenty-seven years old. The next big step for me after the Boudin—and it was an epiphany—was right here at the League. It was art! And I was running alongside it and . . . bang! I was now on track . . . I wasn't able to see Boudin's design (his composition) yet, but the work came together in the way he designed it. My next big move was to go look at Rembrandt's drawings, and one day I walked into the room with a Rembrandt and I saw "it." The canvas was the *Woman with a Pink*. And then all my art books were brand new again. So I was closer to the core.

CC: What do you mean by "the core"?

KM: The core of Art is van Eyck, Titian and Veronese and Cezanne. The next big jump after Rembrandt's drawings was Paul Cézanne. There was a loan exhibition in the late spring at the Metropolitan Museum, and here was the Pissarro and the Seurat, the impressionists and the postimpressionists. I looked out the window, and it had just rained, so the tree trunks were very dark and the leaves

were very, very green. I came back because I had bypassed the Seurat, and I went to the window and I turned back and I looked at the Cézanne and bam! I was struck at the lightning of pure art. And again the big jump occurred at seeing the Cézanne.

My fourth big jump occurred when I was at the Louvre and I was looking at Gericault's *Raft of Medusa,* and here is a giant Veronese, which was *The Wedding at Cana,* and in the foreground was a table and at the table dining was Titian—one of the greatest artists of all time—playing a cello, and Veronese was at the table, as was Tintoretto, and I said, "Great, terrific, here is the core of art." And I left that room and I went past a little hall and I had not expected to see it—there was a Velázquez, *The Infanta Don Margarita de Austria* in a black dress with silver borders all about, and the totality of all art hit me. I was taken over and ravaged and art had its way with me, and I was every possible nook and cranny, every fold, every big turning thing, geometry, the personification of the Infanta the whole . . . portions of the painting, we were rooted together and welded together for all time. That, for me, is like a knockout punch.

CC: So how do you carry all this excitement into your own work?

KM: You have Jan van Eyck, painting in the 1420s, who was maybe the greatest artist of all time, along with Titian. All of my work relates to what he was about, the passion, precision, and organization. I've been doing a big drawing

Knox Martin
Woman
2013, acrylic mounted on linen,
20 x 18 in.

Page 271
Knox Martin
Woman with Red Shoes
2010, acrylic on linen,
75.5 x 62 in.

thing for a month and a half; I just finished up my ninetieth year and I just finished the most beautiful painting I've ever done. It's 80 x 65, and it's very much a woman dancing, personified. I think that it is going to be photographed for *Art in America* as a full page. It might be one of the most beautiful things I've ever done. It took me eight months to finish it.

The reference is: every brushstroke is an awareness of Eugène Boudin and Cézanne, and the structure was the admiration of Cézanne and Gauguin and Soutine and Dufy and Matisse to Picasso who said Cézanne is my father . . . and to de Kooning who said, "Everybody thinks I'm a super cubist, but it's Cézanne that I work through." I would go to the museum and go back to my instructors, and I would talk about the work. Any time I go to a museum I do that—I single out one. For example, I went to Munich to see Titian's *The Crowning with Thorns* that he did in his ninety-fifth year. It's one of the greatest things he ever did. And I went there and I stayed there for three days and it was filled with other paintings, but it was like I singled out a herd of gazelles and picked the one. Here's another example. The Isabella Stewart Gardner Museum in Boston has a major, major painting by Titian, *The Rape of Europa*. I spent the entire

day with that painting; because of an injury to my knee I use a cane, so the guard took an antique chair to the side and fixed that for me and I sat there all day, stood up walked around, came back and got close . . . I did this for an entire day! Another painting by Titian inspired a recent painting of mine.

CC: Which one?

KM: Titian's *Danae,* not literally, but metaphorically. You know the story. Zeus fell in love with a mortal named Danae, and then seduced her in a tower where she had been locked away, coming on her as a shower of gold. Different artists have portrayed it differently, as dust or coins but none equaled Titian. Believing it to be ordinary gold, Danae's attendant tries to catch the gold in her skirt. But this was not gold, not candy, but the seed of a god. In my painting of Danae, the metaphor occurs where the blue middle ground suddenly becomes another hand, and then her other arm. Her body lives in a space where there is no foreground, middle ground, or background.

CC: When you start planning a painting, do you make drawings and sketches?

KM: I never sketch. Sketching is for the Germans, the Americans, the British. I draw. In my opinion, anyone who thinks sketching is the same thing as drawing is an asshole. The word *dessin* in French means drawing. I make drawings, not sketches. I am involved with a poetic geometry, attendant to the metaphor and what it truly was. Poetic geometry is, for example, when I do a drawing and have all this stuff floating around. It's not here or there, and you don't know what it is—like *Danae.* In other words, art cannot be seen unless you learn what it is.

CC: So how does one learn about art?

KM: Picasso asked, "Who are all these people trying to understand art?" If I want to speak and write in Chinese, then I'll have to learn Chinese. The same is true with art. What beckons so many people into what they think is art might be a teaching they think they can understand, or things they can be taught. Studying anatomy,

proportion, technique and all of that is worthless without understanding composition and design. Where only those things are present, art is gone!

I was at the Museum of Modern Art when there was a small group asking, "How can the museum put this painting on the wall? Its incomprehensible!" It was Picasso's *Three Musicians.* I overheard them and said, "There's a dog under the table, his muzzle disappeared and part of the body is there . . ." And they said, "Oh!" I asked them where the tail was, and they pointed it out. Then I explained the musician and the guitar. That is what Picasso was saying. If you want to speak Chinese, you have to learn Chinese. If you want to speak art, you have to learn art.

CC: Knowing what is art is not the same as being an artist. How does one learn to become an artist?

KM: All the years I've been teaching I have tried to explain that as an artist—to be a real artist—you must surround yourself with art. Now, Cézanne had a reproduction of Manet's *Olympia* enlarged and hung it on his studio wall. Everyone should have it on the wall because it is such a marvelous painting.

During his Paris years Cézanne haunted the museum. He would talk about finding little convex pieces of geometry in the paintings of Chardin, in the shadow and the glasses. He said if you want to see it, go look at it.

CC: People go to museums every day. They look at art, but how can they see what you're talking about? What can you say to them to help them understand it?

KM: There was a class taught here and all the students' works looked the same; they were all doing little gray nudes. And it was a very popular instructor. But art should be enjoyed for the spectacular. People claim to understand Cézanne, but most of them can't see what he is doing. A professional lecturer on Cézanne once invited me to the MoMA with only a few other people to visit a show of Cézanne's late works. As we stood before Cézanne's *Mont Sainte-Victoire* series and talked about it, I said to myself,

this is bullshit. This man doesn't have a clue. He's talking about Cézanne but he can't see it!

Cézanne got rid of perspective and all the nonsense. He said he wanted to do the virginity of Nature, which meant using no particular method to look at nature. Matisse said that if you're going to paint a rose, forget all the roses you've seen and everything you've read about roses. Your eyes must be fresh and unaccustomed to roses. Only then you paint an original. Cézanne said something similar about painting an original carrot. How deceptive that is! To paint an original carrot . . . nobody can do it, you sit to draw and all the carrots you've ever seen impact you.

It's criminal to teach students to follow a formula. An instructor leading a class where everyone was painting the same little gray nudes had the students number their grays so that "on the triceps, the biceps, and the deltoid: number 16 gray. And at the elbow: number 12." The instructor gave extensive directions on how to put in shadow and highlight. When they were finished, every student's work looked the same. The great thing about my studio is that from student to student, every one is radically different. They're not copying the teacher. They are individuals.

CC: So how did you get into teaching?

KM: I never had any idea I was going to teach. I had some publicity and such, so I was invited to teach at Yale. I said at the time art can't be taught. It's useless. In my household my three kids were drawing; I would have a reproduction of a Velázquez on the wall, and I would offer my expression and attitude while looking at the Velázquez; and half an hour later, they would be looking at the Velázquez. It's the same principle with poetry and music. That was my way of reaching out to my family. The worst thing you can do is show a kid a van Gogh and try to teach them—the most boring thing about it! It must be seen. Instead give them a big splash of red color and a wide brush and whoa! Then you have action with

the kid, not by showing the van Gogh. No way is a kid going to see a Velázquez. No way. To explain it would be deadly.

I agreed to teach the class, and I projected a Velázquez on the wall. A student brought me a wonderful reproduction of the *Arnolfini Wedding* by van Eyck, I put it up for discussion. We looked at the shade and the hand and the dog by the hem, the vertical lines of the robe come to the vertical lines of the window edge . . . the crenellation of the candelabra echoes the crenellation of her dress . . . the work on the leather belt and the background and the mirror and the back of the couple and the inscription that reads "I was witness to this" and the stations of the cross in miniature . . . each station of the cross . . . the cross actions and references and all of that. We looked at it together, and then discussed it.

When Jack Tworkov asked me to teach at Yale, I had never planned to teach, mind you. I already knew a lot of the faculty up there in New Haven, like Jack Tworkov and Al Held. I asked them about how they did it. How does one teach art? I didn't think it could be done. I would ask many teachers at many universities, and nothing they told me was ever very satisfying. Then I met a guy named Joseph Stapleton. He was brilliant, but I couldn't get his message. I was open to the idea of teaching at Yale or anyplace, but was unsure how to go about it.

CC: What did you do?

KM: So I went home and started looking through a big book I owned of Rembrandt drawings. I opened the book, looked down at the page, and said "whoa."

There was a drawing by one of Rembrandt's students of an annunciation scene, with corrections by Rembrandt. The student's drawing was a little thing that had nothing to do with the corners or the top or the side; it made no attempt to fit the page— just an illustration of an angel as the student might imagine one. In a polite tone of voice, the student's angel was saying to Mary [*speaking in a falsetto whisper*] "Mary, you are the mother of God."

Knox Martin
She
2012, acrylic on linen,
80. x 65 in.

So Rembrandt came in and made radical changes to the drawing so that the angel's head almost reached the top of his wings, which filled one side of the page. Rembrandt lay down some marks on the Virgin's head-drape and in the background he added a few bold, dark verticals. After these corrections, Rembrandt's angel said [*speaking in a deep booming voice*] "MARY! YOU HAVE BEEN CHOSEN!"

Rembrandt had transformed that rectangle, giving the image more power. After that I understood what Joseph Stapleton had been trying to explain to me. He made me realize if I *wanted* to teach, I could teach.

CC: What's your idea of a great lesson?
KM: One of the great things is for the work itself to look at you. It looks right at you. Titian made a portrait of the poet Pietro Aretino, who upon seeing the finished painting

Knox Martin
Crow With No Mouth
2007, acrylic on linen, 80 x 65 in.

said, "Titian's work looks at you and becomes the subject." The tilt of the mouth, the humor in the face, the sharp lines back there, the hair rising up. Each piece is measured from the top, side, bottom, and corners. How the space works is what makes the painting work.

CC: What advice do you give your students? Can you give me an example?

KM: I tell my students, "Look! Don't just draw what you know. If you follow some method of drawing the model, you will be looking at the model through that method. What are you actually seeing? The model, or the method?"

Picasso said, "I am the prisoner of my painting, it tells me what to do. I start out with a collaboration, and when I'm finished, I'm alone."

A student once told me that he was not getting anything from drawing the model. I told him if that was the case, he was not interested in art. He said the model did nothing for him. I replied that while all he could see was a human body, the model represents art.

It's not journalism or engineering. It's a part of the self. It's not psychiatry or science. Art is something else. Art covers all kinds of things.

The core of art is van Eyck, Titian, Veronese, and Cézanne. I have looked at Cézanne's work several hundred times and I've never tired of it. There has to be something about a painting that holds your attention, forces you to keep returning to it, something that keeps it forever fresh. It's not habit or addiction; it's a destroyer of habit. It is a bridge to the known and the unknown. Whatever you learn and whatever you know, it takes all your learning, attention, and mindfulness to see art.

One lovely thing I do: I had a botanical print because it's descriptive of the plant itself. Every stem and joint is exactly, honestly detailed. So I took this botanical print and did a drawing of it in pen and ink and demonstrated in the drawing that the leaf was like a vignette on the page: I extended the leaf so that it addressed the middle of the page, made a slight diagonal (the left corner was now activated), and I pushed the stem in one direction and the right-hand side of the page became alive. When I pushed the arc in the other direction, it began to speak with the drawing as a whole. Without making it unrecognizable, the leaves and folds began to rotate this way and that until the whole rectangle was activated. Every fraction of an inch of the drawing in ink came alive in a way that the botanical illustration was not. It was merely descriptive.

CC: How do you begin a painting or a drawing?

KM: I'll tell you how I begin a painting. In 1915, T. S. Eliot, one of the most important men in literature, published a poem entitled *The Love Song of J. Alfred Prufrock*. It was one of the most innovative things published. It starts off with Dante, and all major poets in a metaphorical way, and suddenly the realization is that what Mallarme ends up with . . . whatever you have . . . is not enough to just have. You have to work on it. Modern art is all ideas . . . Warhol, Rauschenberg, Johns, Twombly—all of them worked with ideas, but art is never just an idea.

CC: What is your first move?

KM: Okay, so let's say you start working. You're on fire with *Danae* by Titian, and you go find it in a book, open the page, and it keeps singing. And then you find another late Titian of a nymph with a faun. And you stop playing the music. She rests on a wild animal skin. Her face is turned towards him, in the background is a tree going up and the leaves, and the tree looks like a major erection, and the action between their legs, and the space, his feet, their legs, and then the metaphor of that space, the tree, the goat, all the various things, but it's mostly the way the thing is painted that drives me crazy I am so enchanted by it. I go into a spin of ecstasy when I see the application of brushstrokes and his finger brushstrokes. It was never vetted through anything known before. The thing that is manifested radiates. Nothing can be said. So if you

eliminate all that is not art, and if you really discuss what remains, what does it mean to make a *first* in art? Like a Bach or a Titian or Shakespeare, they all take you home.

CC: How do you mean?

KM: When I am at home playing Mozart and I turn away my eyes, suddenly there is Velázquez on the wall, and I'm home. On one wall there is a Watteau painting and on the floor is a Cézanne book . . . where I find myself drawing a reproduction of Rembrandt looking at me.

I have had a varied life. From World War II and Omaha Beach up to this very moment, I've lived an amazing life. I'm living an amazing life that includes the most amazing things that men have ever done. I would rather not listen to Wagner, or look at Turner, Constable, or Sir Joshua Reynolds. I'm not crazy about Florentine Renaissance painting.

My mother once said to me, "Show me your friends and I'll show you who you are." So that's all I'm doing; relating it to a Titian or a Velázquez or a van Eyck or a Matisse or a Picasso. I draw these paintings, and they relate to the van Eyck on the wall. I tell my students not to draw what they know but to draw what they see. For the last three months I've been drawing flowers. A group of things strike me and an idea emerges. Like in the *Rape of Europa* or *Zeus and Danae,* when I see a woman and the way her hips move, I personally go into an epiphany! I see a woman move, there and then my knees get weak. It is within a mélange of these things that my work is located.

CC: Didn't you just publish a book of poems? For you, how does that relate to painting?

KM: Yes! I have been writing mermaid poems, which I love. William Butler Yeats wrote a poem about a mermaid who seduces a young lad, forgetting that he would drown in her embrace. Yeats inspired my book *The Mermaid Poems* (2012), a little book I had published. My poems are like my drawings. Any drawing that I do—even the smallest one—is *art*. It's never a preparation for something. I'll do a drawing that'll feed into the painting and a drawing after

the painting if the drawing has informed me about other stuff. These things are for me. I'll put them down, intent on radical metaphors.

CC: Women appear a lot in your work, I don't mean individuals but the female gender. Why is that?

KM: Years ago I visited Sinai. One night as I was sleeping in the desert God spoke to me and said, "Knox! All women are yours!" "Thank you very much", I said, "but I already knew that."

I recently had a one-person show: *She: An Exhibition by Knox Martin* (2012). The title of each one of the artworks is the name of an individual woman: a Chinese woman, an Israeli, an Irish woman. These were all inspired by Velázquez, Titian, Picasso, Matisse, Cézanne, and de Kooning, and also by the women in their lives. I am an heir to their legacy. I live in their village. So for me, the woman-as-metaphor is suddenly the joy of making art. Most of these are large paintings. In them the women's fingers remind me of squiggly music notes. Breasts turn this way or that, soft forms becoming flat shapes. These women come on with their squiggly forms curving down here or there. Each corner is radically different. There are the eyes, and instead of the pupils, the nose is over there, at the top left instead of where a proper nostril belongs. The white background could be a space behind her or the side of her face. Blue comes into and over the nostril, so it's not just a hole, while the mouth is yellow. The eyes are in one place, the mouth is over here, and her dress is over there. There is no foreground, middle ground, or background. All the human figures in my work are females. What Picasso did was make art about women. Bill de Kooning produced his *Women* paintings. It's not only by their example, but I unabashedly enjoy the stories inspired by each woman. A step, a look, and I don't analyze it. I enjoy the company of men, but I'm more inclined to go in the direction of the female. That's the strange thing. Rembrandt said that the true artist is a woman. For Rembrandt's time this would have been someone like Judith Leyster. Let me tell you a story.

One day I was giving a talk in Oregon, where some collectors of my work had set up this talk. I showed some slides and there were seventy people or so in the audience, a mix of collectors, professors, and students. One college student said, "Tolstoy said that art is very subjective and no one knows what art is." I had just given a talk about art. From the lectern I held up a reproduction of Cézanne's *Boy with the Red Waistcoat* and said, "I suppose I could point to art and talk about it."

I held up the Cézanne and said, "This is art."

Who else thought this was art? Gauguin, Dufy, Modigliani, Soutine, Matisse, de Kooning . . . and every major museum has a Cézanne. And there are five hundred books on him, and I'm pointing to art; I can point to it and talk about it. I gave a brief description of the painting in color, shape, division between the rest of the painting and the beauty of the boy's sleeve. All I said was, "This is art." For my small audience, it was like parting the sea. They all walked away.

CC: Do you think about sales? Have you ever worked on commissions?

KM: I have never done anything thinking about what would sell. I have accepted portrait requests or commissions to do wall murals. I've done all kinds of walls on commission. The department store Neiman Marcus commissioned a mural twenty-five feet wide by eighteen feet tall, covering three floors on the exterior facade of the building. I was very involved with African dance, and with that in mind, I said sure. So when I went to meet with him Stanley Marcus said, "This is what I want you to do."

And I said, "I'm not doing anything you want me to do. You asked me if I wanted to do it, you pay me for what I've done. If you like it we'll go ahead, if not drop it."

Three months later I got the plans together, and he flew in from Texas and looked at the maquette. He loved it. He had my assistant, Craig McPherson, and one of his own assistants to help him out. I came to see the finished product and had to redo it myself because the other assistant put too much of himself in it. He extended the form ever so much more than the maquette. It took me two days to repair it, and then I fired him.

CC: The moral of the story?

KM: When I'm involved with a work, I am totally involved, and when I am working on a painting nothing else matters. And there is nothing anyone can tell me about the painting, except maybe if Titian or van Eyck walked in and started talking.

I've never done anything for fame ever. When I was at Yale, I was offered a curatorial position at the Metropolitan Museum of Art. I'm sorry I didn't take it because I would have had access to so much great art. I have been at work on 115 small paintings over the past twenty-nine years. I might take up one, look at it, and then think, it's beautiful but what if I eliminate that shape down there? I try it, and wow! I reworked one of them the other night, just took out a part of it. Maybe it's in your personal psyche when you review it to think, I don't need that, but it—the painting— needs that. I feel as if when I'm looking at a painting and would say that in order to make a work of art, you must know what art is! Essentially true art is revelation—not the illustration of revelation. One must teach without ego. Only by seeing beyond the self can true art be perceived. The false will fade away. What remains is that which is fresh, unique— eternal Dada!

I might ask myself, "Suppose I do that?" I thought that my most recent painting was finished, and then I went back and made some changes. Maybe I'll try it again in a year or two. Maybe the best paintings are never finished.

STUDENT GALLERY

Candace Browne
Untitled
2013, acrylic with glitter, crayon, pencil,
applied fabric, and paper on canvas,
32 x 33 in.

Next page
Karon Johnson
Pale Moon Arising
2014, collage, 11 x 14 in.

David Kramer
Salla
2015, acrylic on canvas,
60 x 48 in.

Concours: Painting and the Public at the Art Students League

Dr. Jillian Russo

Jillian Russo is curator of the Art Students League of New York permanent collection and director of the Phyllis Harriman Mason Gallery. She holds a PhD in art history from the Graduate Center of the City University of New York.

Annually from January through May, every class at the Art Students League presents its work in a series of one-week exhibitions known as student *concours*. A substantial component of the Phyllis Harriman Mason Gallery's exhibition program, the tradition of the concours and the continued use of the French word (meaning "competition" or "examination") express a long-standing commitment to French atelier practices. As these practices were applied in America, specifically at the Art Students League throughout the twentieth century, the function of the concours exhibition has shifted. Today the exhibitions retain a significant competitive aspect (the majority are judged by faculty members and red dots are awarded to the strongest works) but have evolved into a community-oriented activity that represents a range of artistic styles.

In nineteenth-century French ateliers, concours exhibitions were used as preparation for the rigorous *concours des places* examination required for entrance into the premier national art school, the École des Beaux-Arts. The École required students to advance through increasingly rigorous concours, which culminated in the competition for the prestigious Prix de Rome scholarship, which supported study at the French Academy in Rome. In this competition-centered system, art education was structured around a network of small private studios through which master artists such as Jacques-Louis David, Martin Drolling, Antoine-Jean Gros, Paul Delaroche, Charles Gleyre, Thomas Couture, and François-Édouard Picot offered intensive instruction in drawing from the model, a prerequisite for success on *concours des places*. One of Picot's students, Isodore Pils, described Picot's process of preparing his students for the École:

> Once a month, the students' painted figures and sketches were assembled, and the five best of each were chosen in preparation for a final judgment held every three months. A silver medal . . . was presented for the best of the fifteen figures and the best compositional sketch. The prize-winning works were exhibited in the studio, forming a little museum, which was of interest to both old and new pupils and encouraged a spirit of emulation.[*]

[*] Isodore Pils, Notice sur M. Picot, 24 July 1869; in Académie des Beaux Arts: Séances publiques, vol. XV(1864–70). Translated in Albert Boime, The Academy and French Painting in the Nineteenth Century (New Haven: Yale University Press, 1971), 22

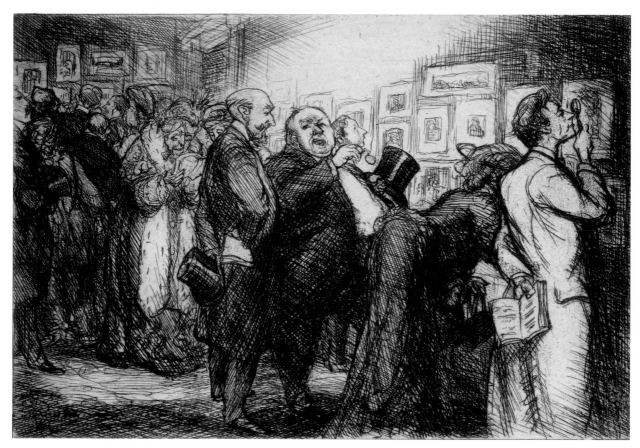

John Sloan
Connoisseurs of Prints
1905, etching, 4.75 x 7.75 in.,
The Art Students League of New York

This practice of juried exhibitions within the atelier is the model from which the Art Students League concours developed.

The concours first became a prominent feature of the League programs at the beginning of the twentieth century. At the time, the school, which had been founded in 1875, was celebrating its twenty-fifth anniversary. Eight years earlier, in 1892, the League had moved into its present building, designed in a French Renaissance style by Henry J. Hardenbergh, the architect of the Plaza and Dakota hotels. The new building, which it shared with the American Fine Arts Society, offered additional studio and exhibition space. In 1901, the League's Board of Control established an Art Committee to oversee the monthly concours, competitions for prizes and scholarships, and the collection and preservation of artworks for the permanent collection. That same year, the students and classes exhibiting were recorded, and League circulars advertised the concours, which were held the last week of every month from October through May.

The records from the 1900–1901 concours document the participation of the women's life drawing classes, a significant and publicly visible departure from the nineteenth-century French

ateliers, in which women were prohibited. Founded on democratic and inclusive principles, the League, from its inception, offered classes to "all who are thoroughly earnest in their work," with men's classes held in the mornings and ladies' classes meeting in the afternoon. The policy of separate life drawing classes did not entirely prevent controversy about a co-ed art school emphasizing drawing from the nude. In 1906, Anthony Comstock, secretary and special agent for the New York Society for the Suppression of Vice, initiated a raid of the Art Students League to seize issues of its publication *The American Art Student*. The "offensive" images under dispute were reproductions of nudes from a recent student exhibition. A female bookkeeper was arrested for distributing the journal and called to testify in court, where the charges against the League were ultimately dismissed.

Despite this incident, the concours offered female professional and aspiring artists an opportunity to exhibit and to compete for scholarships. In 1908, Georgia O'Keeffe, a student of William Merritt Chase, won the Scholarship Prize in Chase's still life class for her painting *Dead Rabbit and Copper Pot*. In exchange for the scholarship, which supported summer study at the League's Outdoor School in Lake George, New York, the painting was acquired for the League's art collection and has been preserved as an exceptional example of her early work. The departure from the traditional rules of the French atelier to open the League and the concours to women suggested a shift from a restrictive system toward a democratic, inclusive, community-driven art education. These principles would be reflected throughout the League's history, including the appointment of esteemed African American artists Charles Alston and Jacob Lawrence as instructors in 1950 and 1967.

Photographs from the 1940s through the present illustrate the importance of the concours as a community-building activity that strengthens relationships between instructors and students, celebrates each class's achievements, and encourages an exchange of ideas. Teachers and students collaborate to install their exhibition and host a reception, which offers an opportunity for students to interact and view the work created in other classes. This encourages exposure to a range of approaches, subjects, and techniques, including social realism, impressionism, geometric abstraction, landscape painting, portraiture, life drawing, welding, assemblage, watercolor, and printmaking.

Although the concours now place a greater emphasis on collectivity, receiving a red dot remains a hard-earned mark of achievement for students. Following the concours, the red-dot-winning works are featured in a Red Dot exhibition, and several are selected for purchase for the Art Students League collection. These dual competitive and communal aspects of the concours reflect the continuation of the atelier tradition at the League and its new meanings for contemporary artists.

Julian Levis Concours,
1976, photograph, 8 x 10 in.,
The Art Students League of New York

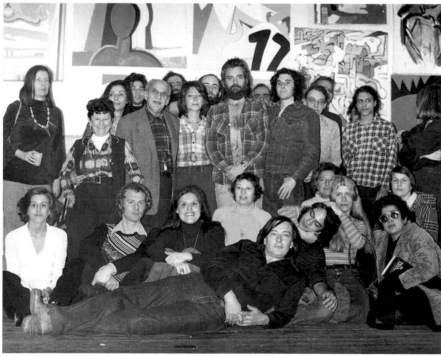

Knox Martin Concours,
1975, photograph, 8 x 7.875 in.,
The Art Students League of New York

Index

A

Abandoned Houses, Richmond, Virginia
 (Rubenstein), 45
Abstract expressionism, 76, 182, 194,
 237–38, 257–58
Académie de la Grande
 Chaumière, 167
ACA Galleries, 149
Accademia degli Incamminati, 10
Acrylics, working with, 168, 171, 215
Adam, Eleanor, 105
Albers, Josef, 245
Albright College, 181
Alexander, John White, 77
Aljira Center for Contemporary
 Art, 181
Alonzo Gallery, 181
Alston, Charles, 284
Amaryllis I (Takei), 133
Amblong, Bill, 234
Amilivia, Diego Catalán, 56
A. M. Sachs Gallery, 181
Anastasio (Jones), 146
André Emmerich Gallery, 251
Andrew (McKenzie), 33
Angelico, Fra, 49
Annunciation (Rubenstein), 48, 49
Antonello da Messina, 159
Apelles, 6
Apotheosis 1 (Thompson), 85
Apple Tree (Tucker), 9
Arakawa, Shuseki, 194
Arcadia Gallery, 75
Aretino, Pietro, 275
Arkay Studios, 195
Arnheim, Rudolf, 244
Arnolfini Wedding (van Eyck), 274
Art Academy of Cincinnati, 10

Art Gallery of Ontario, 75
Art Institute of Chicago, 10, 251
The Artist (Torak), 59
Art Student (Sprung), 93
Art Students League of New York
 artist residency program of, 12
 concours exhibitions of, 282–84
 digital age and, 11
 formation of, 10–11
 inclusiveness of, 284
 instructional culture of, 1, 11, 111
 instructors and students of, 11
 location of, 11, 12, 283
 study-abroad programs of, 12
 women at, 283–84
 *See also individual instructors
 and students*
As We Move Forward (Causer), 248
Asada, Takeshi, vii
The Ascent (Mead), 121
Ashley (Eagle), 135
Astroland (Brosen), 112
Audubon, John James, 7, 217

B

Bailey, William, 245
B & H Dairy (Yost), 120
Barbizon School, 216, 217
Barnes, Albert, 168–69
Barnes Foundation, 167, 168
Barnet, Will, vii, 9, 11, 235
*Bashakill Wetlands from Westbrookville,
 N.Y.* (Storms), 227
Bearden, Romare, vii
Beckmann, Max, 170
Beijing World Art Museum, 75
Bell, Larry, 194
Bellamy, Dick, 257
Bellotto, Bernardo, 108
Ben and Maeli (Mosley), 73

Beñat (McKenzie), 27
Bengston, Billy Al, 258
Bennington College, 251
Benton, Thomas Hart, 11
Bergstrom-Mahler Museum
 of Glass, 59
Betty (Perez), 73
Between Woods and Frozen Lake
 (Torres López), 57
Bierstadt, Albert, 217, 253
Bischoff, Elmer, 169
Blackston, Lester, 234
Blake, Alisyn, 88
Blake, William, 216
Blanch, Arnold, 262
Bleau, Laura, 147
Blue Beach #1 (Kneapler), 267
Bluebird (Landfield), 251
Blue Yellow (Hinman), 197
Boathouse at Malestroit
 (Finkelstein), 19
Bodley Gallery, 257
Bodmer, Karl, 217
Bonington, Richard Parkes, 108
Bonnard, Pierre, 170
Bontecou, Lee, vii, 195
Booth, Cameron, vii
Boston Museum of Fine Arts, 10, 27
Boudin, Eugène, 270, 272
Bowdoin College, 213
Boy with the Red Waistcoat
 (Cézanne), 279
Brackman, Robert, 27, 28, 235
Braque, Georges, 7, 241
Bread and Wine (Torak), 71
Breakfast (Torak), 63
*Bridges at the Hudson and Sacandaga
 Confluence* (McElhinney), 222
Bridgman, George Brandt, 77, 235

Brooklyn Bridge Foggy Morning (Honigsfeld), 121
Brooklyn Museum, 27, 39, 40, 107, 167
Brosen, Frederick, iv, 107–19
Browne, Candice, 280
Burban, Michael, 135
But in His Duty Prompt at Every Call... (Rockwell), 12
Butler Institute of American Art, 27, 39, 59, 181, 251

C

California College of Arts and Crafts, 135
Callas (Sprung), 99
Callner, Richard, 214
Campbell, Gretna, 17
Campbell, Naomi, 123–31, 133
Canaletto, 108
Caravaggio, 7
Carl (Bleau), 146
Carles, Arthur B., 168
Carlsen, Emil, 77
Carlson, John Fabian, 5
Carnegie Museum of Art, 167
Carracci brothers, 10
Cartoon of Miranda XI (Vavagiakis), 159, 160
Catlin, George, 217
Catskill (Homitzky), 181, 189
Causer, Alison, 248
Cave paintings, 6
Cézanne, Paul, 7, 168, 170, 217, 237, 253, 254, 270, 272, 273–74, 277, 278, 279
Chaet, Bernard, 213, 235
Chamberlain, John, vii
Champlain College, 123
Chardin, Jean-Baptiste-Siméon, 7, 108, 273
Charioteer of Delphi, 150
Charlot, Jean, 11

Chase, William Merritt, 11, 284
Chautauqua Institution, 59
Christensen, Dan, 259
Church, Frederic Edwin, 7, 253
Cimabue, 7
Cintron, José, 27
City College of New York, 108, 136
The Clock (Campbell), 130
Color
 choosing, 25
 -spot painting, 40–41
 theory, 244
 unity and, 19
 universality of, 124
 variations of, 18–19, 22, 25
Columbia University, 39
Composition
 forms of, 232
 importance of, 28
 understanding, 215
Comstock, Anthony, 284
Connie V (Vavagiakis), 156
Connoisseurs of Prints (Sloan), 283
Constable, John, 216
Conversations with the Body (Campbell), 131
Cooksey, Chelsea, 270, 272–75, 277–79
Cooper School, 27, 193
Cooper Union, 27, 28, 195, 257
Cope, Gordon, 182
Corcoran College of Art and Design, 10, 75
Corcoran Gallery of Art, 75
Cornell University, 91, 92, 193, 195
Corot, Jean-Baptiste Camille, 7, 159, 216, 217
Cotman, John Sell, 108
Couple Sleeping (Christina and Benait) (McKenzie), 31
Couture, Thomas, 282

Cox, Kenyon, 2, 11
Craig II (Vavagiakis), 153
The Crowning with Thorns (Titian), 272
Crow With No Mouth (Martin), 276
Cunningham, Francis, 40

D

DaCosta, Arthur, 236
Danae (Titian), 273, 277, 278
Dance of Man (O'Cain), 231
Dancing on the Fringe (Blake), 88
Danville Museum of Fine Arts & History, 59
David, Jacques-Louis, 7, 282
David Richard Gallery, 194
Da Vinci, Leonardo, 1, 159, 214
Davis, Stuart, 11
Dawn Scaffold (Scharf), 174
D. D. & B. Gallery, 231
Dead Rabbit and Copper Pot (O'Keeffe), ix, 284
De Castro, Sue, 190
Degas, Edgar, 41, 138
De Kooning, Willem, 194, 237, 241, 257, 272, 278
Delacroix, Eugène, 7, 216
Delaroche, Paul, 282
Delehanty, Patricia, 37
The Deluge (Landfield), 255
Denise Bibro Fine Art, 203
De Solar, Jose, 190
Detour (Song), 179
DFN Gallery, 181
Diamond Lake (Landfield), 231
Dickens, Charles, 49
Dickinson, Edwin, vii, 40, 41, 235
Dickinson, Sidney, vii, 235
Diebenkorn, Richard, 169, 259

Dinnerstein, Harvey, 92, 135, 150

Domberger, Poldi, 195

Donarski, Ray, vii

Don't Let the Sun Go Down
 (Tokon), 266

Dorfman, Bruce, 204, 235

Dorin, Marsha, 133

Draconios (Hinman), 199

Drake, Douglas, 193

Drawing, role of, 28–29, 41, 139, 150,
 151, 159–60, 170, 217, 259, 273

Dream of Yusef (Thompson), 83

Drescher, Diane, 22, 23

Drolling, Martin, 282

Duccio, 7

Duchamp, Marcel, 124

Durer, Albrecht, 214

D. Wigmore Fine Art, 194

E

Eagle, Ellen, 135–45

Eakins, Thomas, 40

East Carolina University, 213

Eastman, Seth, 217

East Sixth Street Synagogue
 (Brosen), 107

École des Beaux-Arts, 282

Eleanor Ettinger Gallery, 75

El Greco, 254

Eliot, T. S., 277

Ella Sharp Museum of Art and
 History, 231

Ellis Island from the Battery
 (McElhinney), 218

Emerging III (O'Cain), 233

Emily in Profile (Eagle), 143

Encaustic painting, 203, 204–5

Erasures (Campbell), 129

Erin (Adam), 105

Evan (Mosley), 73

Evening Music (Landfield), 264

Everson Museum of Art, 194

F

Fairlawn Community Center, 231

Female Portrait (Da Silva), 89

Fields, Holly, 133

Figure painting, 29, 35, 76–79,
 92–93, 103

Figure Study (Verdeza), 89

Figure in Motion (Parnell), 249

Figure with Window (Drescher),
 22, 23

Finkelstein, Henry, 17–22, 25

Finkelstein, Louis, 17

Fitzgerald, Maureen Guinan, 249

Flack, Audrey, 11

Florio, Rosina, vii, 184

Folding Chairs (Sprung), 97

Fondren, Jason, 89

Forum Gallery, 135

Frank Caro Gallery, 181

Freedman, Edward H., 40, 50

Friedrich, Caspar David, 7

Frye Art Museum, 149

G

Galerie Denise René, 193, 194, 195

Gallery Henoch, 91

Gallery Korea, 231

Garber, Daniel, 168

Garden Shed with Roses
 (Finkelstein), 21

Gasmask 2 (Rubenstein), 50, 54

Gateway (Homitzky), 188

Gauguin, Paul, 7

Gen Paul Gallery, 231

George Billis Gallery, 39

Georges, Paul, 235

*George Washington Bridge from Fort
 Tryon Park* (McElhinney), 220

Gericault, Theodore, 270

Gesture, concept of, 77, 87

Ginsburg, Max, 150

Gioia VIII (Vavagiakis), 156

Giotto, 7

Girtin, Thomas, 108

Glasier, Marshall, 235

G. Lawrence Hubert Gallery, 181

Gleyre, Charles, 282

Goldberg, Ira, viii

Golden Moments (Zeller), 211

Gorky, Arshile, 257

Gottlieb, Adolph, 257

Grand Central Academy of Art, 75

The Great War and Me
 (Rubenstein), 50, 52

Greenberg, Clement, 237

Greenberg, Irwin, 150

Greene, Daniel, 27, 92, 135

Greene, Stephen, 257–58

Green Gallery, 257

Gros, Antoine-Jean, 282

Grosz, George, vii, 11

The Guggenheim, 167, 169

Gu Kaizhi, 6

Guston, Philip, 257

G. W. Einstein Gallery, 181

H

Hackett-Freedman Gallery, 149

Hale, Robert Beverly, vii, 59, 60

Halpert Gallery, 181

Hals, Frans, 253–54, 263

Hand Studies for Miranda XI
 (Vavagiakis), 160

Hans Mayer Gallery, 193, 194

Hardenbergh, Henry Janeway,
 12, 283

Harlequin (Sprung), 101

Hartley, Marsden, 183

Harvest (Rizika), 190
Hatofsky, Julius, 169
Headlines (Rosenquist), 12
Held, Al, 235, 274
Henri, Robert, 43, 77
Her Digestion (Ogasawara), 201
Hernandez, Peter, 178
Hesse, Eve, 195
Highline at W. 30th St. (Katz), 227
High Museum of Art, 167
High School of Art and Design, 150, 255, 257, 259
High School of Music & Art, 108, 136
Hinman, Charles, vii, 193–99
Hirsch, Joseph, 181, 182, 183
Hirschl & Adler Modern, 107, 149
Hirshhorn Museum, 193, 251
Hockney, David, 217
Hodges, William, 7, 217
Hofmann, Hans, 22, 235, 237, 258
Hokusai Sketchbooks (Michener), 214
Homitzky, Peter, 181–89
Honigsfeld, Molly, 121
Horikawa, Yukimasa, 147
Houston Street (Brosen), iv
Hudson River School, 216
Hunterdon Art Museum, 181
Huntsville Museum of Art, 59
Hurricane (Landfield), 261
Hymn for the General Slocum (March), 57

I

I against I (Thompson), 83
I Love You With My Ford (Rosenquist), vi
Impressionism, 7, 254
Indiana, Robert, 195
The Infanta Don Margarita de Austria (Velázquez), 270

Ingres, Jean-Auguste-Dominique, 108, 159
In Heat of the Trapezoid (Scharf), 175
In Memory of Primo Levi (Rubenstein), 50, 52
Inness, George, 40
Insley, Will, 195
Julian Levis Concours, 285
Institute of Contemporary Art, 167
Interior with Bust of Minerva (Finkelstein), 17
International School of Art, 269
In the Studio (Torak), 59
Inverted Figure (McKenzie), 31
Irina (Thompson), 75
Irish Museum of Modern Art, 167
Irwin, Robert, 194
Isabella Stewart Gardner Museum, 272
Isidiris (Landfield), 256
Ives, Norman, 194

J

James I (Thompson), 81
James River, Winter 2 (Rubenstein), 42
Jane Voorhees Zimmerli Art Museum, 181
Janus Collaborative School of Art, 75
Jersey City Museum, 181
Jessie (Horikawa), 147
John Pence Gallery, 75
Johns, Jasper, 277
Johnson, Karon, 280
Johnson, Philip, 258–59
Jones, Robert, 146
Jones, William Fletcher, 234
Journal painting, 214–17
Juan de Pareja (Velázquez), 150

Judd, Donald, 257
Jun at the Light (LoPresti), 162

K

Kansas City Art Institute, 257
Kantor, Morris, vii, 194, 235
Katz, Morris, 182
Katz, Nora, 227
Kendrick, William, 234
Kern brothers, 217
Kitakiya (Thompson), 79
Klein, Jack, 195
Kline, Franz, 183, 237, 257
Klonis, Stewart, vii, 182
Kneapler, John, 267
Knox Martin Concours, 285
Kramer, David, 280
Kramer, Hilton, 183
Krasl Art Center, 59
Krasner, Lee, 11
Krishnamurti, Jiddu, 269
Kuniyoshi, Yasuo, 11

L

Lackawanna (Leon), 191
Landfield, Ronnie, 231, 251–64
Landscape painting, 108, 110, 185, 216, 253
Larré, Yellow and Blue (Finkelstein), 20
Larson, Renée, 37
Lawrence, Jacob, 284
Lawson, Ernest, 5
Layton School of Art, 10
Lee, Haksul, 22, 24, 25
Leffel, David A., 235
Lehman College, 107
LeLande (Hinman), 198
Le Moyne, Jacques, 216, 217
Leo Castelli Gallery, 251, 257

Leon, Rick Davalos, 191
Les Roses 1 (Rubenstein), 48, 49
Letitia Wilson Jordan (Eakins), 40
Levi, Primo, 50
Levine, David, 40
Lewis, David Dodge, 41
Liberté, Jean, 181, 182
Library 1 (Rubenstein), 49, 51
Lichtenstein, Gary, 195
Lichtenstein, Roy, 257
Life Drawings (Prendergast), 226
Light, importance of, 43, 61
Light and Transparency
 (Wakabayashi), 133
Light key, 78–79
Lin, Maya, 133
Lipchitz, Jacques, 150
Little Accidents #6 (Del Solar), 190
Little Angel of the Pike (Scharf), 172
Liz (Shim), 105
LoPresti, Christopher, 162
Lorrain, Claude, 216
Los Angeles County Museum
 of Art, 193
Louisiana Museum of Modern
 Art, 193

M

Maier Museum of Art, 39
Mailer, Norman, 234
Malabarismos (Melo), 201
Manet, Édouard, 273
Mangold, Robert, 195
Mann, David, 257
Marantz, Irving, 184
March, Eric, 57
Marc Straus Gallery, 194, 195
Marcus, Stanley, 279
Marissa (Delahanty), 37
Marissa (Mendl), 89

Maroger, Jacques, 235–36
Marquet, Albert, 18–19
Marsh, Reginald, 11
Martin, Knox, 235, 269–79
Maryland Institute College
 of Art, 39
Mason, Frank, 59, 60, 235, 237
Masur Museum of Art, 59
Matisse, Henri, 170, 171, 253, 254,
 274, 278
Maxine Hong Kingston (Eagle), 141
Maxwell, Fred, 182
Maxwell Galleries, 182
McElhinney, James L., 1, 3, 6–7, 10–
 12, 213–24, 232, 234–38, 240–41,
 244–45, 247, 253–55, 257–59,
 262–63
McKenzie, Mary Beth, 27–35
McPherson, Craig, 279
Mead, Stephanie, 121
Meditation #1 (for Naomi)
 (Fields), 133
Melo, Michelle, 201
Mendl, Roy, 89
The Mermaid Poems (Martin), 278
Merrimack Valley of Music and
 Art, 231
Metropolitan Museum of Art, 27, 39,
 75, 107, 150, 169, 215, 235, 247,
 251, 253, 270, 279
Michelangelo, 1
Michener, James, 214
Midwest Museum of American
 Art, 231
Miller, Alfred Jacob, 217
Miranda I (Vavagiakis), 159, 160
Miranda III (Vavagiakis), 159, 160
Miranda V (Vavagiakis), 159, 160
Miranda VII (Vavagiakis), 159, 160
Miranda VIII (Vavagiakis), 159, 160
Miranda IX (Vavagiakis), 160

Miranda X (Vavagiakis), 159, 160
Miranda XI (Vavagiakis), 159, 160
Miranda XI Study I (Vavagiakis), 160
Miranda XI Study III
 (Vavagiakis), 160
Miriam Perlman Gallery, 231
Mirzakhani, Maryam, 217
A Mischief of Magnets (Scharf), 167
Miss Leonard (Eagle), 140
Mondrian, Piet, 124
Monet, Claude, 253
Montclair Art Museum, 181
Mont Sainte-Victoire (Cézanne), 273
Moore, Henry, 150
Moore College of Art and
 Design, 213
Moran, Thomas, 217
Morris, Robert, 257
Morris Museum, 181
Mosley, Walter Lynn, 73
Motherwell, Robert, 257
Mount Dora Center for the Arts, 203
Mowbray, H. Siddons, 77
Museum of Fine Arts Houston, 251
Museum of Modern Art, 167, 169,
 193, 251, 257, 273
Museum of the City of New York,
 27, 107, 149
Museum of the Russian Academy
 of Arts, 91

N

Nagaoka City Local Museum, 193
National Academy Museum and
 School, 10, 17, 27, 39, 59, 91, 92,
 107, 150
National Arts Club, 75
National Gallery, 251
National Museum of American
 Art, 27

National Museum of Women in the Arts, 27

National Portrait Gallery, 149

Neuberger Museum of Art, 167

Newark Museum, 167, 181

New Britain Museum of American Art, 27

New Jersey State Museum, 181

Newman, Barnett, 194

New Museum, 195

New Onions (Torak), 65

New York Academy of Art, 75

New York Historical Society, 27

New York University, 251, 269

Niagara (McElhinney), 224

Night and Day (Hinman), 196

Night Street V (Vavagiakis), 149

Noble Maritime Collection, 75

Noland, Kenneth, 259

Northern Illinois University, 231

Norton Simon Museum, 251

Noyes Museum of Art, 181

Nude with Hands Touching (Eagle), 139

Numero Cinco (Sura Sababa), 201

O

O'Cain, Frank, 231–47

Ogasawara, Aya, 200

Oil painting techniques, 151

O'Kane Gallery, 91

O'Keeffe, Georgia, ix, 11, 284

Olitski, Jules, 259, 263

Olympia (Manet), 273

On the Heights (Winiarski), 206

Open Worlds (Campbell), 123

Optical mixture, 22

Orange Dress (Lee), 24

P

P (Sprung), 98

Painting

defining, 232, 253–54

as discovery process, 171

drawing and, 28–29, 41, 150, 151, 159–60, 170, 217, 259, 273

finishing, 138, 217, 241, 244, 279

history of, 3, 6–7

as language, 253

learning, 28, 77, 245, 247, 262–63

from life, 28–29, 76–79, 92–93, 103

light and, 43, 61

motivation and, 204, 215

nature of, 1, 3

from observation, 18, 40–41, 43

preparing materials for, 60–61, 87

role of past in, 60

style and, 62

subject matter for, 41, 61

teaching, 3, 10, 29, 77, 92–93, 110, 133, 169–71, 184–85, 205, 244–45, 259, 262–63, 274–75, 277

in three dimensions, 194

as way of being, 29, 263

Pale Moon Arising (Johnson), 280

Palette, setting up, 61, 92, 103, 215

Palmer, Samuel, 216

Park, David, 169

Parnell, John, 249

Pasadena Museum of California Art, 75

Pastels, working with, 22, 136–39, 145

Peale, Rembrandt, 217

Pearlstein, Philip, 22

Pearson, Henry, vii

Pelepko, Isaac, 162

Pennsylvania Academy of the Fine Arts, 10, 167, 168, 169, 236

Perez, Rick, 73

Persian Archer (Thompson), 85

Peter (Smith), 104

Philadelphia Museum of Art, 10, 60, 167, 168, 169

Philipp, Robert, 27, 28, 29, 235

Phillips Collection, 167

Photographs, working from, 119

Phyllis Harriman Mason Gallery, 282

Picasso, Pablo, 7, 171, 241, 254, 272, 273, 277, 278

Picot, François-Édouard, 282

Pigeon (Dorin), 133

Pils, Isodore, 282

The Pink Kimono (Carlson), 5

Pollock, Jackson, 11, 194, 257

Porter, Fairfield, 235

Portrait bust, painting, 87

Portrait of a Young Woman (van der Weyden), 159

Portrait of Djordje Milicevic (Barnet), 9

Portrait of L (Sprung), 94

Portrait of the Honorable John Keenan (Sprung), 95

Poussin, Nicolas, 215, 254

Pratt Institute, 107, 108, 193, 195, 213

Prendergast, John, 226

Princeton Arts Society, 231

Princeton University, 193, 195

Professional Art Institute, 234

Prometheus (Rubens), 60, 62

Purdue University, 231

R

Raft of Medusa (Gericault), 270

Rainbow XXXVI (Vavagiakis), 153

The Rape of Europa (Titian), 272–73, 278

Raphael, 159

Rauschenberg, Robert, 257, 277

Realism
 in pastel, 136–39
 in watercolor, 108, 110–11, 119
The Recorder Player (Torak), 67
Reese Gallery, 181
Reginato, Peter, 258
Reinhardt, Ad, 194
Rembrandt, 7, 216, 237, 253–54, 263, 270, 274–75, 278
Rhode Island School of Design, 39
Rice, Dan, 181, 183
Richard Feigen Gallery, 193, 194, 195
Rijksmuseum, 107
Rilke, Rainer Maria, 41, 49
Rite of Spring (Landfield), 253
Ritual in the Courtyard (Ogasawara), 200
Riverside South (Rosen), 227
Rizika, Marne, 190
Rockwell, Norman, 12, 169
Roko Gallery, 181
Rooftop I (Vavagiakis), 155
Root-Bernstein, Robert, 247
Rose, Leatrice, 184
Rosen, Laura, 227
Rosenquist, James, vi, vii, 11, 12, 195
Roshmi (Perez), 73
Rothko, Mark, 171, 194, 237, 257
Rottmann, Carl, 7, 216, 217
Rubens, Peter Paul, 1, 60, 62, 235
Rubenstein, Ephraim, 17, 39–55
Rule of Thirds, 215
Russo, Jillian, 282–84
Rutgers University, 181
Ryman, Robert, 195

S

Saff, Don, 195
Saffron I (Winiarski), 203, 207
Saginaw Art Museum, 231

Sagittarius (Hinman), 193
Salander-O'Reilly Galleries, 149
Salla (Kramer), 280
San Diego Art Institute, 59
San Francisco Art Institute, 181, 182, 258
San Francisco Museum of Modern Art, 181
Sargent, John Singer, 108
Scharf, William, 167–77
Schleifer, Trudi Mara, 210
School of Visual Arts, 123, 193, 251, 259
Schoonover, Frank, 169
The Scratched and Unfixed Air (Scharf), 176
Seagulls and Sirens (Mead), 121
Sealey, Beverly, 133
Seattle Art Museum, 251
Selected notebooks (McElhinney), 213
Self-Portrait, Green Background (McKenzie), 33
Sensuous equivalents, 49
Series, concept of, 41
72nd Street (Brosen), 116
Seymour, Samuel, 217
Shaken, Not Stirred (De Castro), 190
Shape, perception of, 77
She (Martin), 275, 278
Shikler, Aaron, 40
Shim, Sun, 105
Sid Deutsch Gallery, 181
Sidney Janis Gallery, 193, 194, 257
Sillman and Ives, 195
The Silver Bowl (Torak), 67
Silverman, Burton, 27, 40, 150
Singing the Blues (Sealey), 133
Skidmore College, 213
Slater, John, 234
Sloan, John French, 11, 283

Slutzky, Robert, 194
Smith, David, 150
Smith, Robin, 104
Smithson, Robert, 195
Smithsonian American Art Museum, 167
Smithsonian Institution, 27, 91, 149
Solin, Dee, 267
Somerset Division (Homitzky), 186
Somerset Division 2 (Homitzky), 187
Song, Shyun, 179
Songs My Ancestors Sang (O'Cain), 243
Sospirando (Winiarski), 209
South Street Seaport Museum, 107
Spawn (Campbell), 127
Speight, Francis, 168, 169
Springfield Museum of Fine Art, 59
Spruance, Benton, 168
Sprung, Sharon, 91–103
Stack, Dan, 195
Stadtmuseum (Munich), 251
Stairway to Heaven (Solin), 267
Stanford University, 251
Stapleton, Joseph, 274, 275
Staten Island Academy, 195
Stearns, Joyce, vii
Still, Clyfford, 194
Still life paintings
 emotional range of, 49–50
 as group portraits, 71
Still Life with Books, Mirrors and Lenses 1 (Rubenstein), 49, 51
Still Life with Burned Books (Rubenstein), 17, 50, 51
Still Life With Empty Nests (Rubenstein), 48, 49
Storms, Kevin, 226, 227
Studio Incamminati, 75
Studio Interior with Model (Rubenstein), 47

The Studios of Key West, 203
Study for the Seal of the Art Students League of New York (Cox), 2
Stuempfig, Walter, 168
Style
 concept of, 62
 copying, 138, 245, 274
Sunrise (Lawson), 5
Sura, Jeanette, 201
Syracuse University, 193, 194, 195

T

Takei, Yuko, 133
Tatıstcheff Gallery, 39
Telfair Museum of Art, 167
Temperance Fountain, Thompkins Square Park (Brosen), 115
Theano Stahelin Kunstsalon, 231
Thompson, Dan, 75–87
Three Musicians (Picasso), 273
Tiao, David, 195
Tibor de Nagy Gallery, 39, 257
Titian, 1, 235, 270, 272–73, 275, 277, 279
Tokon, Md, 266
Tokyo Gallery, 193
Torak, Thomas, 59–71
Torres López, Hipólito, 57
Toschi, Joe, 182
Toulouse-Lautrec, Henri de, 7
Tram (Fondren), 89
Tribal Necklace (Larson), 37
Trochee of Citrus (Scharf), 177
Tropical (Kneapler), 267
Trumbull, John, 7
Tsunami (Schleifer), 210
Tucker, Allen, 9
Turner, Joseph Mallord William, 7, 108, 216, 217

Twombly, Cy, 277
Tworkov, Jack, 269, 274
Tyler School of Art, 213, 214
Tyrone (Amilivia), 56

U

University of Colorado, 213
University of Georgia, 193, 195
University of Guelph, 123
University of Michigan, 231
University of Richmond, 39, 41
Untitled (Brown), 280
Untitled (Fitzgerald), 249
Untitled (O'Cain), 236, 243, 246
Untitled (Thompson), 80
Untitled (Velazquez), 210
Untitled (When Mentioning My Name) (Campbell), 126
Untitled I (Campbell), 130

V

Valley Farm, Pine Bush, N.Y. (Storms), 226
Van der Weyden, Roger, 159
Van Eyck, Hubert, 7
Van Eyck, Jan, 7, 235, 270, 274, 277, 278
Van Gogh, Vincent, 7, 41, 274
Vatsyayana, 6
Vavagiakis, Costa, 149–60
Velázquez, Diego, 150, 262, 270, 274, 278
Velazquez, Elizabeth, 210
Verdeza, Sergio, 89
Verdure (Winiarski), 208
Vermeer, Johannes, 7, 108, 254, 263

Veronese, Paolo, 270, 277
Villard de Honnecourt, 214
Virginia Commonwealth University, 234
Virginia Museum of Fine Arts, 39, 234
Visual Arts Center of New Jersey, 181
Von Humboldt, Alexander, 216
Vossberg's Grove (Homitzky), 183
Vytlacil, Vaclav, vii, 231, 235, 237

W

Wadsworth Atheneum, 107
Wakabayashi, Yoko, 133
Walker, Antonia, 37
Walker, William, 234
Walker Art Center, 251
The Wandering (Hernandez), 178
Warhol, Andy, 7, 257, 277
Watercolor
 classic realism in, 108, 110–11
 as medium, 124–25, 215
 size and, 125
 working from photographs in, 119
Watkins, Franklin, 168
Waugh, Frederick Judd, 77
The Weapons Become the Altar (Scharf), 167
The Wedding at Cana (Veronese), 270
Weiwei, Ai, 11
Wesselmann, Tom, 195, 257
West 10th Street (Brosen), 115
West 76th Street (Brosen), 109
What Goes Around (Harrison), 211
Whistler, James Abbott McNeill, 7
White, John, 216, 217
Whitman, Robert, 194

Whitney Museum of American Art, 193, 251
Wichita Art Museum, 181
Wilde, Oscar, 185
Windowpane (Sprung), 96
Winiarski, Deborah, 205–9
Winter 2006 (Eagle), 142
Wiregrass Museum of Art, 59
Woman (Martin), 272
Woman with a Pink (Rembrandt), 270
Woman with Red Shoes (Martin), 272
Woman with Wonderbread Breasts (Martin), 269
Women in Art II: Preparing to Paint (Torak), 68
Woodley Interior Sunlight 3 (Rubenstein), 39
Woodley Summer Dawn (Rubenstein), 42
Woodmere Academy, 195
Woodstock Artists Association & Museum, 203
Woodstock Torline (Homitzky), 185
Wyeth, Andrew, 168
Wyeth, Jamie, 41
Wyeth, N. C., 168, 169

Y

Yale University, 27, 28, 213, 214, 235, 245, 269, 274, 279
Yeats, William Butler, 278
Yost, Christine, 120
Young Man in Red Shirt (Walker), 37
Young Woman in Snow (Pelepko), 162

Z

Zeli (Sprung), 91
Zeller, Lori Hope, 211
Zeuxis, 6